MW00903244

INSIDE CHINATOWN 域多利華埠

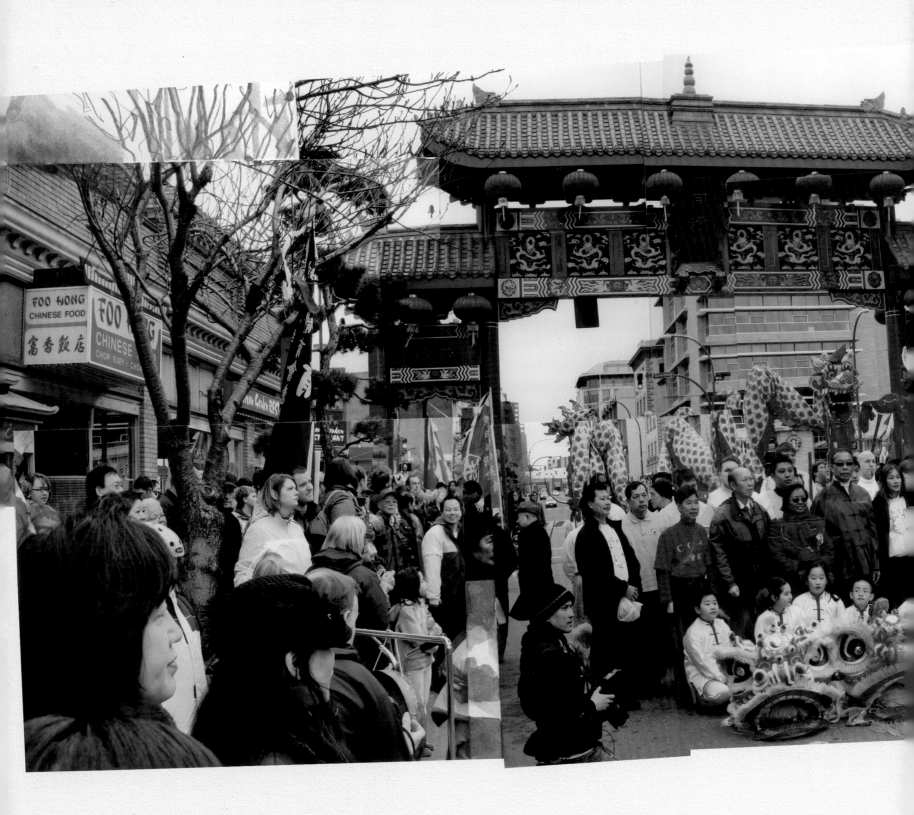

INSIDE CHINATOWN 域多利華埠

ANCIENT CULTURE IN A NEW WORLD 歲月留痕 古貌新風

ROBERT AMOS 埃莫斯 KILEASA WONG 吳紫雲

TouchWood
Editions

Copyright 2009 © Robert Amos and Kileasa Wong

All rights reserved. No part of this publication may be reproduced,stored in a retrieval system, or transmitted
in any form or by any means—electronic, mechanical, recording, or otherwise—without the prior written
consent of the publisher or a licence from The Canadian Copyright Licensing Agency (Access Copyright).
For a copyright licence, visit www.accesscopyright.ca.

TouchWood Editions
www.touchwoodedtions.com

LIBRARY AND ARCHIVES CANADA CATALOGUING IN PUBLICATION
Amos, Robert, 1950–
Inside Chinatown : ancient culture in a new world / Robert Amos and Kileasa Wong.
Includes bibliographical references. Text in English and Chinese.
ISBN 978-1-894898-91-1

1. Chinese Consolidated Benevolent Association (Victoria, B.C.)—History.
2. Chinatown (Victoria, B.C.) Pictorial works. 3. Chinese Canadians—British Columbia—Victoria—
Socieities, etc.—History. 4. Chinese Canadians—British Columbia—Victoria—Pictorial works.
5. Chinatown (Victoria, B.C.)—History. I. Wong, Kileasa II. Title.
FC3846.9.C5A46 2009 971.1'28004951 C2009-902904-9

Edited by Marlyn Horsdal
Proofread by Holland Gidney
Book design by Jacqui Thomas
For photography credits, see page 157. The copyright for all photos is held by the owner.
To reproduce any please contact TouchWood Editions.

TouchWood Editions acknowledges the financial support for its publishing program from the Government of
Canada through the Book Publishing Industry Development Program (BPIDP), Canada Council for the Arts, and
the province of British Columbia through the British Columbia Arts Council and the Book Publishing Tax Credit.

PRINTED IN HONG KONG

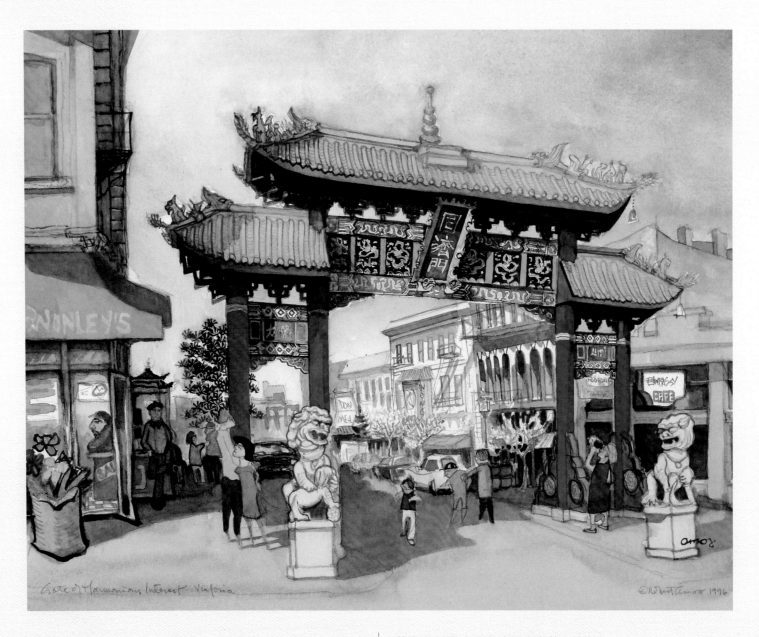

The Gate of Harmonious Interest, erected
at the intersection of Government and
Fisgard streets in Victoria in 1981.
(WATERCOLOUR BY ROBERT AMOS, COURTESY OF THE
CIVIC ART COLLECTION OF THE CITY OF VICTORIA)

華埠同濟門，位於加富門街與菲士格街交
界處，一九八一年建造。(羅伯特.埃莫斯之
水彩畫，維多利亞市政廳藝術部收藏)

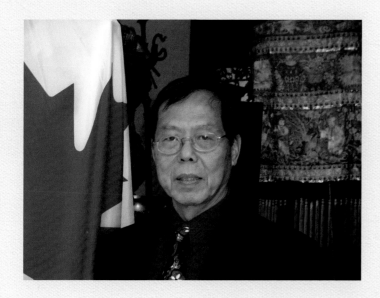

Seal of the CCBA.

域多利中華會館印章

Kit Wong,
President of the CCBA of Victoria.

域多利中華會館主席黃 杰

FOREWORD

As president of the Chinese Consolidated Benevolent Association of Victoria I am pleased to invite you to look in the door of our member organizations and to view some of their activities. In the 150 years since the first Chinese arrived on these shores, the CCBA has mirrored their changing needs and those of their descendants and successors. It is with pride that we can now share our Chinese traditions, and the success and confidence that we feel as part of a vibrant Canadian community.

Kit Wong
President
Chinese Consolidated Benevolent Association

黃杰序言

身為中華會館主席，我很榮幸地在這裏邀請大家一同瞭解本會館屬下各僑團及其活動。由首批華人到達本埠至今，一百五十年來，中華會館見証了華裔在本地的變遷。我們可以自豪地與大家分享我們的傳統文化。我們的成功與自信，使我們成為這個充滿活力的社區之一份子

黃杰 謹上
域多利中華會館主席

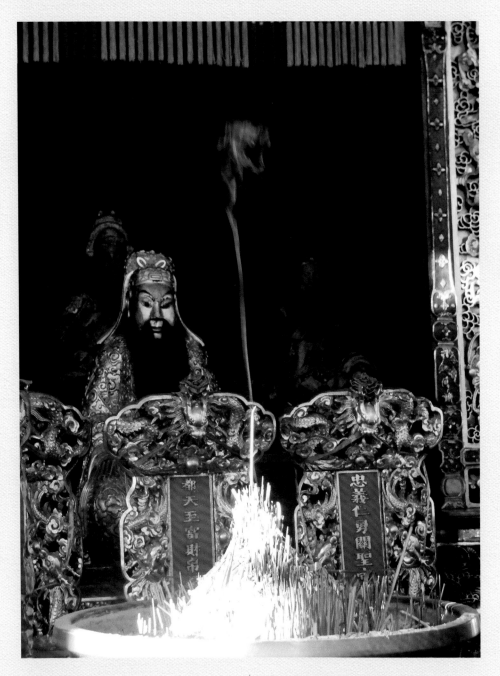

Incense burning on the main altar of the
Chinese Consolidated Benevolent Association
in the Victoria Chinese Public School.

中華會館華僑學校禮堂內神壇香爐
上之縷縷清煙。

CHINESE MEETING HALLS IN VICTORIA
維多利亞市華埠之聚匯禮堂

There is strength in numbers, and the Chinese people have always seen the advantage of coming together. The associations and clubs that make up the Chinese Consolidated Benevolent Association have 87 directors and about 1,500 members combined. Some of these groups are based on ties of family name and kinship, place of origin or religious and political affiliations. Other group identities were forged by shared cultural interests in art, music, dance or literature. Larger social endeavours—the school, the hospital, the cemetery—naturally involved many people. Service clubs benefit the community through their concerted actions and they also foster business relationships. A few of these organizations, such as the school and the hospital, have employees but all are directed by members who are volunteers. They do not all have their own meeting halls, though those that do are featured prominently in this book.

These meeting halls provide a central place for reading the newspaper and catching up on conversation. Many also provide space for activities that are not done at home, such as kung fu, musical performances and table tennis. Certain ceremonial aspects of Chinese life require an altar and shrine where a clan's origins and a sense of spirituality may be honoured. Food is often served in these clubs, though kitchens are not usually a part of the meeting halls, perhaps because there are so many excellent Chinese restaurants nearby. Each meeting hall is different.

華人的習慣是喜歡聚滙一堂，中華會館屬下有二十九個僑團，八十七位理事及共約一千五百名成員。其中有些是以姓氏、藉貫、宗教或政治信仰等為創會宗旨。有些團體則以分享文化、藝術、音樂、舞蹈或文學為興趣。大的僑團有足夠人力設立學校、醫院及墳場。以服務為宗旨的社團為社區福利而作出貢獻，這些社團一般與促進商業發展有相聯關係。有些組織如學校和醫院，需聘請職員，由義務的執行理事管理。並不是每個僑團都有會址及禮堂，但中華會館屬下的所有僑團，都包括在這本書中。

一般僑團的禮堂都有空間可閱讀新聞報紙，或與他人閒話家常。有些僑團更提供功夫練習、音樂表演或乒乓球等不常在家中做的活動。禮堂中通常置有神壇及先僑的神龕，以便定期拜祭。每個僑團的禮堂佈置各異。雖然並不是每個堂所設均有厨房，但僑團經常舉辦聚餐活動，因華埠中有很多提供美食的餐館。

Meeting halls are open according to need. At some, regular groups meet first thing in the morning; at others, members come together late at night; and of course special events have their own timetables. The membership of the older groups was exclusively male, but now there are also associations for women. In most cases family participation is encouraged.

Certain groups conduct their activities mostly in Chinese languages, while others, which are directed more toward Canadian-born Chinese, operate in English. Some non-Chinese also find their needs met in the halls in matters of sport, education and business. There are groups for seniors and others that focus on youth. The majority of people in the Chinatown community are affiliated with at least one association.

The meeting hall of an association usually contains pictures of the members, works of calligraphy, paintings, a framed list of executive members, acknowledgments of financial donations, banners, congratulatory messages from other associations and formal furniture. In a central location there is usually an altar and shrine. The shrine may consist of a portrait of a mythical forefather or ancestor with a couplet from a poem or historical messages on each side. Often in front there is an altar table bearing an incense burner, joss-stick holders, flower vases and plates for sacrificial food.

Offerings and observations are made at the altar and shrine every day and most clan associations also observe the birthdays of their ancestors. The executive and members gather in front of the altar, stand in silence and bow three times to the portrait of the ancestor. The principal worshipper offers incense and wine; then the accompanying members present sacrificial offerings, such as chicken, pork, cakes, fruits and flowers. A eulogy is read detailing the history, moral conduct, glories and achievements of the ancestor. The observances are concluded with the serving of tea, during which a few leaders or elders are asked to speak. They tell stories of the ancestor and remind those present that they are all descended from the same forefather "just like water that flows from the same source." The ritual conveys a sense of common identity and group solidarity.

These are private clubs and their meeting halls are not open to the public; please respect their privacy.

僑團的禮堂因需要而開放,有些每天早上聚會,有些則在晚上見面。特別的活動則另定時間舉行。歷史較悠久的僑團,通常其會員均是男性。但目前已有以婦女為主的僑團。大部份的僑團是合家歡迎的。

華埠佔多數的僑團,開會時以中文粵語為主,也有些以加國土生華裔佔大多數的僑團是以英語為開會語言。經常在華埠出入的華人,每人至少參加一個僑團。

僑團禮堂通常擺放會員的相片、書法、國畫、理事名單、捐款者名單、橫額、及其他僑團的賀詞、古董傢俱等。在中央位置通常都有一座神壇及神龕,神龕內掛著先僑的肖像,兩邊掛有詩句或處世格言。神壇的前方設有桌子、擺放著香爐、簽筒、花瓶和各類祭品。

禮堂裡的神壇,每日均進行拜祭。大多數的僑團會在其先祖的誕辰舉行儀式。儀式中,執行理事們齊站在神壇前,向先祖畫像鞠躬三次。主祭人上香和敬酒,然後獻上祭品,如雞、燒豬、糕 儀式使會員更有歸屬感,更加團結。

這些僑團均是私人堂所,是不對外開放的。請尊重他們的私隱。

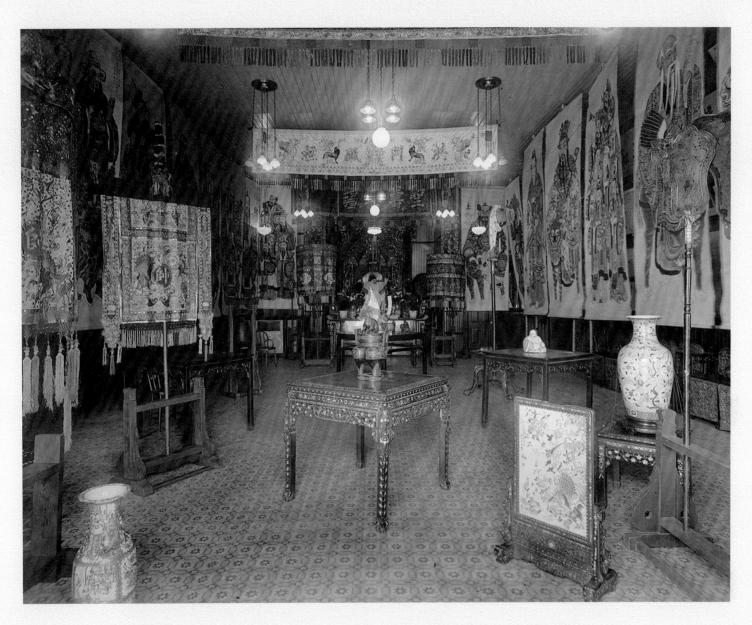

This photograph from the 1880s shows the original meeting hall of the Chinese Freemasons on Fisgard Street. Some of the banners hanging on the right still belong to the Freemasons.

位於菲士格街的洪門民治黨舊址禮堂，右方懸掛著的橫額至今仍然保存在洪門機構。攝於一八八零年代。

台山中學校地前面圖

A photograph of Hoy Sun village in Taishan County, Guangdong Province, in South China, *circa* 1890.

一幅中國南方廣東省台山地區的鄉村相片，約攝於一八九零年。

THE CHINESE CONSOLIDATED BENEVOLENT ASSOCIATION A BRIEF BACKROUND AND HISTORY
華埠與中華會館 歷史與背景簡介

SOUTH CHINA

The Chinese Consolidated Benevolent Association of Victoria was founded in 1884 by men who left China and came to *Gum Shan*—"Gold Mountain." This was the name the Chinese gave to the land of their dreams, a land that held the promise of wealth and happiness. As early as 1851, many young men sailed from China across the Pacific Ocean to the goldfields of California; by 1858, others had reached Victoria and the Colony of British Columbia. Almost all the Chinese in Gold Mountain came from a rural area west of the Pearl River basin in the Guangdong Province of South China.

The Qing Dynasty (1644–1911) was established by Manchu invaders who set up their capital in the northern Chinese city of Peking. Over the centuries, it became a weak and stagnant political power and the southern seaports of Guangchou, Macau, Fujian, Ningbo and Zhejian were partially colonized by the British, the Portuguese and the Dutch. During those centuries, when Guangdong Province was cut off from northern China by its topography, language and political realities, the Qing Dynasty provided few services and very little protection for the people; in the countryside, it subcontracted local political arrangements to powerful landowners.

中國華南地區

維多利亞中華會館成立於一八八四年，是由當時從中國來<金山>尋金的華人所成立。<金山>是過去中國南方人給太平洋彼岸的那片土地所起的名字，這個名字包含了財富和幸福的諾言，是華人的夢想之邦。眾多的中國青年人於一八五一年渡過太平洋到加州尋金，至一八五八年，其中有些來到了卑詩省的維多利亞市。在當年，幾乎所有的華人尋金者都是來自中國南方廣東省珠江流域。

滿清帝國(一六四四至一九一一年)是由北方之滿族人從關外入侵後於北京建都而立。經過幾世紀之變遷，其皇朝權力漸弱，南方沿海廣東、澳門、福建、寧波及浙江等海港部份政權已落入英國、葡萄牙及荷蘭人的手中。清廷只剩下中國華南地區的部份统治權。在這段時期，基於地理環境、語言及政治原因，廣東省與中國北方的聯繫幾乎中斷。

清朝的國策並沒對其百姓子民提供足夠的福利及保障。南方農村地區，成立了非正式的地方自治組織，其權力更甚於朝廷，有時亦代表清廷行使地方政權。

Clans were the basic political unit of the rural villages. From time immemorial, the Chinese have organized themselves internally through clans, which trace their descent from ancestors through the paternal line. A clan was a source of stability and, since clan members shared a founding ancestor, it was not unusual for all the residents of a village to have the same family name. Family and property disputes could be settled within the village context; health and welfare issues were considered from a local point of view; and, in many cases, armies were mustered from within the ranks of the clan. The clans worked to develop all their assets and assure themselves a leading voice in local politics.

Kinship provided protection and a channel for social mobility. Smaller clans formed alliances to increase their power, creating units as large as possible. The people of Guangdong were said to have the strongest clan ties in China.

The home region of most of the Chinese who came to Victoria spanned eight counties, characterized by differences in language. Sam Yap, or "Three Counties," included the commercially advanced areas surrounding the city of Guangchou: Nanhai, Panyu and Shunde. There, Cantonese in its standard form is spoken. Say Yup involved the four counties a little farther west, with a more pronounced agricultural character: Taishan, Xinhua, Kaiping and Enping. These have a subdialect of their own. Zhongshan, which is the peninsula leading to the port of Macau, is also part of the homeland and has a distinct variant of Cantonese. In addition, the Hakka, a "guest people" who lived in the mountains, came from various counties and speak a distinct dialect of Chinese.

Seaports of this coastal region were subject to early and extensive Western penetration. The Portuguese arrived in the early 16th century; the Dutch in 1622; and the British in 1637. In subsequent years, the Chinese government limited Westerners to certain ports. When the British defeated the Chinese in the Opium Wars in 1842, they forced the Chinese to open the ports to wider trade and took over Hong Kong as a British colony. In 1858, the Chinese surrendered in the Second Anglo-Chinese War and granted further concessions to the West. China had become, in many respects, a subject nation.

宗族是農村地區的基本行政中心。中國人通過宗族來組織自己，這樣，團體的成員能通過父系之淵源而追踪到其歷代的祖先。宗族是局世穩定的根源。由於宗族是由世代的祖先組成，所以同村的村民有相同的姓氏是十分普遍的。家庭和物產爭端可以在村內解決，健康和福利救濟問題可從地方的觀點來考慮。並且在許多情況下，地方防禦的隊伍是從宗族內部按等級徵集。 宗族開發和累積的財產使他們有最大的能力成為當地的行政機關。

血緣之關係，使各宗族的社會活動有所保障。較小的宗族通過聯盟的方式去增強他們的社會地位及權力。廣東省之地方勢力，是全國最強大的。

大部份維多利亞市之華人，其祖藉是廣東省八個不同地方方言的地區。三邑地區包括廣州市附近的南海、番禺和順德。再往西一點之四邑地區，包括台山、新會、開平和恩平，這些地區有其各自的方言。中山與澳門相聯，其方言與一般粵語有異。客家人的祖先來自多個不同的區域，他們說的客家話亦與粵語有別。

葡萄牙人在十六世紀初登陸，繼而一六二二年荷蘭人，一六三七年英國人陸續抵達，沿海港口之人文風氣逐漸受西方滲透。其後中國政府有段長時期限制西方人在某些港口登陸。於一八四二年鴉片戰爭清廷戰敗後，英國政府強迫清廷開放港口，擴展貿易，香港亦被佔領為英國殖民地。一八五八年的第二次鴉片戰爭後，中方被迫再向西方勢力作出了更大的讓步，動搖了中國在世界上的地位。

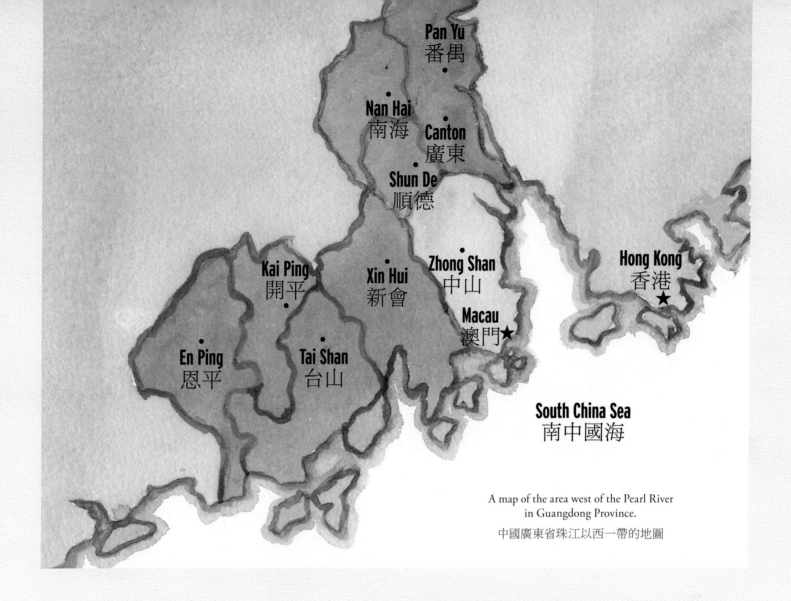

Pan Yu
番禺

Nan Hai
南海

Canton
廣東

Shun De
順德

Kai Ping
開平

Xin Hui
新會

Zhong Shan
中山

Hong Kong
香港 ★

Macau
澳門 ★

En Ping
恩平

Tai Shan
台山

South China Sea
南中國海

A map of the area west of the Pearl River
in Guangdong Province.
中國廣東省珠江以西一帶的地圖

After the military defeat by the British in 1842, Guangdong Province went into a drastic economic decline. Popular unrest and a sort of civil war ensued. Among those at war were the Hakka. Hundreds of years before, the Hakka had moved from the north. When they reached Guangdong, they were pitted against the Punti, local people who farmed the more fertile river valleys. Fighting between the Hakka and the Punti reached a climax with the Taiping Rebellion (1850–1864), though that was only the largest of several mass uprisings which rocked China at that time. In those unsettled days, many young men in South China heeded the siren song of Gold Mountain.

一八四二年中英之役戰敗後，廣東省的經濟急劇衰落。局勢之動盪不安最終導致內戰爆發。而這些戰爭的主要組織者是客家族，他們是居住在山區的<客人>。數百年前，客家人從北部移居到廣東，並且與當地人爭奪肥沃的河谷地區。當時爭執最強烈的地方是在台山地區，最後引發了太平天國之亂(一八五一至一八六四年)。雖然太平天國叛亂只是當時中國眾多的起義活動之一，但也動搖了中國的政權及安定。所以，不難理解為甚麼在那些動盪的歲月裏，中國南方眾多的年輕男子會關注前往金山汽船之汽笛聲。

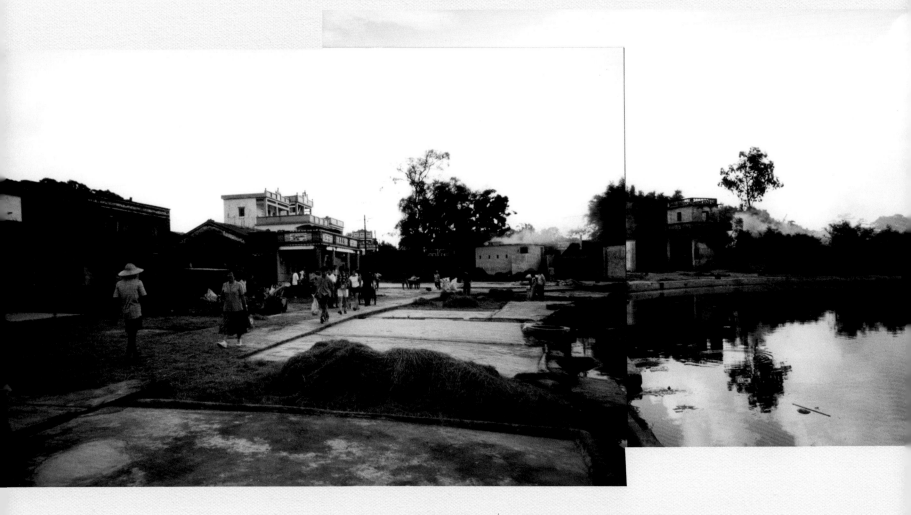

Ton Wan Lee village in Kaiping County, July 2007. Rice is drying along the sides of the pond.

開平地區之塘灣里村，池塘邊的空地上正在曬穀，相片攝於二零零七年七月。

GOLD MOUNTAIN

The Chinese who travelled to Gold Mountain found themselves with diminished social standing. Their citizenship was beneath "second class"; they were granted no political rights and were subject to harassment of many sorts.

In 1851, as many as 25,000 "coolies" were reported to be working in the goldfields of California. Not allowed to stake mining claims themselves, the Chinese took over gold workings that American prospectors had left behind when richer areas beckoned. Swiftly they spread through California, Oregon, Washington and then British Columbia. They continued mining and they also built railways, constructed levees to hold back rivers and worked in salmon canneries.

At that time anti-Chinese feeling in the American West verged on genocidal and some Chinese thought that Canada, with its British rule of law, offered them a better chance for justice. When gold was discovered along the Fraser River in April 1858, thousands of American prospectors arrived from California. With them was Ah Hong, a merchant working for a Chinese company based in San Francisco. When he returned to California, he published a report in a San Francisco newspaper and, within a few months, 20,000 Chinese left the United States to try their luck in Canada. The first wave of Chinese gold seekers travelled overland; subsequently, most came by ship to Victoria, where they made arrangements and gathered supplies before setting off for the Mainland. In 1860, the first ships arrived directly from Hong Kong; during that year 4,000 Chinese came through Victoria.

THE CANADIAN PACIFIC RAILWAY

In 1871, the Colony of British Columbia became the Province of British Columbia in the new Dominion of Canada. One of the promises with which Sir John A. Macdonald enticed British Columbia to join Confederation was the construction of the Canadian Pacific Railway.

金山

從中國越洋而來的華人，發覺其社會地位低微，他們之權利低於二等公民之下。沒有政治權，其處境也在多方面受到搔擾。

在一八五一年，約二萬五千名"苦力"在三藩市外圍地區的金礦工作。由於他們沒有合法的採礦權，所以，他們通常是在美國淘金者遺棄的金礦裡淘金。他們淘金的路線迅速地延伸，由加州至俄勒岡州、華盛頓州而來到了卑詩省。他們除了繼續淘金，也建築鐵路、築防洪堤及在三文魚加工廠裡工作。

當時在美國西部反華情緒猖獗。有些中國人認為在行使英屬法律的加拿大或能獲得較公正的待遇。一八五八年四月，菲沙河域沿岸發現了金礦，吸引成千上萬的淘金者從加利福尼亞州前來。在三藩市有一家中國公司的商人杭安便是其中之一位。他回到加州後，在三藩市一家報紙上發表了關於金礦的報告。短短數月內，便有二萬名中國尋金者從美國來到加拿大碰運氣。首批穿越北美洲的淘金者，大多數是乘船經維多利亞市登陸加拿大。他們在維多利亞為前往卑詩內陸的淘金工作做好安排及準備物資。在一八六零年，從香港直達維多利亞的第一艘船正式抵岸。在那一年裡，約有四千名中國勞工經維多利亞進入加拿大。

加拿大太平洋鐵路

一八七一年，金礦的開採沿著菲沙河流延伸至百家委路鎮。在該年，卑詩殖民地正式成為加拿大新的一個省份。其中的一個承諾，就是約翰.麥當勞爵士所提倡的建築加拿大太平洋鐵路。但實際上還需一段時期的準備才能動工。

When the building of the railway finally began in 1881, chief contractor Andrew Onderdonk knew from experience that for the difficult portion through the BC mountains, he would need Chinese labourers. The British colonists had expected Irish "navvies" to do the work but despite the unpopularity of his decision, Onderdonk recruited Chinese workers. Joseph Tassé, who had built the 88-mile Montreal and Western Railway, wrote in 1885 that the Chinese worker has "no superior as a railway navvy." Sir Matthew Begbie, BC's chief justice at the time, saluted the personal qualities of the Chinese in his reply to a Royal Commission: "industry, economy, sobriety and law-abidingness."

Between 1881 and 1885, as many as 17,000 Chinese were brought to BC to construct the railroad. Labouring like slaves in the rugged interior of the province, young Chinese men were paid $1 a day—half the rate of any other labourers. The typical salary was $25 a month for only nine months, because construction shut down in the winter. From this annual income of $225 deductions were made for provisions, clothing, room rent, tools, transportation, revenue and road taxes, religious fees, doctors and medicine (if available), oil, light and tobacco, which usually left about $43 for everything else. After five years, a worker might have $215 but only a few saved even that much. Passage back to China cost a further $70.

The Chinese workers were often victims of unconscionable conditions, and more than 600 of them died. Beginning in 1883, when the job was done, the bosses fired the Chinese at the work sites in the Interior so, worn out, dejected and penniless, they had to make their way back to Victoria, their port of entry.

一八八一年,當建築太平洋鐵路的契約辦妥後,承包商安德魯.昂德東克根據經驗;在修建橫貫大陸鐵路的卑詩省部分,他將需要中國勞工來完成。儘管當時人們認為愛爾蘭工人可以完成這項工作,但昂德東克仍決定徵集中國勞工,因他知道只有中國人才可以完成這項艱巨的工程,在一八八五年,約瑟.塔斯,這位已完成了滿地可通往西面八十八英里鐵路的工程師,在他的書面報告中形容中國勞工為:「沒有較他們更優秀的鐵路工人」。當年卑詩省首席法官馬菲.畢比爵士亦對華工的個人品質作出表揚,形容他們「勤奮、節約、節制及安份守己」。

在一八八一年至一八八五年之間,多達一萬七千名中國勞工沿著卑詩省建築鐵路。在卑詩省內陸的艱苦環境中,他們像奴隸般的工作,所得酬勞微薄,每天的工資是一加元,僅為其他族裔勞工的一半。其中最甚者是月薪二十五加元及在冬季停工三個月。在這二百二十五元的年薪中,另要扣除糧食、衣著、房租、工具、交通、收入稅及道路稅、宗教費、醫藥費(若有此服務的話)、油費、燈費及煙草費等,只剩下四十三加元支付其他開支。辛勤工作五年後,或可儲到二百一十五元,但也是屬於少數。當時坐船回中國的費用是七十元。

中國勞工在此惡劣的環境及不合理的待遇下像奴隸一樣的工作,超逾六百名中國勞工在此地獻出了生命。在一八八三年初,當工作完成後,冷酷無情的老闆們,將華工就地解僱,華工被遺下在卑詩省內陸的山區裏。失業的華工,帶著筋疲力竭、沮喪、絕望的心情,身無分文地返回當年入境的維多利亞市。

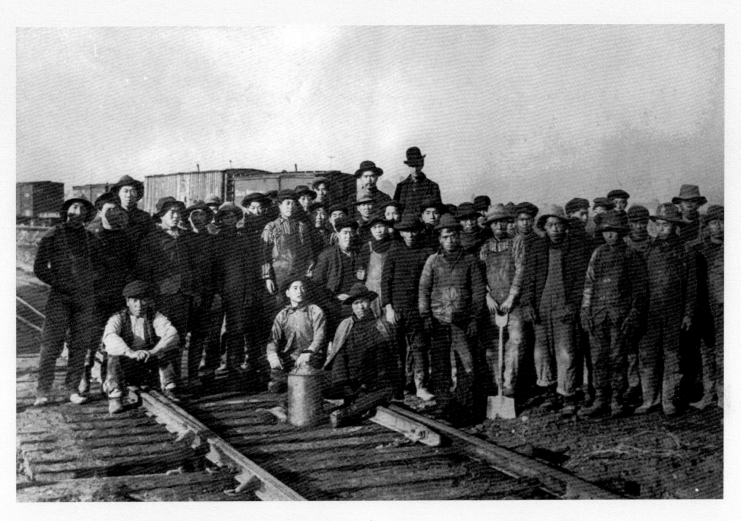

Chinese workers on the Canadian Pacific Railway, *circa* 1886. (BC PROVINCIAL ARCHIVES D-07548)

中國勞工在加拿大太平洋鐵路，約攝於一八八六年。(卑詩省檔案儲藏館，D-07548)

VICTORIA

The Victoria to which they returned was a troubled community, where an Anti-Chinese Society had been founded in 1873. Many racist agitators, including British Columbia's premier, Amor de Cosmos, Victoria city councillor Noah Shakespeare and F. L. Tuckerfield of the Knights of Labour, all called for more taxation of the Chinese, limited jobs and straightforward exclusion, based on fear of Chinese competition for employment. Racism against the Chinese, when practised by people at the top, emboldened those who preferred less genteel outlets for their hostility.

The sudden influx of thousands of unemployed Chinese workers increased the social malaise. Ad hoc committees in Chinatown tried to solve the growing problems and, in 1884, a Royal Commission on Chinese Immigration was convened. Amid dozens of presentations, only two Chinese had a chance to speak to the commission; both were officials from the Chinese consulate in San Francisco. The unfortunate result was the imposition by the federal government of a $50 head tax on every Chinese person entering Canada.

Nevertheless, there remained much work to be done in the new province and the Chinese found jobs. Along the Cariboo Road they worked as teamsters and strung cables for the telegraph line to Quesnel. They went underground in the coal mines of Vancouver Island, worked in the canneries and in shingle mills and took on the endless labour of clearing the land of giant trees. After they had cleared the land, they planted vegetable gardens and raised pigs to feed the local population. In towns they set up laundries, restaurants and tailoring establishments. Some worked as domestic servants; others kept the Canadian Pacific steamships in operation, shovelling coal and serving as cabin attendants. The homes of European immigrants were made comfortable by the hundreds of "house boys" and cooks. In fact, Victoria's Olde English veneer rested entirely on the careful attentions of these Chinese men.

維多利亞市

中國勞工剛回維多利亞時，當地社區正處動亂狀態。一個反對華人的組織於一八七三年在當地成立。 情緒激昂的種族主義鼓吹者中，包括卑詩省省長阿摩.德.可士摩斯、維多利亞市議員諾亞.莎士比亞、和英國工黨州議員達卡菲德；他們均主張以重稅、少就業機會、及明確的排除法令，迫使僱主在僱用員工時作出選擇。反華的種族歧視主義由這些掌權之政客執行，漸斬令一般有修養的上流社會人士也感到種族歧視是理所當然之事。

蜂擁而至的失業華工，令維市的的市況更混亂。華埠社團因應而起，以解決日漸增加的糾紛。一八八四年，政府成立了審核華人移民的部門，只有兩位華人有機會與審核官面談陳詞，他們均是來自三藩市的中國領事。很不幸，這次會面的結果，是聯邦政府實行向每位進入加拿大境的華人徵收五十元人頭稅。

當時卑詩省剛剛成立，這個新省份有許多的工作仍待完成。在內陸卡內布沿路上，許多中國勞工在架設通往奎斯內爾鎮的電報電纜。中國勞工在溫哥華島的煤礦中開採煤炭。他們在魚類加工廠、木材處理場工作。他們開墾土地、種植蔬菜和養豬以供應城市居民的需要。在城市中，他們還開設洗衣房、餐館及裁縫店等營業所。有些華工成為白人家庭的傭工，也有些在加拿大太平洋蒸汽船上擔任鍋爐工或服務生。數以百計的家庭男傭和廚師之辛勤工作，使來自歐州的移民家庭能過著舒適的家居生活。事實上，維多利亞市的繁榮與這些華工的努力息息相關。

Because Victoria was a port, Chinese shops were depots for the exchange of goods and headquarters for labour contractors large and small. These premises immediately became gathering places for newcomers; they could receive messages and send remittances back to China, find temporary shelter and enjoy some conversation. Of course, it was natural for the Chinese to import their clan associations. Among fellow clansmen, they could make contacts, find jobs and partners for joint ventures, and pool or borrow funds to start new businesses.

The Chinese needed to demonstrate that there was a permanent and stable institution dedicated to their aid, and that problems affecting them would be taken care of by the Chinese people themselves. After some years of negotiation and compromise, 31 local groups in Victoria came together in 1884 to establish the Chinese Consolidated Benevolent Association.

In that year, when a group of Chinese merchants convened to tackle the problems and to unite the Chinese in BC, the Chinese consulate in San Francisco sent Huang Xiquan to help them. He drafted the regulations of the CCBA in Victoria, and it was registered with the provincial government on August 9, 1884. The association was intended as a unified voice to protest against discrimination both public and private, and to ease the problems of unemployment.

First, the CCBA unsuccessfully petitioned the Chinese consul general in San Francisco for welfare relief monies. Next, they relocated some hundreds of workers to railway projects in Mexico. Chinese men were also sent up the Fraser River, to pan for gold or to find other work in the Interior. Ships chartered by Chinese carried the weak and sick back home, and the Chinese government was asked to slow the flood of immigrants to Canada. Despite these actions, the problems continued, and the City of Victoria refused to provide any meaningful assistance.

維市是一個港口，各種貨物在此地轉運，是各行業之大、小承包商購置物資及設備的總部。維市很快成為新來者的聚集地，他們在此可接收信件或匯款回中國。新來者或失業的人可在此找到臨時住所，並享受與同鄉交談之樂。當然，融入同鄉之社交圈子是自然而然的事。在同鄉的圈子內，他們能互相交流接觸，介紹工作和尋找合作夥伴，為新業務聯款或籌借資金。

在建築鐵路期間，約一萬五千華人抵達加拿大。在加國的華人需確保加國政府有穩定的制度去保障加國華人之權益。而不是由中國人自己去解決所面對的難題。經過數年的籌備及協商，華埠三十一個堂所，於一八八四年共同成立了中華會館。

同年，一群當地的華商，發起與卑詩各地的華人聯合組織團體以處理糾紛。三藩市之清廷中國領事館派出黃錫銓專員到維市協助華商，並草擬了中華會館的創辦章程。一八八四年八月九日，中華會館向省政府註冊登記，正式成立社團。這個代表華人聲音的機構，團結卑詩省各地的華人，反對種族歧視及解決由失業率所引起的種種問題。

中華會館成立後，首先向駐三藩市之清廷中國領事館申請福利救濟金但不成功。繼而，會館安排數以百計的華工到墨西哥修建鐵路工程。華工被安排往菲沙河流域工作或在內陸淘金。安排船舶運送病弱的華工回國返鄉，要求中國政府控制來加移民人數。儘管多方努力，但社區問題還是在繼續增加，情況繼續惡化。維市市政廳則拒絕伸出援手。

Through the CCBA, a permanent "court," a policing agency and a welfare bureau were established. The association's by-laws show its intent to arbitrate in monetary and property disputes when Chinese people requested mediation. If a Chinese person avenged himself on the CCBA, he would be apprehended and turned over to the Chinese consul general or the Canadian or Chinese authorities. If a Chinese person was assaulted, robbed or cheated by a non-Chinese, the association would assist him in his appeal to the law. The CCBA also created a defence fund to fight against any attempts by Canadian society to institutionalize racism. The association clearly meant to act as the de facto Chinese government in BC. It also set out to raise funds for relief efforts in China and to operate a school, a hospital and a cemetery.

The executive of the CCBA included a president, secretaries for both English and Chinese, a treasurer and an auditor, some of whom were paid. The association was directed by a general assembly and a smaller executive council. Funds were generated through monthly dues from the members. There was also a "port duty" of $2, a fee levied on anyone who was returning to China. This money was used to offset costs incurred in the CCBA's duty of returning the bones of any Chinese who died in Canada to their respective ancestral shrines in China. The association coordinated this service for people all across Canada.

Prominent among the early members of the CCBA was Alexander Cumyow, the first child born of Chinese parents in the Colony of BC. Cumyow was born, with the Chinese name Wen Jinyou, in Port Douglas at the head of Harrison Lake in 1861 and spent his childhood in New Westminster. He was widely travelled and spoke Cantonese and Hakka as well as English. These skills made him an excellent choice to become the first English-language secretary of the CCBA.

加國華人社會上地位崇高的殷商,在中華會館章程中制定了中華會館是華人社會的「法庭」,承擔警務及社會福利的職責。會館對華人在金錢上或物業權上的爭執,可居中調解,也有仲裁權。若有華人因此而報復,將被送往清廷之中國總領事館、英國、或中國之權力部門仲裁。若華人被非華裔襲擊、搶劫或詐騙,中華會館將協助其採取法律途徑。中華會館亦成立基金,作為對抗加國社會之任何種族歧視行為。中華會館在加國所行使的職權,有如在加拿大的中國政府機構。中華會館成立籌款救災基金,賑濟中國災民。創辦中文學校、華人醫院及華人墳場。

中華會館的執行理事包括主席,中、英文秘書、財政和核數。其中有部份是受薪的。會館會務由會員代表大會、及執行理事會進行。會館向會員徵收月費來籌集經費。中華會館負責將加國各地送來之先僑遺骸,定期運送返中國。會館向每位返國回鄉的同胞收取二加元「離港費」,用以支付運送先僑遺骸回鄉之運費。

維多利亞中華會館早期的理事中,有位表現突出的理事名叫溫金有,他是首位在加國卑詩殖民地出世的華裔兒童。他於一八六一年在德格拉斯港的夏里遜湖頭出生,並在新西敏市度過了他的童年。他的父母均為華裔。溫金有遊歷廣泛,能說粵語及客家語,也精通英語。他的才能令他成為中華會館的兩位首任書記中之一位。

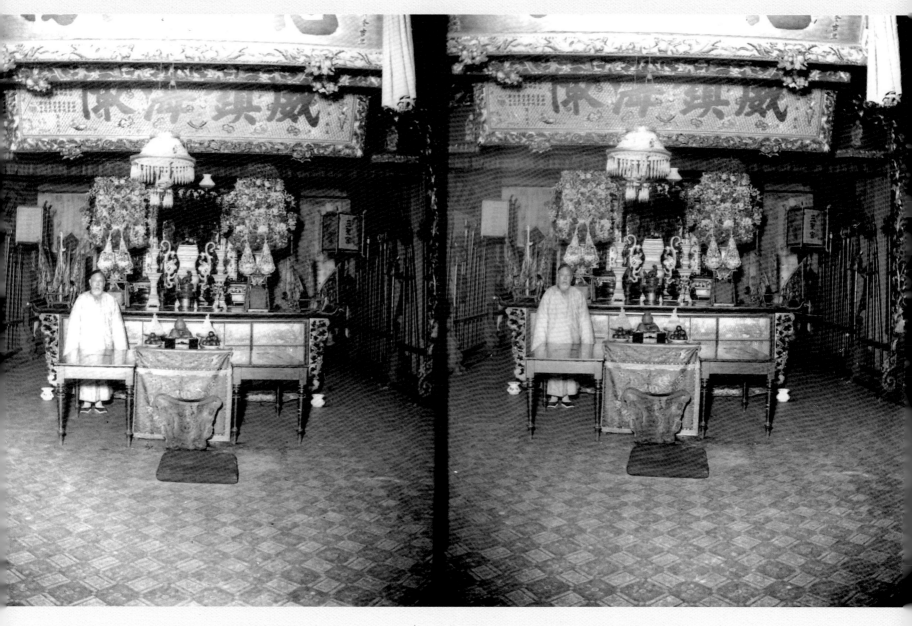

A stereoscopic view of "a joss house in Chinatown," the original CCBA meeting hall at 560 Fisgard Street.
(BC PROVINCIAL ARCHIVES G-01128)

這張立體相片顯示了華埠廟宇之內貌。相片攝於中華會館原址禮堂，位於菲士格街五六零號。

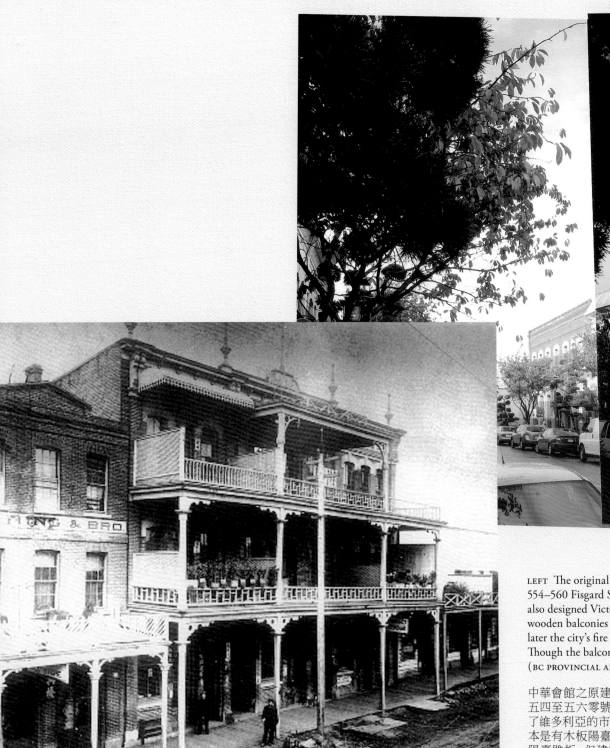

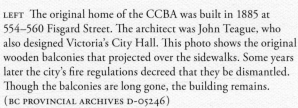

LEFT The original home of the CCBA was built in 1885 at 554–560 Fisgard Street. The architect was John Teague, who also designed Victoria's City Hall. This photo shows the original wooden balconies that projected over the sidewalks. Some years later the city's fire regulations decreed that they be dismantled. Though the balconies are long gone, the building remains.
(BC PROVINCIAL ARCHIVES D-05246)

中華會館之原建築物,建於一八八五年,地址是菲士格街五五四至五六零號。該樓宇由建築師約翰.提格設計(他還設計了維多利亞的市政府大樓)。從此照片可見,在行人路上方原本是有木板陽臺的,後因違反市府消防法例而被要求拆除。陽臺雖拆,但建築物仍在。

The north side of Fisgard Street, showing the original CCBA building to the right, 2009.

菲士格街北面，可見中華會館之原建築物在正中央之右方。攝於二零零九年。

In its first appeal for funds, the CCBA raised nearly $30,000 for a headquarters and a hospital. Completed in July 1885, the new building was a three-storey brick structure, three bays wide, which still stands at 554–560 Fisgard Street. The ground floor of the building was rented out; the second floor was used for the association's offices. Eventually, the third floor housed the temple and the school. The hospital, a goal of the founders, was built nearby at 555 Herald Street.

In the late 19th century, the Yukon gold rush brought hordes of gold seekers through Victoria, where they purchased the supplies they needed to take north. Business was booming, and the merchants of Chinatown started investing in real estate. They were able to demolish many of the ramshackle wooden structures that had outlasted their original purposes, and replace them with handsome brick buildings. Between 1900 and 1911, much of the distinctive architecture of Chinatown was created. These three-storey brick buildings, with recessed balconies and decorative wrought-iron railings, have stood the test of time.

THE HEAD TAX

From the beginning, the Chinese fought discrimination in every way available to them. In 1876, they formed the Victoria Workingman's Protection Association to protest business restrictions and ill treatment in the workplace. In 1878, the Chinese merchants of Victoria petitioned Ottawa to disallow a head tax of $60 imposed by the government of British Columbia. This was a fee charged to each immigrant who arrived in Canada from China. The federal government did disallow the provincial tax but went on to replace it with its own tax of $50 per immigrant, beginning in 1885.

This levy resulted in a five-day strike by the Chinese in Victoria in September of that year, but the tax remained. Though it slowed the number of immigrants at first, it came to be accepted as part of the cost of working in the new world. The tax was increased in 1903 to an almost impossible $500. In fact, between 1885 and 1923, the Canadian government collected $23 million from 81,000 Chinese immigrants.

中華會館首次籌款，籌得經費三萬元，用以興建會館總部及華人醫院。全新三層高的石磚建築物，位於菲士格街五五四至五六零號。該處地鋪出租，二樓作為會館?公室，三樓是學校及列聖宮。華人醫院則建於隣近的喜路街五五五號。

19世紀晚期，育空地區的淘金熱吸引了大批淘金者，他們在維多利亞購置和準備必需品，然後北上。維市的商業發展迅速，各行業生意興隆，華商開始投資房地產。他們拆除了很多瀕臨倒塌的木屋，以漂亮的石磚樓房代之。在一九零零年至一九一一年之間，許多獨特建築物在華埠興建。這些三層樓高帶有凹入陽臺和裝飾著鐵扶手的建築物，經受了時間的考驗，至今仍屹立於華埠。

人頭稅

加國華人從一開始就以各種可用的方法去對抗種族歧視政策。一八七六年，華人組織了維多利亞工人保障協會，以抗議行業限制和工作場所的苛待。一八七八年，華商向渥太華請願要求解除卑詩省政府針對華人徵收的60加幣人頭稅。這是每個進入加境的華人須付的稅。聯邦政府解除省府的人頭稅，但改為徵收聯邦政府已於一八八五年實施之每位新移民五十加元入境稅。

華人於當年的九月份以罷工五天作為抗議，人頭稅卻仍然實施。但也令移民人數減少。後來華人逐漸接受這筆額外費用是往新大陸工作的必要開支。一九零三年，人頭稅已增加至令人不可致信的五百加元高額。事實上，自一八八五年至一九二三年期間，加國政府從八萬一千名華人移民身上徵收了兩千三百萬加元。

Head tax certificate. | 人頭稅表格紙

The head tax was only one of many obstacles the Chinese faced in Canada. They were not allowed to become citizens or to vote, and this exclusion had further consequences. It meant that Chinese or Chinese Canadians were not properly registered and were thus unable to enter professions such as medicine and law. Furthermore, by specific provincial regulations Chinese were not allowed to bid on labour contracts for public works projects.

The head tax did not stop immigration. It was halted only by the passage of the Chinese Immigration Act on July 1, 1923, which mandated a complete ban on immigration from China to Canada. For many years afterwards, the Chinese refused to celebrate July 1 as Dominion Day, calling it Humiliation Day instead.

The hated law was repealed eventually, due to the efforts of young Canadians of Chinese parentage who volunteered to fight in World War II. Their valour was clear and their worthiness of being full citizens of the land of their birth was unmistakable. The first stages of the repeal of the Chinese Immigration Act came in 1947. Wives and children of Chinese Canadians were at that time allowed limited entry to Canada; the BC Provincial Elections Act allowed Chinese Canadians to vote and to enter previously barred professions such as accountancy, pharmacy and law. However, it was not until 1967 that the discriminatory immigration regulations were completely revoked.

In 1984, the Chinese Canadian National Council asked the Government of Canada for an apology and financial recompense for the head tax, with a petition signed by 4,000 Chinese Canadians. Despite the restitution that had recently been paid to Japanese Canadians, nothing came of the Chinese-Canadian claim. In 1994, the Government of Canada finally refused.

人頭稅只是華人在加國謀生中遇到眾多困難中之一。儘管支付了人頭稅，華人仍未有公民權與選舉權。這種排斥產生連帶後果，比如華人不准從事醫療、法律等行業。而且，省政府的特殊條例還禁止華人取得公共工程項目的政府勞工合同。

人頭稅並未能阻止移民的增幅。一九二三年七月一日，聯邦政府立法通過針對華人的移民法例，完全禁止華人移民加國。直至多年之後，華人仍拒絕慶祝七月一日之加拿大國慶日，且改稱為恥辱日。

這令人遺憾的移民法例，實行多年後才撤消。此因在第二次世界大戰期間，一群加國土生華裔年青志願加入加拿大軍隊出國參戰。他們的英勇愛國事蹟，為他們取得在其出生之地的公民權利。新的移民法例於一九四七年實施，加國華人的妻兒允許有限度地進入加拿大；卑詩省選舉法例容許加籍華人有選舉權，准予華人從事先前被禁止的行業如會計師、藥劑師和律師等。歧視性的移民法例直至一九六七年後才完全廢除。

一九八四年，四千加籍華人聯合簽名，由全加華人聯會向加國政府請願，要求對徵收人頭稅公開道歉並進行經濟賠償。儘管加籍日裔已獲賠償，但華人的要求如石沉大海。一九九四年，加國政府最終還是拒絕了華人的請求。

LATER DAYS

The problems of the Chinese in Canada were exacerbated by a recession that began in 1912. The demand for BC lumber dropped and due to the subsequent lack of jobs, the CCBA made an official request to the government in Guangdong to stop sending Chinese workers to Canada. During the Great Depression of the 1930s, unemployment among Chinese Canadians was far higher than among the general population.

The Chinese population in Victoria had been in decline since 1923 and by 1951, many of the smaller Chinese settlements on Vancouver Island, and in the interior of the province were withering away.

This economic downturn had a serious effect on the CCBA. Older Chinese were returning to China and newcomers often did not want to join the original associations. Yet at the same time new groups were forming and others were consolidating. These groups were not held back by former political affiliations, religious divisions or partisan interests. After the repeal of the Chinese Immigration Act in 1947 a surge of immigration occurred. Newly formed youth-oriented groups appeared to attract the younger immigrants and Canadian-born Chinese. These associations included musical and recreational societies, literary, dramatic and theatrical organizations and libraries.

POLITICS IN CHINA

Because they were excluded from full participation in Canada, immigrant Chinese always followed the news of activities back in China with great interest. It was the conditions in China that had led many of them to emigrate and after they left, the turmoil continued. The Chinese in the United States and Canada felt a profound concern for the welfare of their homeland.

後期

一九一二年的經濟蕭條導致加國華人的問題進一步加劇。卑詩省木業市場萎縮，勞工失業問題加重。由於失業率高，中華會館發公函請求中國廣東省政府停止派遣華工到加拿大。一九三零年代的經濟大蕭條使形勢更進一步惡化，加國華人失業率較其他族裔更高。

自一九二三年後，維多利亞的華人人數不斷減少。從中國來加的新移民被吸引前往溫哥華和多倫多。至一九五一年，溫哥華島以及本省內陸眾多的小型華人聚居地逐漸衰微

經濟蕭條嚴重影響中華會館的運作。年老的會員返國回鄉，新來的移民通常無意加入舊式的堂所。與此同時，新的社團組織成立或合併，並迅速發展。這些新團體不受以往之政治派別、宗教分歧或黨派利益的影響。自一九四七年排外移民法例撤消後，新的移民潮湧起。新成立的青年組織吸引了年輕移民及加國土生華裔。這些組織包括音樂和娛樂、文學、戲劇組織及圖書館。

中國政治

由於華人在加國受排斥而不能完全融入這個社會，華裔移民總是十分關注中國局勢動態。也正是中國的局勢，導致他們舉家移民。他們離鄉後，祖國前所末有的動盪仍在繼續。美國和加國的華人為祖國的安危感到十分擔憂。

The events on which their attention was focussed had a basis in distant history. In 1664, when the Manchu, a tribe of Mongol horsemen, swept into China from the north and west and defeated the Ming Emperor, opposition naturally sprang up. In those early days, a "blood brotherhood" known as the Chee Kung Tong was formed, dedicated to ousting the Manchu invaders.

Anti-Manchu rebellions took place, off and on, for the next two and a half centuries, the Taiping Rebellion being perhaps the best known. When that rebellion failed, many members of the CKT felt it prudent to leave China, and some came to Victoria.

In 1895, northern China was invaded by the new Japanese army. Resisting domination by the Japanese, the Chinese people rose up and demanded reforms to modernize and strengthen their nation. A progressive government minister named Li Hongzhang made proposals for the radical reform of the empire, establishing it as a constitutional monarchy. The last emperor, Pu Yi, was in favour of such reforms, but he was displaced by his mother, the Dowager Empress, who opposed them.

Gum Shan, or Gold Mountain, was safe territory for exiled reformers and revolutionary émigrés. In 1899, a Chinese Empire Reform Association (Bao Huang Hui) was founded in Victoria, one of 103 branches of the CERA outside China that supported efforts to make China a constitutional monarchy. The formation of the CERA in Victoria was inspired by a visit by Kang Youwei, a reformist member of the Chinese government who went into exile and visited Chinese expatriates around the world.

With the progressive disintegration of the Qing Dynasty, China was in disarray and people rebelled in the Boxer Uprisings (1900–1901). Insurgents seized the many foreign legations in Peking. Newspaper reports of this uprising and its eventual suppression by the British were widely published and certainly reinforced white perceptions of the Chinese in Canada as barbaric and uncivilized.

引人關注的事件可追溯到久遠的歷史中。一六六四年,蒙古騎人的一個部落滿族人,從北部和西部橫掃中原,滅了明朝皇廷。從那時起至一九一一年,統治中國人的是稱為清朝的外族人。顯而易見反抗不斷興起。早年,同盟結義為兄弟的致公堂成立,致力於反清復朋,驅逐滿洲侵略者。

抗擊滿洲人的革命活動時有發生,持續了兩個半世紀。一八五零年至一八六四年,太平天國起義是最為世人所知的革命活動。當革命失敗後,許多致公堂成員為謹慎起見離開中國大陸,其中一些人來到了維多利亞。

一八九五年,中國北方受新日本帝國海、陸軍的侵略並佔領。中國人民奮起抗戰,並強烈要求改革振興中國。清廷政府首相李鴻章提議對清廷王朝進行徹底改革,建立君主立憲制國家。清廷末代皇帝溥儀贊成改革,但他的母親慈禧太后反對其改革理論,罷免了他的政權。

金山這塊安全的土地,成為改革者及革命者流亡之地。一八九九年,保皇會在維多利亞成立,支持革命力量建立君主立憲制。這是保皇會在中國大陸以外103個組織中的其中一個。中國政府改革者康有為對維多利亞的訪問促成了它的成立。

隨著清帝國的崩潰,中國處於一片混亂。在極度的不滿中,中國人民奮起反抗,策劃義和團起義(一九零零 - 一九零一年),起義軍佔領了北京的多處外國使館區。報館廣泛報導了此次起義,及英國人鎮壓起義之事件,這些報導使白人認為加國華人是尚未開化及不文明的。

Sun Yat-sen, the leader of the movement toward representative government, was himself a native of Zhongshan in South China. He travelled in England, the United States and Canada, coming to Victoria first in 1897 and returning in 1910 and 1911. He found a warm welcome among his fellow countrymen and raised much support for his organization, the Kuo Min Tang (or Nationalist Chinese). In Victoria, it was the Lee Association, the Lung Kong Association, the Hoy Sun Benevolent Association and the Hoy Ping Society that were associated with the KMT. The Chinese Freemasons, whose allegiance had been with the Chee Kung Tong and then, the Chinese Empire Reform Association, also moved to help Sun. In 1911, they mortgaged their Victoria headquarters, raising $12,000 for his revolution.

In 1911, the Qing Dynasty was overthrown and the Republic of China created. During the Qing Dynasty, Chinese men had worn a submissive hairstyle with a long plait, called a queue, at the back, but when Sun Yat-sen became president of the provisional government they cut them off.

革命領袖孫中山是中國南方中山地區香山人。他到過英國、美國和加拿大，首次到維多利亞是一八九七年，隨後在一九一零年和一九一一年先後重來此地。他受到此地同胞的熱烈歡迎和對其同盟會組織的極大支持。當時，維市的李氏公所、龍岡公所、台山寧陽會館及開平會館等，均與孫中山的同盟會組織建立聯繫。維市洪門民治黨組織的前身是致公堂，與後來成立的保皇會關係密切，亦鼎力支持孫中山的革命事業。洪門組織甚至將其維市總部的物業抵押與銀行，為孫中山籌得一萬二千加元經費。

一九一一年，清朝被推翻，中華民國成立，孫中山就任為臨時大總統。中國男子也剪掉了腦後的長辮子。

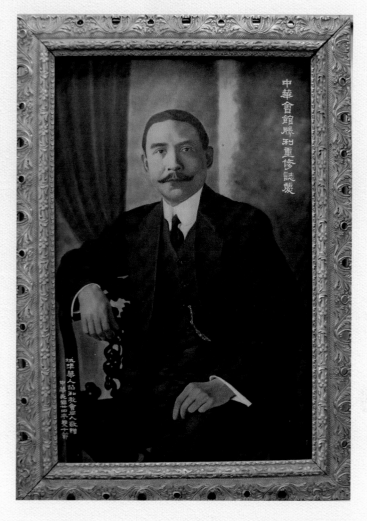

This painting of Sun Yat-sen was given to the Chinese Public School. It still hangs in a place of honour at the school.

贈與華僑公立學校的孫中山先生畫像，
仍然懸掛在學校大堂正中

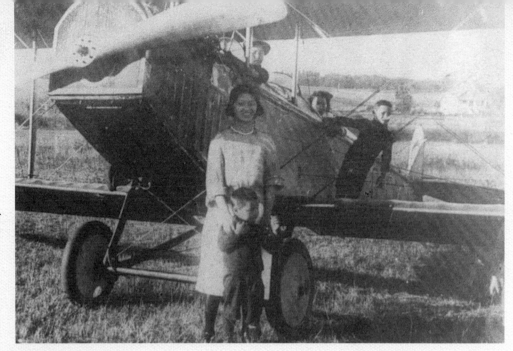

The Chan family, posing in front of one of Chan Dun's airplanes at the Lansdowne Airfield in Victoria in 1917. Pilots were trained here to fight for the Republican cause in China.

此為陳氏家族的舊相片，陳氏家人在停泊於維市蘭士登停機坪陳敦之飛機前合照。飛機師在此受訓，以便回國參戰。相片攝於一九一七年。

Sun Yat-sen resigned in 1912, leaving power in the hands of one of the other revolutionary factions and by 1916, he had set up a government in Canton in opposition to the new regime in Peking. In Canada, overseas Chinese trained airplane pilots to fight in the homeland.

Between 1923 and 1927 Sun Yat-sen's Kuo Min Tang and the Communist Party united to fight warlords throughout China. Sun Yat-sen died in 1925 and in 1927 Chiang Kai-shek took over as his successor. At that time the KMT broke with the Communists, who had fled south to set up new bases.

The KMT's promise of modernity and national dignity inspired huge contributions on the part of the overseas Chinese to relief efforts in China. These donations increased when the Sino-Japanese war began in 1937, and the considerable contributions of men and materials continued throughout World War II.

孫中山於一九一二年辭職，把政權交給其他革命黨派人之手。一九一六年，孫中山在廣東成立政府反對北京新政權。在加國，華人訓練飛機師回國參戰。

一九二三年到一九二七年間，國民黨和共產黨聯合反抗北洋軍閥。孫中山於一九二五年逝世，一九二七年蔣介石繼任。此時國民黨與共產黨決裂，逃往南方建立新基地。

國民黨承諾要使中國現代化以保護民族尊嚴，海外華人在激勵下努力捐獻支持。海外華人的貢獻從未間斷，一九三七年中日戰爭爆發，幫助國家救亡運動的各種活動達到高峰。人力物力方面的捐獻，一直延續到第二次大戰後。

In China, the Nationalists fought a civil war with the Communists during and after World War II, and the economy of China was on the verge of collapse. The US backed the Nationalists when the Communist revolution succeeded and, in 1949, under the leadership of Mao Tse-tung, established the People's Republic of China. At that time, the Nationalists moved to the island of Taiwan. Their leader, Chiang Kai-shek, could do no wrong in the eyes of the CCBA, and support for his activities was intensified by the pervasive anti-Communist sentiment on this continent. Over time, Chinese Canadians strengthened ties with both the mainland and the Taiwanese Chinese.

The People's Republic of China was effectively closed to both emigration and visitors from the West in the 1950s and '60s, but there was a constant and growing interest in the vast nation. The Chinese Canadian Friendship Society was set up in 1971 to help those who wanted to go to the People's Republic. At first, its members were mainly non-Chinese who sympathized with Mao's state. After 1970, relations between Canada and China were normalized and have continued to open up, allowing trade and tourism in both directions.

LOCAL ACTION

While all this was going on, the reading rooms in the meeting halls of Victoria were busy with men keeping up to date on current events in China. Even today, reading Chinese newspapers and watching Chinese-language television are among the most important activities of the halls.

It is difficult to understand the shifting ground of politics in China a century ago and while underlying differences existed among members, the associations in Victoria were involved primarily with community spirit and local benevolent activities. In 1910, there were 3,500 Chinese in Victoria, many of whom had arrived after the dark days of the gold mines and the railways. They gathered to create new associations reflecting a modern spirit, such as the Chinese Young Men's Progressive Party, the Chinese Canadian Club and the Chinese Athletic Club.

在第二次大戰期間，中國國民黨與共產黨發生內戰，國內經濟崩潰。美國支持的國民黨，亦即是中華民國政府，把政權遷去了台灣。中華會館當時繼續支持國民黨領袖蔣介石的反共活動。時至今日，加國華人與兩岸均有聯繫。

在一九五零至六零年代，中華人民共和國關閉了國門，禁止移民和來自西方的旅遊者。但人們對這泱泱大國在國內的各種活動，興趣與日俱增。在一九七一年，華僑聯誼會成立，協助欲往中國旅遊探親者辦手續。一九七零年後，加拿大與中國恢復邦交，允許雙方貿易和旅遊，一直開放至今。

地方反應

在祖國大陸發生這一切之同時，維多利亞華人在堂所禮堂內密切留意有關大陸事態變化的新聞報道。直至今天，閱讀中文報章及收看中文電視節目仍是禮堂內的重要項目。

要理解一個世紀前中國政壇的變遷不易，儘管存在分歧，各堂所的主要宗旨仍是參與社區服務和慈善活動。一九一零年，維多利亞約有三千五百華人。其中很多人是從開採金礦和修築鐵路的黑暗日子以後到來的。他們聚集在一起創建具現代精神的新社團，如中華青年人進步黨，加拿大華人俱樂部和中華體育俱樂部等。

A new sense of empowerment inspired the CCBA to form an Anti-Segregation Association. In 1907, when the trustees of Victoria's schools suspended all 200 Chinese-Canadian students in Victoria, the CCBA led a strike by the schoolchildren to bring attention to bear on this incident of segregation. At that time, the Lequn Yishu, a Chinese school located in the CCBA building with 55 students, was superseded by a Chinese Free School, which was opened to teach students in English. After one year, the Victoria School Board trustees reconsidered and allowed the students to attend public school once again.

When British troops fired on Kuo Min Tang demonstrators in Shanghai in 1925, the CCBA called for a boycott of British-made goods. When Japan pushed its way into northern China in the 1930s, the Chinese in Victoria formed a Resist Japan and Save the Nation group. So determined were the local Chinese Canadians to help the motherland that during World War II they raised more than $750,000 to aid China in the fight against Japan.

During World War II, more than 500 Chinese Canadians joined the Canadian armed forces. After the war, in 1947, they won the right to vote in federal, provincial and municipal elections.

With their new position in society, and a growing middle class of Chinese born in Canada, many Chinese Canadians established themselves in business and various professions. The Chinatown Lions Club was formed in 1954, and demonstrates how the member associations of the CCBA have evolved; the Chinatown Lions are part of an international organization known for its high profile in public service. The Chinatown Lioness Club, a women's association, shares the same values. The Chinese Girls Drill Team was formed to promote community spirit and keep the Chinese presence before the public. In this way bridges were formed between an ethnic group and the larger society.

新的使命感促使中華會館成立了反種族歧視協會。一九零七年，當維市學校局立令要約二百名華童停學時，中華會館發起罷課抗議，引起人們對學校種族隔離事件的關注。此時，中華會館屬下的樂羣義塾，負起了教授華童英語的責任。一年後，維市學校局重新考慮此事並允許華童返回公立學校上學。

類似的政治活動還在繼續。例如，一九二五年英國軍隊在上海向國民黨示威者開火後，中華會館發起抵制英國貨。一九三零年代日本侵入華北，維市華人組成了抵抗日本拯救中國的組織。維市華人在第二次大戰期間，踴躍援助中國，並籌集了七十五萬加元經費資助中國抗日。

在第二次世界大戰期間，逾五百名加國土生華裔青年志願參與加拿大軍隊出征。戰後，於一九四七年，他們為華裔爭取了選舉權，包括聯邦政府、省政府及市政府。

在爭取得新地位後，加國華裔逐漸成為社會上的中產階級。眾多華裔從事商業及專業的行業。華埠獅子會於一九五四年成立，並與中華會館聯繫，成為其中一個會員。華埠獅子會是世界獅子會組織之一個分會，其主要宗旨是服務社會，與華埠女獅子會抱著同一目標。華人女子體操隊的成立，是宣揚華埠社區精神，在華埠與主流社會之間搭起了溝通的橋樑。

RIGHT Victoria's Chinese community has always drawn the attention of the wider populace with its ceremonial archways, floats and drill teams during civic celebrations. This is a first-prize float from the Victoria Day parade, *circa* 1950.

右圖：維市華人社區的節日慶祝活動，往往引起主流社區之注目。圖中相片是中華會館參加維多利亞日花車大遊巡榮獲第一名。約攝於一九五零年。

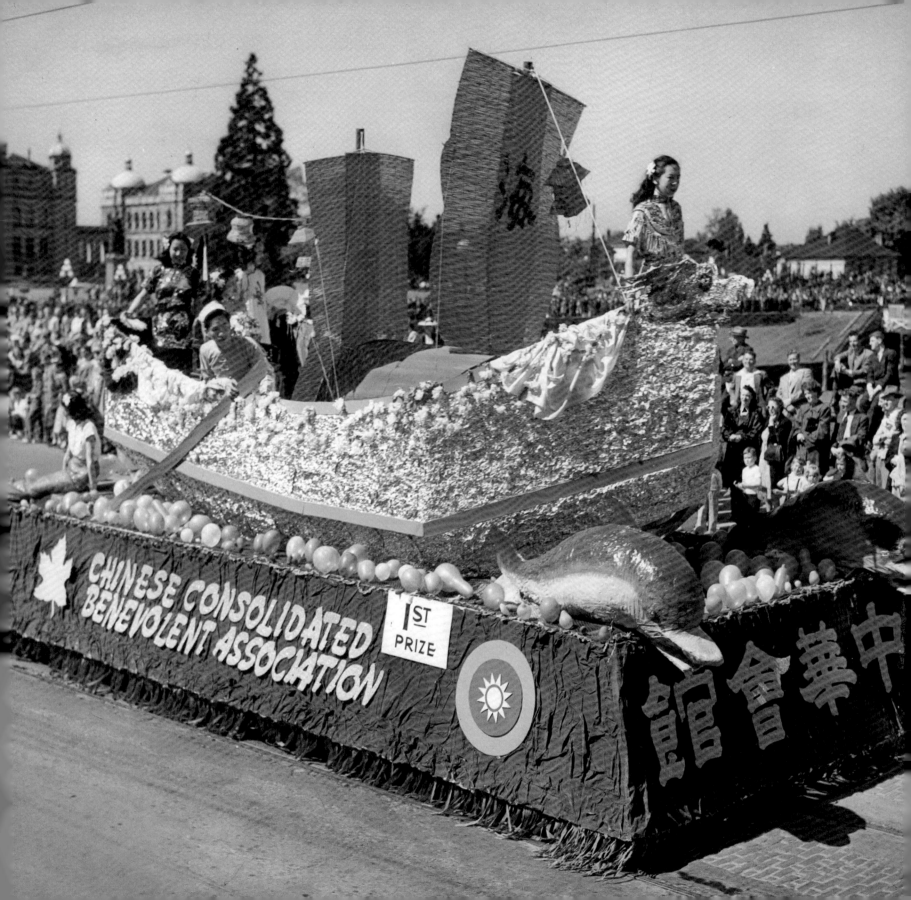

CHINATOWN IN DECLINE

After World War II, many businesses in Victoria's Chinatown closed. The people who had come to Victoria and lived in tents en route to the goldfields were a distant memory; the young bachelors brought from China to build the railway had grown old and died on Fisgard Street. Gaudy neon signs now lit up the night in front of Chinese restaurants, amid the fire escapes and tangled telephone wires, but the tenements and the dormitories were vacant and echoing. Many clan and district groups dissolved as the older generation passed away, and new immigrants chose to settle in larger cities.

With fading membership and changing times, the CCBA was no longer able to maintain the Chinese hospital properly and it became the City's responsibility. In 1961, the last of the cleaned bones were gathered up from all across Canada and buried in a mass grave at Harling Point. Martin Segger, writing in *Monday Magazine* in 1977, described Chinatown as "the tattered skeletal survival [of] a once vibrant and colourful past."

華埠衰退時期

第二次世界大戰後，維市華埠多個行業關閉。那些曾在金礦場帳蓬裏渡過的日子已成記憶。由中國前來建築鐵路的年輕單身漢，年紀漸老，並於華埠菲士格街去世。晚上，餐館俗麗的螢光招牌在防火梯及糾纏雜亂的電話線間閃爍，但華埠十室九空，只留下了空洞寂寞的回音。

中華會館在缺乏人手及經費之下，已無能力維持華人醫院的運作，迫不得以將醫院的產業權移交市政廳。一九六一年，中華會館將全加國各地運來的先僑遺骸清潔後，合葬於哈寧角華人墳場，此為中華會館在該墳場最後一次的運作。馬丁‧西加在一九七七年描寫華埠為「活在過去令人震撼和華美色彩下之破爛骸骨」。

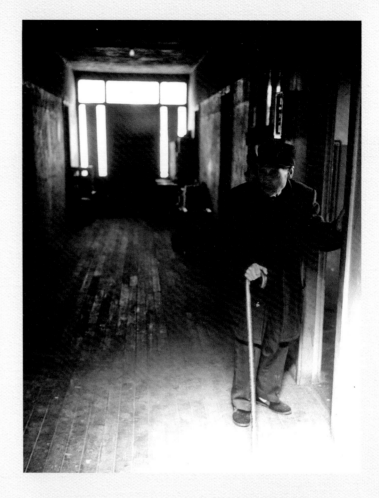

By 1982, there were almost no Chinese living in Chinatown. This man was the last resident of the tenements at the northwest end of Fisgard Street, now known as Dragon Alley.

直至一九八二年，幾乎已沒有華人在華埠居住。這位老人家是菲士格街西北面一幢建築物的最後一位住客。該處現已改建為飛龍巷。

CHINATOWN REBORN

But then a turnaround took place. Dr. David Lai, a professor of geography at the University of Victoria, had come from Hong Kong and shown remarkable curiosity about Victoria's Chinatown. He began to preserve and interpret what appeared to be insignificant scraps of paper —receipt stubs for payments to the CCBA, for example. He first published his findings in *BC Studies* in 1972 and since then has continued to shine a light on the history of the Chinese in Victoria.

In 1978, the City of Victoria asked Dr. Lai to draw up a plan for the revitalization of Chinatown. He recommended a street, beautification project, the erection of a traditional gateway, the building of a new care facility and subsidized housing, a revival of Fan Tan Alley and the creation of a community centre.

The Gate of Harmonious Interest was built at Government and Fisgard streets, with City and private funds, in 1981. The 30-bed Victoria Chinatown Intermediate Care Facility opened in 1982 and Chung Wah Mansions, a subsidized apartment block for seniors, opened in 1984. The Chinese Public School was designated a heritage building in 1988 and was named an Historic Site of National and Architectural Significance in 1996. The Harling Point Chinese Cemetery was named a National Historic Site in 1996 and dedicated in 2001. Each of these projects proposed by Dr. Lai was taken on and seen to completion by the CCBA.

華埠復興

華埠之存亡終於出現了生機，維多利亞大學地理系教授黎全恩博士從香港前來，他對華埠研究有濃厚興趣。他開始搜集華埠歷史資料，舉例來說，在他於一九七二年發表，關於卑詩省研究的著作中，包括早年一些付費給中華會館的單據存根。自此之後，他的華埠研究對華人在加國的歷史帶來了曙光。

維市市政府於一九七八年要求黎全恩博士為美化華埠寫計劃書，他在書中建議美化華埠街道及建造牌樓，建築新的療養院及華埠低收入居屋，重修番攤巷及與建一個華埠社區中心。

華埠同濟門位於加富門街及菲士格街交界處，建於一九八一年。經費來自市政府及各界私人捐獻。設有三十個牀位的華埠療養院於一九八二年開幕。一九八四年中華大廈竣工，內設有可向政府申請補助的耆英低收入單位。華僑公立學校校舍於一九八八年被列為傳统古蹟樓宇。一九九六年，哈寧角華人墳場被列為國家歷史保留區。以上所述的各項目，均是黎全恩博士所建議，由中華會館參與完成的。

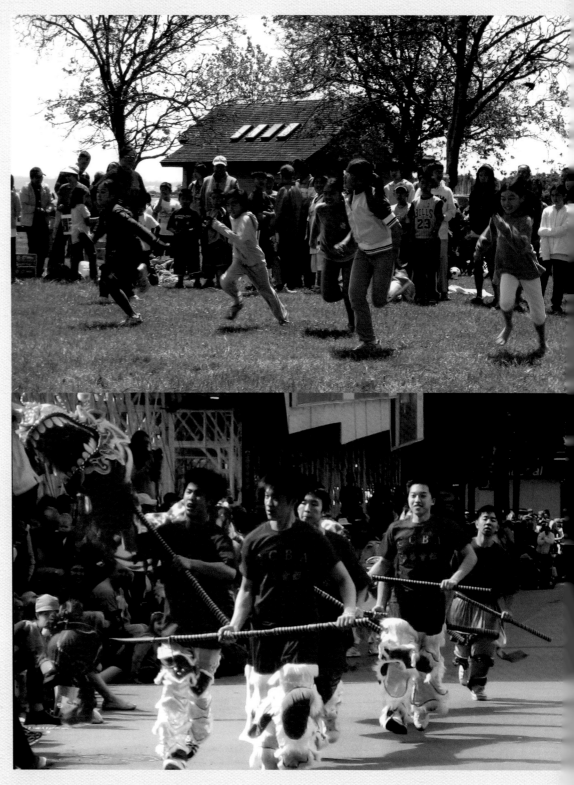

A race for girls, just one of the many activities at the annual CCBA picnic, held in 2007 at Gyro Park in Cadboro Bay.

中華會館每年一度之夏日郊遊野餐，女孩子們正在賽跑。此為該野餐會多姿多采的活動之一。

Junior lion dancers from the Chinese Public School, performing their dragon dance during the Victoria Day parade, Douglas Street, 2007.

華埠幼童醒獅團與華僑公立學校學生在維多利亞日花車大巡遊中表演舞龍。攝於二零零七年。

THE CHINESE PUBLIC SCHOOL

The Chinese Public School, or Huaqiao Gongli Xuexiao, is funded and operated by the Chinese Consolidated Benevolent Association. The first Chinese school in Canada, tracing its origins to 1899, it offers Chinese language and cultural studies to both Chinese and non-Chinese children. The school building is also the headquarters of the CCBA, and continues to be a focal point for the Chinese community in Victoria.

域多利華僑公立學校

域多利華僑公立學校是中華會館屬下的一個機構,於一八九九年創辦。華僑公立學校是全加國首所中文學校,至目前,仍是全加國最古老的中文學校。學校課程包括中文及中華文化,學生中以華裔居多,但亦有小部份為非華裔。學校的建築物亦是中華會館的總部,是維市華人社區之匯聚中心。

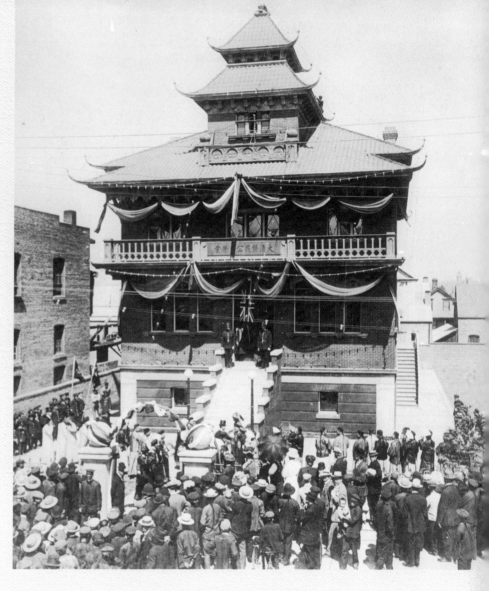

ABOVE LEFT Carved and gilded sign over the front door of the Chinese Public School.

華僑公立學校正門入口處的金漆校名。

ABOVE Opening day of the new building of the Chinese Public School at 636 Fisgard Street, August 7, 1909. The architect was D. C. Frame, who also designed Christ Church Cathedral.

域多利華僑公立學校現址校舍開幕。攝於一九零九年八月七日。該校舍由 D. C. Frame設計,本市的基督大教堂也是由他設計的。

Staff, supporters and trustees of the Chinese
Public School on opening day, August 7, 1909.

域多利華僑公立學校現址校舍開幕，職員與前來道賀的
官紳及支持者合影。攝於一九零九年八月七日。

Students and teacher make dumplings to
celebrate Chinese New Year at the school, 2009.

僑校一片喜氣洋洋，師生們正在包餃子慶
祝春節。攝於二零零九年。

From the start, the Chinese in Victoria were very proud of
their highly developed culture, its values and traditions,
and wanted to protect their children from assimilation and
Westernization. In 1898, Lee Mon Gow, then president
of the CCBA, convened a group to set up a school to teach
these values to the children. It was called the Lequn Yishu
Chinese School and was located on the second floor of the
CCBA building at 560 Fisgard Street. The school opened in
1899 with two classrooms. Lequn Yishu can be translated as
"to enjoy the company of a free school." Once the school was
established, Lee Mon Gow became its principal, a position he
held for 11 years. Lee was responsible for hiring teachers, and
he brought them directly from China.

At that time, the Chinese often wore traditional clothing and
maintained their Chinese culture through their cuisine and
their shops. Most of the immigrants lived in Chinatown and
their children were afraid to play outside the community due
to threats of bullying and harassment.

早期的華人，對其民族之高質素傳統文化感到自豪。為了
海外華裔子弟能繼續學習中華文化，保持傳統，不被西方
民俗同化；於一八九八年，由中華會館副主席李夢九發起
籌資辦學。<樂羣義塾>於一八九九年創辦，此為華僑公
立學校的前身。當時的校址在菲士格街五五四至五六零
號的頂樓。樂羣義塾有二個課室。樂羣的意思是喜愛群體
的生活，義塾是免收費的學校。學校成立後，李夢九成為
首任校長，任校長之職位共十一年。他負責聘請教師，並
協助申請他們直接從中國前來上任。

當時，華人在加國并沒有公民權；他們在加國的生活方式
如衣著服裝、食物、習俗等仍保持其家鄉特色，也習慣往
華人商店購物。為了避免受白人的欺侮及搔擾，大部份的
華人集中住在唐人街，華童也不敢走出唐人街以外的地
方玩耍。

In 1901, for political reasons, the Victoria School Board withdrew permission for Chinese children to attend public school. The CCBA and community members opposed this discrimination, and a court case against the exclusion was fought valiantly by lawyer Fred Peters, hired by the CCBA. He was so committed to the anti-discrimination position that, when the case was lost, he returned to the CCBA most of the money they had collected for his fee.

Excluded from the public schools, an increasing number of students had to be accommodated at the Lequn Yishu school. On August 8, 1908, the CCBA purchased land at 636 Fisgard Street on which to build a new school. A partial lot at 640 Fisgard, the side yard of the home of Lee Mon Gow, was donated to become the school's playground.

When the school moved, with a grand opening on August 7, 1909, it was given a new name: Daqing Qiaomin Gongli Xuetang (Greater Qing Imperial Overseas Residents Public School). It was a proud occasion for the community. The new school received a wide variety of gifts including cash donations, lighting, clocks, maps, globes, chairs and desks, many of which are still part of the school's equipment.

The original curriculum of the school was continued, with Chinese as the language of instruction, but English was soon added, to help students pass the English examination for entering public schools. In 1911, with the election of a new school board, Chinese children were allowed to return to public schools.

After the fall of the Qing Dynasty in 1911, the school had to be renamed to match the new republic and in 1912 it became Huaqiao Gongli Xuexiao (Overseas Chinese Public School). The first graduation ceremony took place in February 1915, with 12 graduates. The current student population is almost 250.

由一九零一年開始，基於政治的理由，維市教育局立例排除華童入讀公立學校。僑界群起反對，抗議之聲不絕，並發起<爭學務籌款>。中華會館於一九零七年用籌得的款項聘請名為法列特.彼得士的律師向法庭提出訴訟，反對此不平等的種族歧視條例。彼得士律師是位反對種族歧視的熱心人，當官司失敗後，他將大部份的律師費退回給中華會館。

樂羣義塾接收了被教育局摒之於公校門外的華童，校舍不敷應用。中華會館於一九零八年八月二十四日，購買了位於菲士格街六三六號的土地興建新校舍。李夢九捐出了他擁有之菲士格街六四零號部份的土地，作為學校操場。

樂羣義塾遷往新校舍，於一九零九年八月七日舉行開幕禮。學校改名為<大清僑民公立學堂>。新校舍的成立，是當時僑界的一大盛事，各地僑界贈送的賀禮絡繹不絕，計有燈飾、時鐘、地圖、地球儀、椅子、書桌及賀金等。其中有些仍保存於僑校。

學校的課程仍保留以中文為主，但亦加入了英語科，使學生能儘快通過教育局的英語考試，返回公立學校就讀。至一九一一年，教育局選出了新的董事，准許所有華童重返公立學校。

滿清朝庭於一九一一年被推翻後，中華民國成立。一九一二年學校改名為<域多利華僑公立學校>。學校於一九一五年舉行首屆畢業禮，共有十二名畢業生。該校現有學生約二百名。

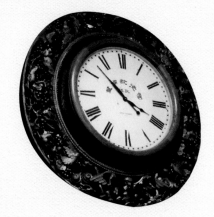

The school's clock, a gift presented at the opening in 1909.

華僑公立學校現仍使用的時鐘，是司徒教倫堂在一九零九年學校開幕時所贈送的賀禮。

Students from the class of 1924 preparing
for a fundraising event at the Chinese
Public School.

學生們正在準備出席籌款活動，
攝於一九二四年。

In 1921, the provincial Ministry of Education decided to segregate Chinese and white students, banishing over 400 Chinese students from their usual elementary schools and gathering them in old huts at King's Road and Rock Bay. In reaction, the CCBA and others arranged that the students would walk out in protest. The Chinese consulate in Ottawa also appealed the government's policy. It took three years and considerable further lobbying before the provincial government changed the law but, ironically, just then the new federal law stopped all Chinese immigration.

The commitment and attitude of the parents and children to Huaqiao Gongli Xuexiao is noteworthy. The students attend regular public school until 3:00 P.M. and then go to Chinese school. School is in session from 4:00 to 6:00 P.M. weekdays, and is open on Saturdays from 9:00 A.M. to 4:00 P.M. for a different group of students. It is organized as an elementary school, with six grades. In Grade One, students begin learning how to read and write simple characters. By Grade Six they are able to write short essays and read Chinese newspapers. The majority of the Chinese people in Victoria are from Canton, so the official language of the community is Cantonese. Both Cantonese and Mandarin Chinese are written the same way but pronounced differently. In September 1998, the school added Mandarin studies for Grades Five and Six.

一九二一年，省府教育廳決定將華裔學生與白人學生隔離上課，逾四百名華童被抽離他們各自所就讀的小學，集中趕往設於國王路及石灣路，被當時老華僑稱之為<雞仔屋>的簡陋鐵皮小屋上課，完全與白人學童隔離。。此為加國華僑史上的<黃白分校>種族歧視事件。教育廳此舉引起僑界的強烈抗議，在一九二二年九月初，中華會館與僑界發動華童罷課。中國駐渥太華領事館向加國政府提出控訴，訴訟一直拖了三年，省政府才改變初衷。同時，於一九二三至一九四七年間，聯邦政府已立新例禁止華人入境。

家長與學生對華僑公立學校的支持要付很大的決心和毅力，學生在下午三時於英文學校放學後，就直接往僑校上課。平日班上課時間是每週五天，每天下午四至六時。週六班上課時間是上午九時至下午一時。僑校的課程是小學制，由一至六年級。由一年級開始，學生學習讀和寫簡單的中文字；至六年級畢業時，學生已能寫簡單的作文及閱讀中文報章。由於維市大部份華裔的祖籍是廣東，所以維市僑界的共同語言是粵語。僑校的傳統是以粵語授課，但隨著社會的需求，自一九九八年開始加設國語班，起初只是提供給五、六年級的學生學習，發展至今日，自一年級起也提供了國語課程。

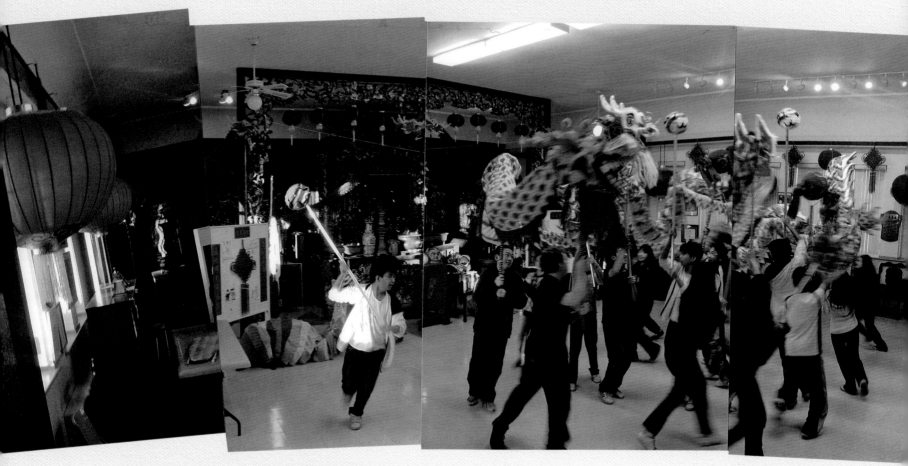

Students rehearse their dragon dance in front of the Palace of the Saints on the third floor of the Chinese Public School.

舞蹈團學生在僑校三樓列聖宮前練習舞龍。

In addition to their academic studies, the students are constantly at work on cultural projects. Calligraphy is integrated into the study of reading and writing. Under Principal Wu, herself a talented painter, they produce pictures with seasonal motifs throughout the year. The long and honourable tradition of dance at the school has now reached new heights, with both senior and junior folk dance troupes winning acclaim and prizes locally and internationally. As well, a junior lion dance team sometimes trains under the senior lion dancers at the Sheung Wong Kung-fu Club.

除了學術上的課程外，僑校也提供傳統的中華文化教育。書法是其中必修的科目。國畫班在多才多藝的吳紫雲校長教授下，依季節學習四季花鳥或山水國畫。僑校舞蹈團在吳校長的領導下，在維市享譽多年，於本市及北美洲的舞蹈比賽中獲獎無數。學生們循著舞蹈團的優良傳統，由師兄師姐們指導初入舞蹈團的小師弟妹基本功。學生們也往黃相健身會向資深的大師兄姐們學習舞獅。

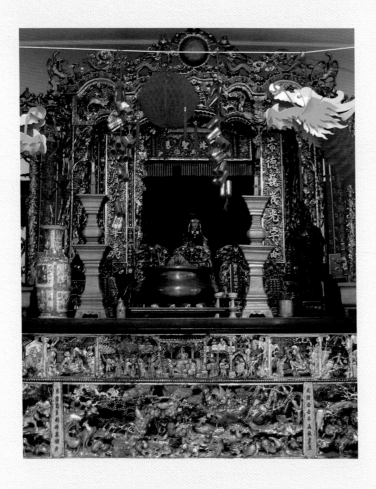

LEFT The Palace of the Saints, main altar and shrine, at the CCBA headquarters on the top storey of the Chinese Public School.

左圖：列聖宮的神壇及神龕，座於中華會館屬下的華僑公立學校頂樓大廳。

THE PALACE OF THE SAINTS

The Palace of the Saints is not dedicated to any religion. It is essentially an expression of traditional Chinese philosophy and customs, recognizing virtues through paying respect and honour to the deserving. In this way, people are encouraged toward worthy actions.

列聖宮

列聖宮並非宗教寺廟。列聖宮中所供奉的五位聖哲，是中國民間習俗所信仰的神明。各神明因其對世人的功績而受民間敬拜。

RIGHT The Palace of the Saints decorated for New Year's, 2009.

右圖：列聖宮充滿著春節的氣氛，一片喜氣吉祥，相片攝於二零零九年。

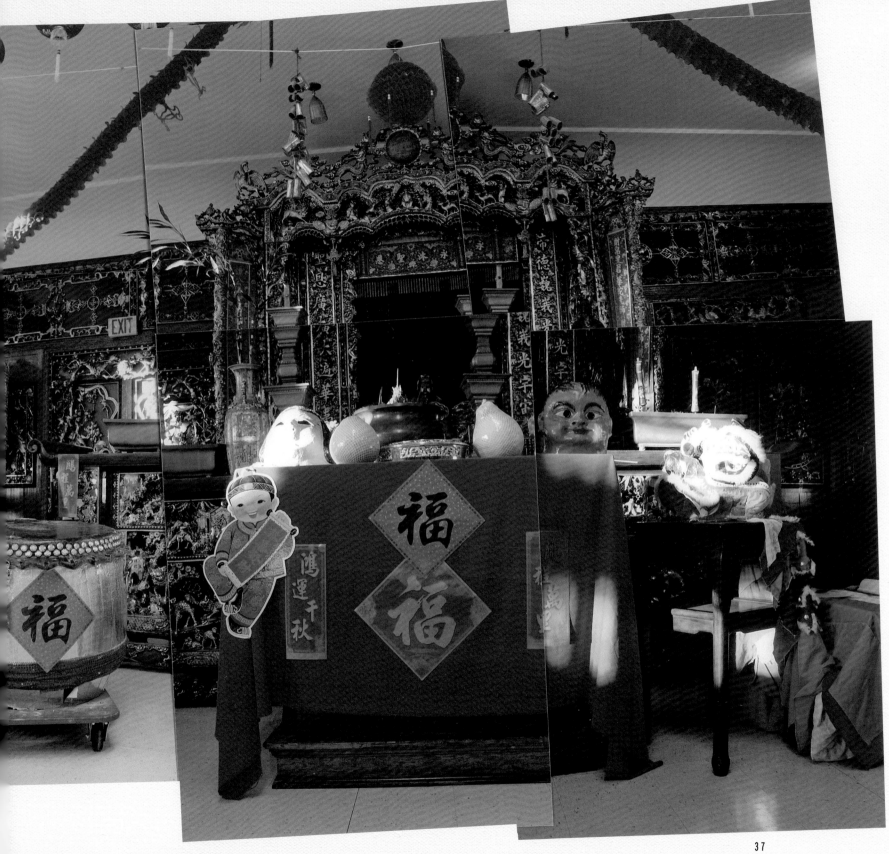

ABOVE The name "Palace of the Saints"
spelled out on a pewter altar vase.
上圖：列聖宮神壇上之錫鉛合金祭
皿刻著＜列聖宮＞字樣。

The main altar and shrine of the Chinese Consolidated Benevolent Association were created in South China and brought to Victoria in 1885. After serving for many years in the CCBA headquarters at 560 Fisgard Street, this assemblage of carved and gilded wooden furniture was brought to the Chinese Public School in May 1966. Jack Lee, then president of the CCBA, was in charge of the ceremony. When the Palace of the Saints was relocated to the school, a volley of fireworks drove away any evil spirits that might have been lurking. Since then it has formed a fitting and memorable backdrop to what is, on a daily basis, the school's auditorium.

列聖宮的神壇及神龕是於一八八五年由中國南方運送來的。中華會館屬下的列聖宮原址在菲士格街五六零號，於一九六六年五月，由當年主席李惠賢主持儀式，把列聖宮遷往華僑學校的頂樓。其金漆雕刻屏風及匾額對聯等，安放在僑校的禮堂，成為僑校禮堂的一部份。宮中縷縷不斷的香火清煙，為僑界驅魔辟邪，祈福求安。

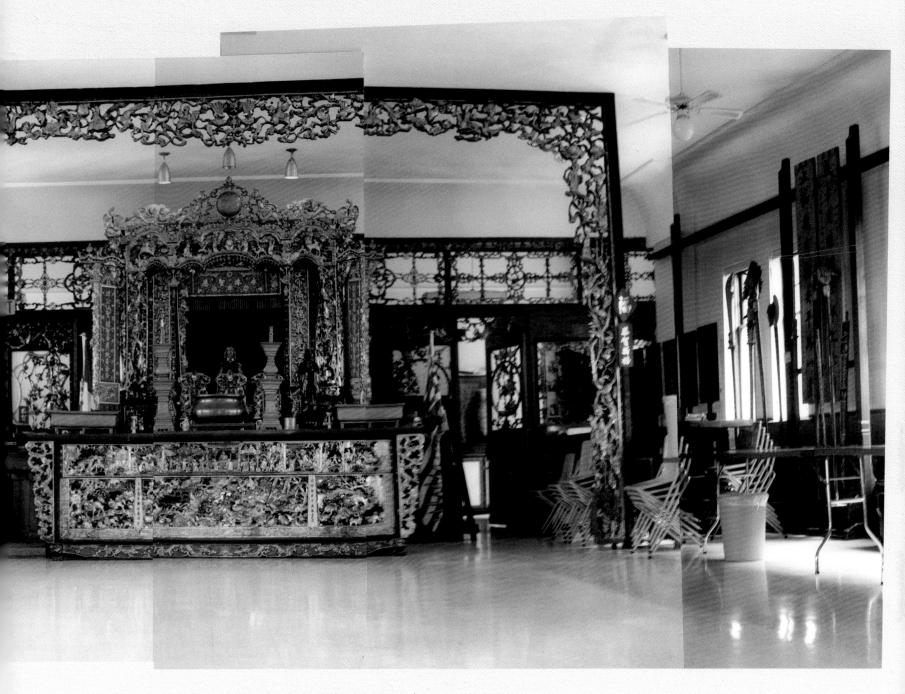

The third-floor meeting hall with
the Palace of the Saints.

僑校三樓禮堂與列聖宮

Behind the table stands an elaborate and remarkable cabinet with an alcove that is the centre of *Lien Shen Kung*, the "all saints" shrine. The elaborately carved altar table itself has an array of objects to hold offerings—trays of sand, candlesticks, pitchers and vases. Offerings of incense, flowers, wine and fruit are always present on the altar. The altar table stands before a handsomely decorated wall, with a filigree of carved and gilded wood over glass and panels. Above and beside the altar is an expansive wooden arch, also carved and gilded.

The shrine and altar are constructed without nails or screws, fitted together like a jigsaw puzzle. The room on the third floor where they are located is richly hung with carved plaques and artwork, donated to the CCBA at the time of its founding and later to commemorate significant events in the life of the community.

The shrine is central to a Confucian view of life. What is sometimes called Chinese "ancestor worship" is not a religion in the Western sense of the word. All the saints revered in this temple were once living persons, and because of their deeds they are deemed worthy of reverence by their descendants and followers.

金漆雕刻的神壇上，排列著祭祀器皿 － 香爐、燭臺、酒壺及花瓶等。香燭、鮮花、酒水、及生果等獻品長期供奉。神壇檯子的正面附有手工精緻的金漆雕刻圖案，描述著多個典故傳記等。神壇的上方及旁邊，有一木製的拱廊，同樣是金漆雕刻品。

神壇及神龕的結構不需使用一顆鐵釘或螺絲而嵌成一整體。三樓禮堂中懸掛著的各種匾額及藝術品，是中華會館創會開幕或盛大喜慶時，各界贈送的賀禮。

列聖宮是民間追源思祖，中國儒家思想的敬拜先祖之地，並非宗教廟宇。宮中所供奉的列聖，均是真實的人物。由於他們生前的功績，及對後代的貢獻，而受民間敬仰及追思。

CONFUCIUS (551–479 BC) was China's greatest philosopher and teacher of ethics. Today's Chinese literature still includes the study of his works and considers him to be the basis of the Chinese language. A statue on the altar table represents him.

孔子(公元前五五一至前四七九年)，孔子名丘，世人尊稱為孔夫子。他是中國第一位大教育家，也是一位哲學家。他的儒家思想、道德和學問受世人的尊崇，其著作仍是學習中國文學者所必修之徑。孔夫子的雕塑像現供奉在列聖宮的神壇上。

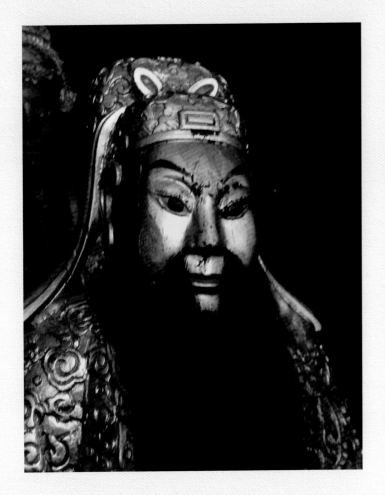

KWAN KUNG (166–219 AD) was the greatest general of the Three Kingdoms. Because of his loyalty to his country and his integrity as an individual, he was worshipped by all. A gilded figure of Kwan Kung stands at the front of the shrine.

關公(公元一六六至二一九)，關公名羽，世人尊稱為關公。他是三國時期的一位名將，以其忠誠俠義精神留名於世，受後人崇拜。關公的金漆雕塑像供奉在列聖宮的神龕內。

TIEN HAW (960–987 AD) is the most recent deity to be enshrined. He is the patron saint of the seas, and all travellers ask for his blessing before embarking on an ocean voyage.

天后娘娘(公元九六零至九八七年)是航海者所敬奉的神。漁夫出海前必先向天后娘娘禱告，祈求風平浪靜，平安歸來。

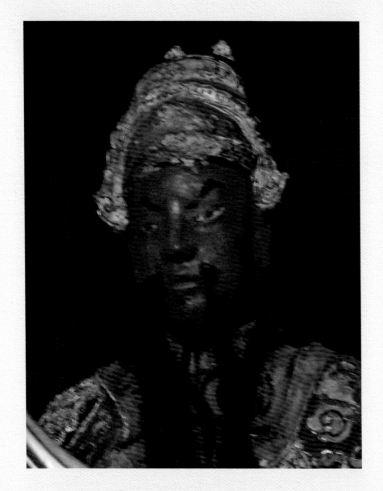

CHOY BOK (354–283 BC) is the patron saint of businessmen. He was reputed to have amassed a fortune in the iron, transportation and salt industries, and to have supported his family and more than 3,000 relatives.

財帛神君趙玄壇(公元前三五四至前二八三年)名公明，被世人尊奉為財神。他在鋼鐵業、運輸業及鹽業上累積了巨大的財富。他為人慷慨，不只養育家人也資助逾三千親戚。

HUA TUO (144–221 AD) was a famous doctor in the time of the Three Kingdoms. His many good deeds in medicine endear him to the sick and those seeking medical help.

華陀(公元一四四至二二一年)是三國時期著名的醫師，他的醫術高明，能令病者起死回生。他在醫學上的成就，被世人尊稱為神醫。

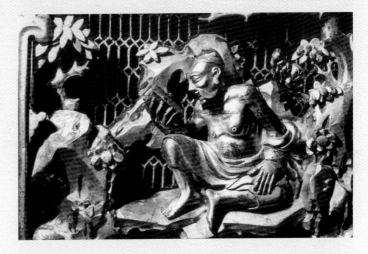

Gilded wood carvings from the front of the
altar table, Palace of the Saints.

列聖宮神壇前面的金漆雕刻圖案。

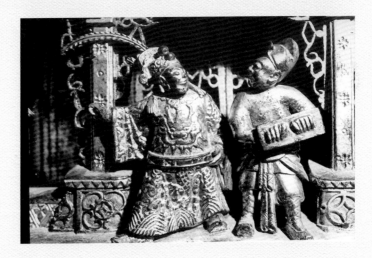

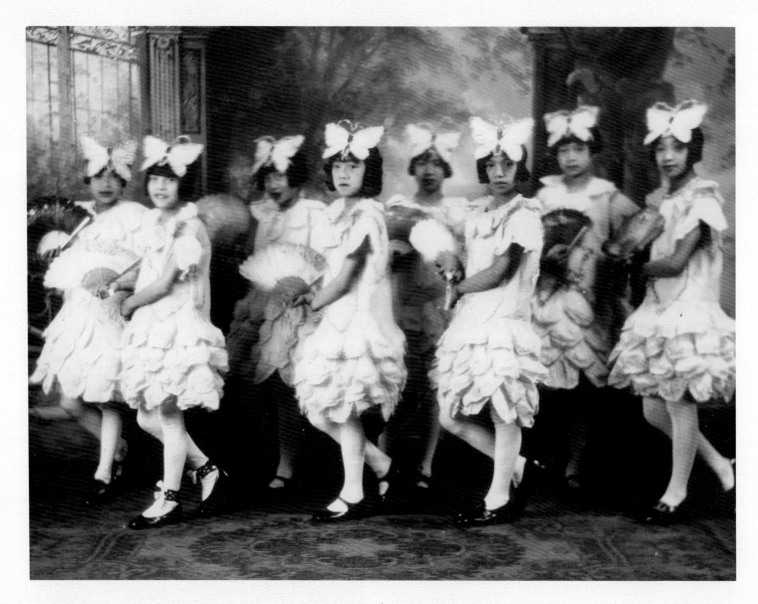

Butterfly dance group at the
Chinese Public School, *circa* 1924.

華僑學校舞蹈團的<蝴蝶舞>，
約攝於一九二四年。

THE DANCE GROUP AND DRILL TEAM

The Chinese School Dance Group has been active almost as long as there has been a Chinese Public School. A Girls Drill Team was active by 1949 and in demand at community events until the early 1970s. The team often performed locally in the Victoria Day parade each May and on occasion in Vancouver and Seattle as well.

Kileasa Wong began the process of rejuvenating the folk dance team in 1992. Wong and her students have made a number of trips to study at the Beijing Academy of Dance, and in Victoria they are acclaimed for their performances at civic events, hospitals, schools and many festivals and celebrations throughout the year. At the recent Greater Victoria Performing Arts Festival, they swept the field as they have done before, winning every category they entered. They travel to North Vancouver annually to compete in the North American Chinese Folk Dancing competition where, in 2008, they placed first and second in the senior category and first in the junior section.

The older girls naturally teach the younger ones in the schoolyard during recess, so a junior dance troupe has sprung up. The boys, many of whom are kung fu students of Sifu Edmund Wong, admired the dazzling lion dance costumes and acrobatics of the kung-fu club, and now a junior lion dance team has been started at the school.

Folk dancers ready to practise a fan dance at the school, 2008.

舞蹈團的學生正在等待綵排太極扇表演,攝於二零零八年。

華僑學校舞蹈團

華僑學校舞蹈團的歷史悠久,幾乎自學校成立以來就一直有舞蹈團的存在。學校早期的相片中有一幅是一群穿著荷葉邊裙子,頭戴蝴蝶結的女孩子們正在表演舞蹈,該相片攝於一九二四年。另有一幅是攝於一九四九年的,是學校的女生體操隊正在彩排。該體操隊經常代表僑校出席社區活動,參加維多利亞日花車大遊行,甚至往溫哥華及西雅圖等地表演。體操隊一直活躍至約七零年代初期才停辦。

黃吳紫雲於一九九二年重組舞蹈團。她曾數次往北京舞蹈學院學習,也帶學生往北京夏令營學習中國舞蹈。僑校舞蹈團重新活躍於維市社區,往醫院、學校、社區節日及各種慶祝活動中表演,並極受讚賞。僑校舞蹈團也參加本市藝術節的民族舞蹈比賽,每年均在所參賽的組別中獲得獎項。舞蹈團也定期前往北溫哥華參加北美洲中國舞蹈比賽,在二零零八年的比賽中,該團奪取十五歲以下組別的冠、亞軍及十一歲以下組別的冠軍。

舞蹈團的資深師姐秉承僑校優良傳統,小息時在學校操場或禮堂指導年幼的師弟妹基本功。很多曾在黃相健身會大師兄黃永安門下習武的男孩子,則醉心於色彩繽紛,動作靈敏的舞獅。僑校的醒獅隊由此而產生。

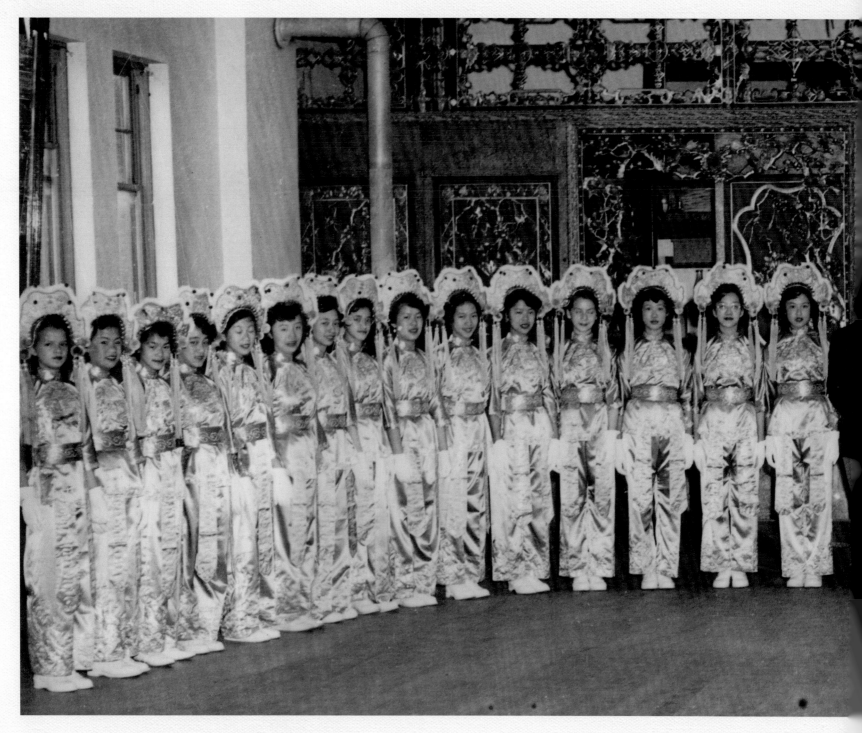

Members and staff of the Chinese Girls Drill Team,
assembled upstairs at the Chinese Public School in
preparation for the Victoria Day celebrations, May 1954.

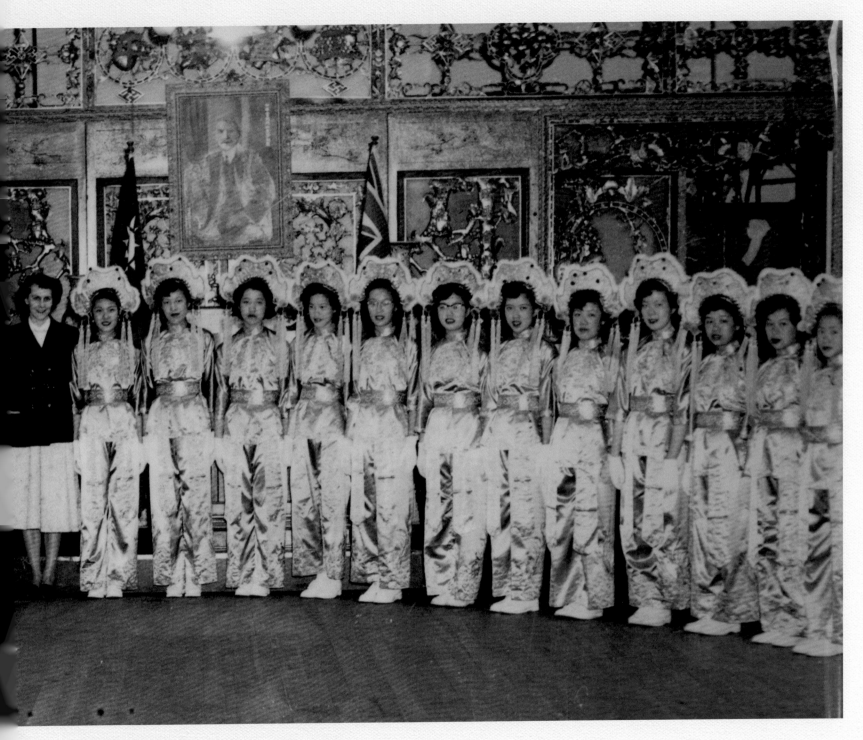

華僑學校體操隊的教練及隊員於僑校禮堂集合，準備
出席維多利亞日花車大遊行。相片攝於一九五四年五月。

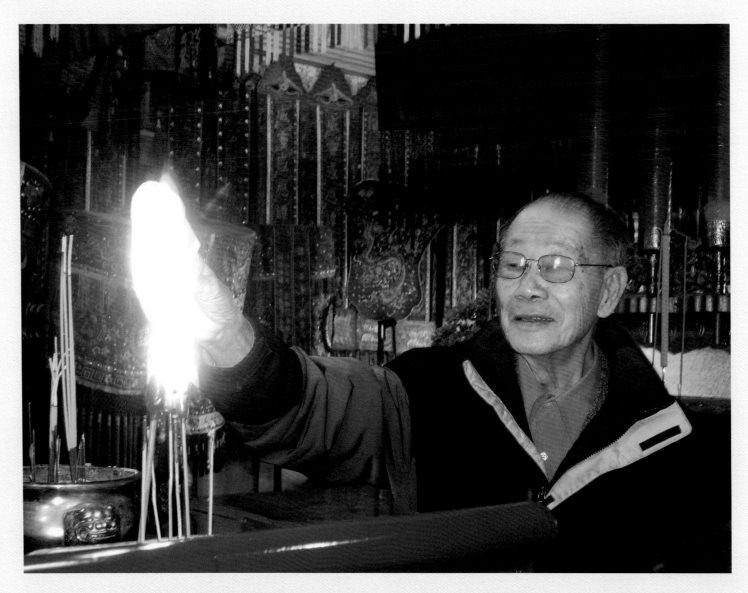

Jimmy Ngai, president of the Yen Wo Society, is the third generation of his family to take care of the Tam Kung Temple, located on the top floor of the Yen Wo Society building.

魏林珍，人和會館主席。他是魏氏家族中在譚公廟的第三代主持人。譚公廟位於人和會館的頂樓

1 YEN WO SOCIETY 人和會館
The Tam Kung Temple 譚公廟

The carved and gilded sign of the
Tam Kung Temple in the Yen Wo building.

譚公廟的金漆雕刻牌匾

The Tam Kung Temple is the oldest Chinese temple in Canada. Legend has it that in the 1860s a Chinese gold seeker, en route to the Fraser Valley from California, brought a statue of Tam Kung to Victoria. Tam Kung, the god of seafarers, is a deity sacred to the Hakka people.

The Hakka people moved to South China from northern China about 1,000 years ago and, despite the years, were never fully assimilated with the residents in Guangdong and Fukien provinces. Life was hard and land was scarce, so the Hakka moved around a lot. They were often involved in coastal shipping, especially in the Hong Kong, Kowloon and Macau areas.

Tam Kung was a real person who lived 800 years ago. Even as a child he was recognized for his miraculous powers. He played in the mountains with tigers, and knew how to treat illnesses; he could call on the heavens for rain, and calm storms at sea. When Tam Kung died at 80 years of age, he still had a childlike face.

譚公廟是全加國最古老的華人廟宇。相傳於一八六零年代，由一位客藉華人從中國攜來譚公神像，在他沿著菲沙流域前往加州尋金時，把神像留下來供維多利亞市客藉華人拜祭。譚公爺爺，航海者的保護神，是客藉人士所敬拜的神明。

約一千年前，客藉人士由中國北方向南移，到達廣東及福建省。異地的生活十分艱苦及難以適應，因此，他們不斷地遷移，其生活背境多與在沿海一帶的船運有關，由其是在香港，九龍及澳門地區。

相傳譚公是八百年前的一位真實人物。他自少就有特異能力，屢顯奇蹟。他經常在老虎出沒的深山中放牛，并與老虎玩耍。能為村民醫病，他能求雨，及平息海上的風暴。他去世時雖已年過八十，但仍面如孩童。所以譚公廟中的譚公神像，是個孩童的面孔。

When the Taiping Rebellion (1850–1864) shattered life in South China, many Hakka were at odds with the ruling powers, and dispersed all over the Pacific Rim. One of them brought the statue of Tam Kung to Victoria and it was first set up in a roadside shrine in the Johnson Street ravine. In Victoria in 1875, Ngai Tse had a dream in which Tam Kung asked him to build a temple for the god. Money was raised and, in 1877, Tam Kung was given his own shrine at Government and Fisgard streets.

In 1911, the Yen Wo Society, an association of Hakka people in Victoria, built a new three-storey brick building on their property and installed the Tam Kung temple on the top floor. It has been a busy centre of the community ever since. Jimmy Ngai, grandson of Ngai Tse, was president of the society and the person responsible for the temple until his death in 2009.

In these photos, daylight comes through the windows of a west-facing balcony that looks out on Government Street. Clouds of incense rise from the altar table in front of the statue of the god of seafarers, Tam Kung.

當太平天國之亂時 (一八五零 － 一八六四)，破滅了中國南方人民的寧靜生活，不平等的統治權力，令客籍人士多遷徙海外各地。其中有位客籍人士攜帶了譚公神像到維多利亞，初時供奉在莊信街橋下路邊的神龕內。一八七五年，譚公托夢於維市客籍人士魏泗，囑他設廟供奉。在魏泗的多方奔走籌款下，至一八七七年，譚公爺爺終於在加富門街及菲士格街有了屬於自身的廟宇。

維市客屬人和會館於一九一一年，將譚公廟原址改建為三層高的石磚樓宇，把譚公爺爺的神像供奉於頂樓。自此，譚公廟成為華人社區中香火鼎盛的廟宇。目前，魏林珍是譚公廟的主持人，也是人和會館的主席。他是魏泗的孫子。

日光從西面露台的窗戶透入，在這裡向外可俯望加富門街。神壇上，點著的香火正從航海者的保護神_譚公爺爺的神像前縷縷上升。

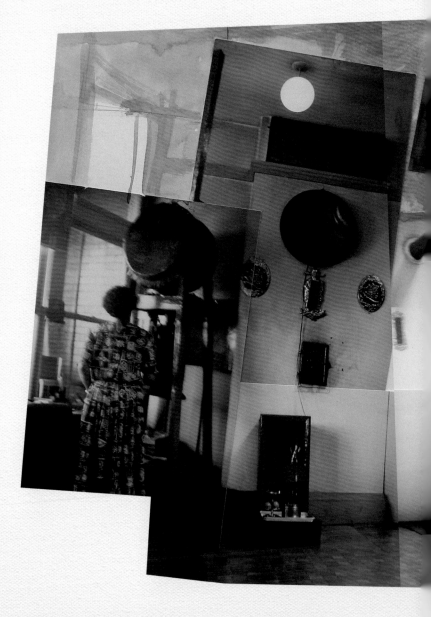

Those seeking favour of the god Tam Kung make offerings to the temple of rich embroideries. These take the form of symbolic umbrellas, fans and banners. Small shrines at the sides are dedicated to other gods, in thanks for benefits received. [INTERIOR OF THE TAM KUNG TEMPLE]

善信者到譚公廟祈福許願，也奉獻上色彩艷麗的刺繡、神傘、扇子及紅綢橫額等。廟中的數座小神龕是善信在祈福後如願以償，願夢已達，特為還福而獻上，以答謝譚公爺爺的庇佑。 [譚公廟的內堂]

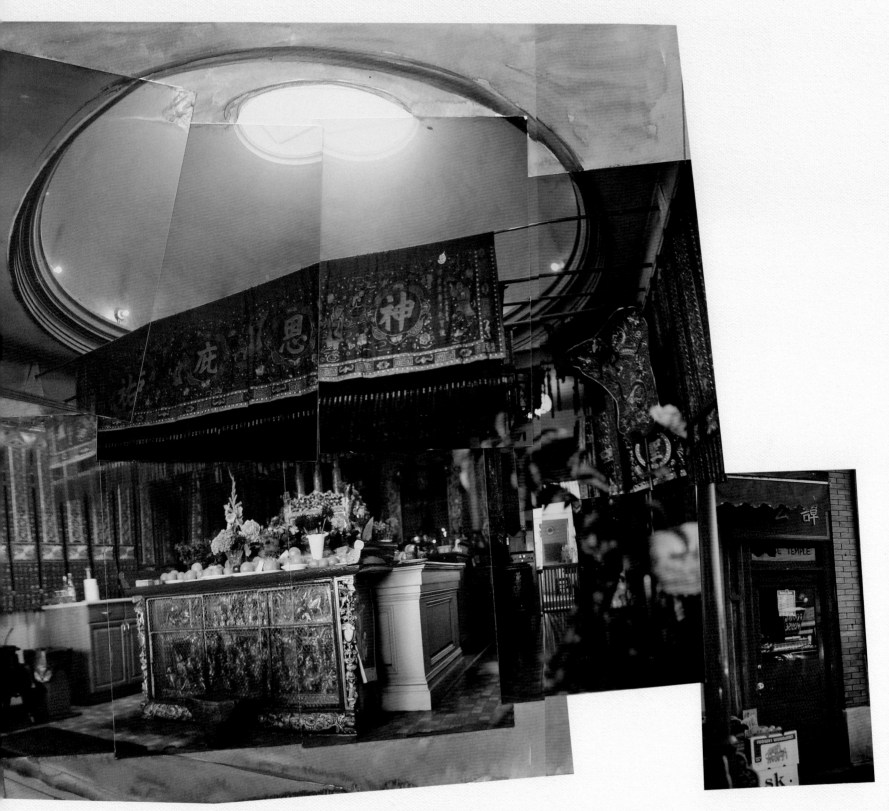

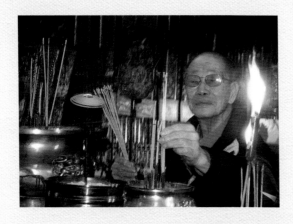

Jimmy Ngai makes offerings of incense. Some of the smoke is sent up a brick chimney built into the building.

譚公廟的主持人魏林珍正在上香。廟中設有石磚通風煙囪以流通香火。

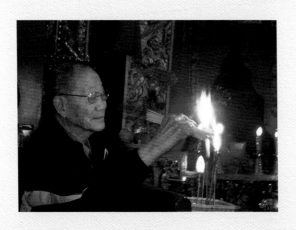

Twice a day, the ancient bronze bell and big wooden drum are struck to summon the attention of Tam Kung.

每日兩次，廟祝敲響廟內的古董銅鐘及木鼓，將所祈求的信息傳達與譚公爺爺。

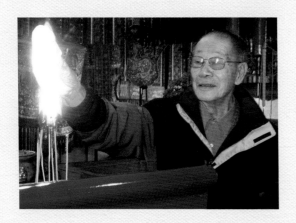 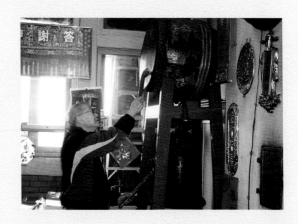

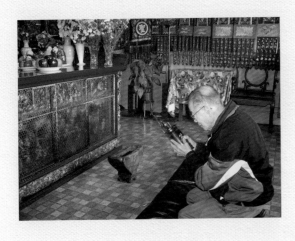

After shaking a vase of yarrow sticks, Ngai selects one through prayerful intervention. The number on the stick is matched one of the "fortunes" in a cabinet full of numbered drawers and the auspices for this situation are read from a printed piece of paper.

在把簽筒裡的竹簽搖動後，魏林珍拿起被搖出簽筒的竹簽，然後從擺滿簽文的抽屜中，抽出與竹簽相同號碼的簽文，上面記載著譚公爺爺指點迷津的詩句。

Ngai makes offerings at a small shrine located on the outside balcony.

魏林珍在露台上的小神龕奉上香火

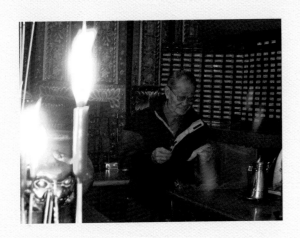
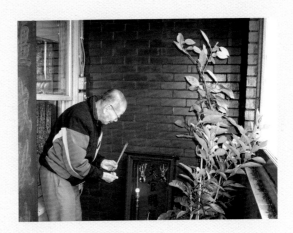

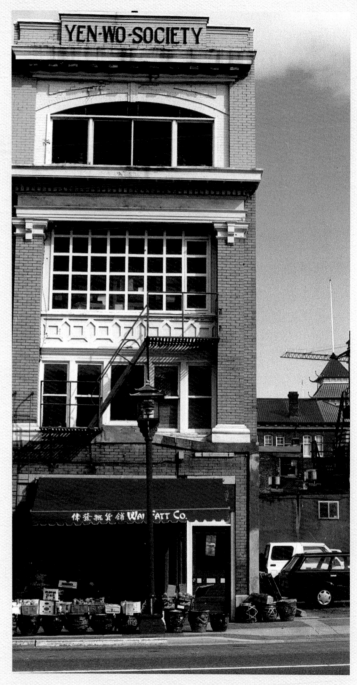

The front door of the Yen Wo Society building.

人和會館建築物的正門

The Yen Wo Society building at 1713 Government Street, designed by L. W. Hargreaves in 1911.

人和會館位於加富門街一七一三號的樓宇，
是由哈貴域斯在一九一一年設計的。

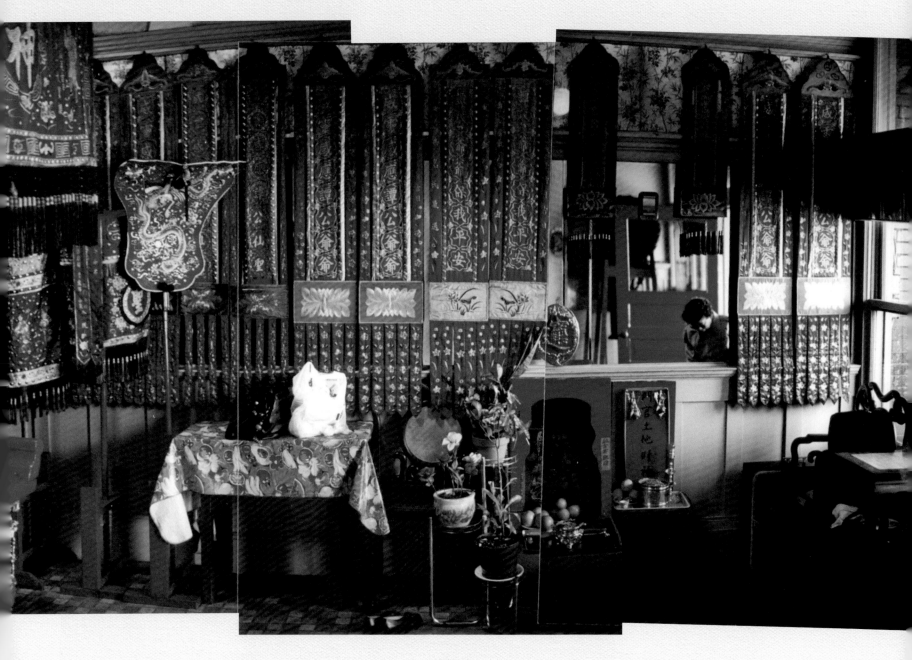

Interior of the Tam Kung Temple. | 譚公廟的內堂

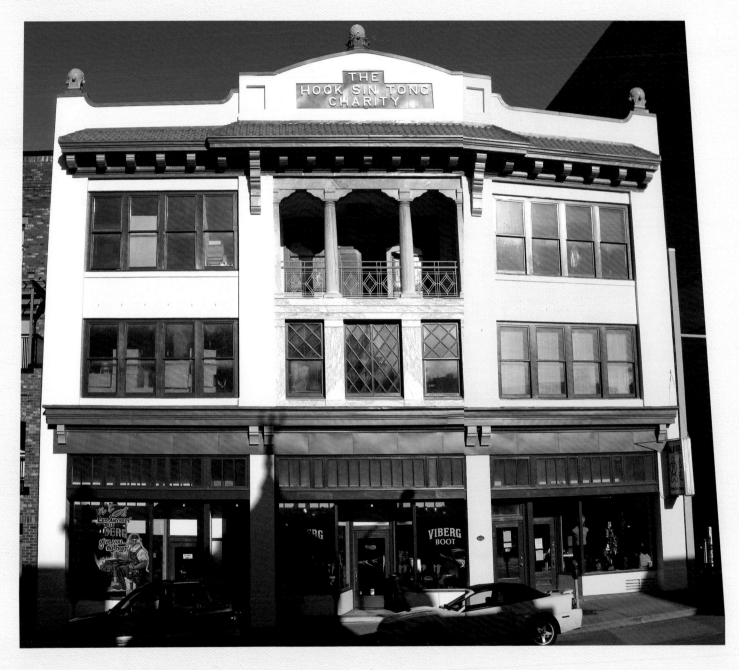

The Hook Sin Tong building at 666 Herald Street, designed by C. Elwood Watkins in 1911.

中山福善堂位於喜路街六六六號，是由艾活屈勤斯在一九一一年設計的。

The carved and gilded panel
with the name "Hook Sin Tong."
中山福善堂的雕刻鑲金牌匾

2 HOOK SIN TONG CHARITY ASSOCIATION
中山福善堂

The Hook Sin Tong Charity Association is one of Victoria's older societies, formed in 1902. Its founder, Kum Jow Lee, brought together people whose ancestral roots were in his home county of Zhongshan, in Guangdong Province, South China.

The original purpose of the group was for people from Zhongshan—almost all of them men—to help one another to make a new life in Canadian society. Zhongshan people in Victoria could receive mail at the clubroom and enjoy the company of others who spoke the same dialect.

中山福善堂是維市歷史最古老的僑團之一。其創辦人李錦周，為了將從中國南方廣東省中山來的同鄉聚集起來，於一九零二年成立了中山福善堂。

中山福善堂創辦的宗旨，是幫助中山同鄉在加國安定下來，這些同鄉大部份是男性。由於當時中國來的移民並不是完全被本地人接受，從中山來的新鄉里可經福善堂收到家鄉來信，得到同鄉的照顧及用中山方言與同鄉交談。

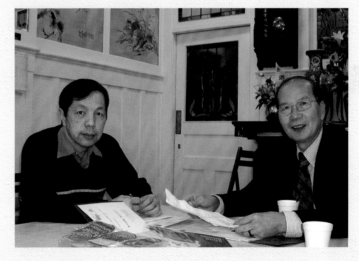

Treasurer Henry Low (left) and President Carlos Choy (right).
福善堂財政劉鴻就(左)與主席蔡雅章(右)

57

Tong means "meeting hall." The Hook Sin Tong has a very elegant meeting room on the top floor of the association's 1911 three-storey building at 666 Herald Street. The designer, C. Elwood Watkins, decorated the front balcony with marble pillars and lintel. Inside, the remarkable stained-glass dome lights the room through a colourful motif of tulips.

The members meet on the third Sunday of every month, coming together to plan events such as a New Year's banquet, a summer picnic or day trips to visit other Zhongshan people. The purpose of the club has always been social, rather than religious or political. Scholarships are provided to university students with Zhongshan connections.

堂」的意思是可容納許多人的寬敞屋子。中山福善堂的會議廳是一座很優雅的大廳，位於堂所之三層高磚屋的頂樓。這座位處喜路街六六六號的建築物建於一九一一年。設計師是艾活屈勤斯。頂樓陽臺的圓柱及門楣是用大理石做成的。室內圓頂天窗華麗的染色玻璃附有鬱金香花的圖案。

會員在每月的第三個星期天聚會，共同討論新春團拜、夏季郊遊野餐、或計劃與其他中山同鄉互訪等會務。該會目前的主要宗旨是聯誼鄉情，并不涉及宗教或政治。福善堂重視下一代的教育，在維多利亞大學為中山子弟設立獎學金。

Beneath the stained-glass dome, the Hook Sin Tong's quarters have a sparkling elegance. Set into wooden panels all around the room are mirrors, silk embroideries and masterful calligraphy describing the founding of the society. A full complement of dark wooden chairs surrounds the hall.

在室內圓頂天窗的染色玻璃下，中山福善堂的會議廳充滿一片亮麗和雅致。兩邊牆上掛著鏡子，刺繡國畫及書法鑲裱在鏡框裏，書法文章中詳細敍述了堂所的創辦歷史。古董酸枝椅子排列在兩旁，古色古香。

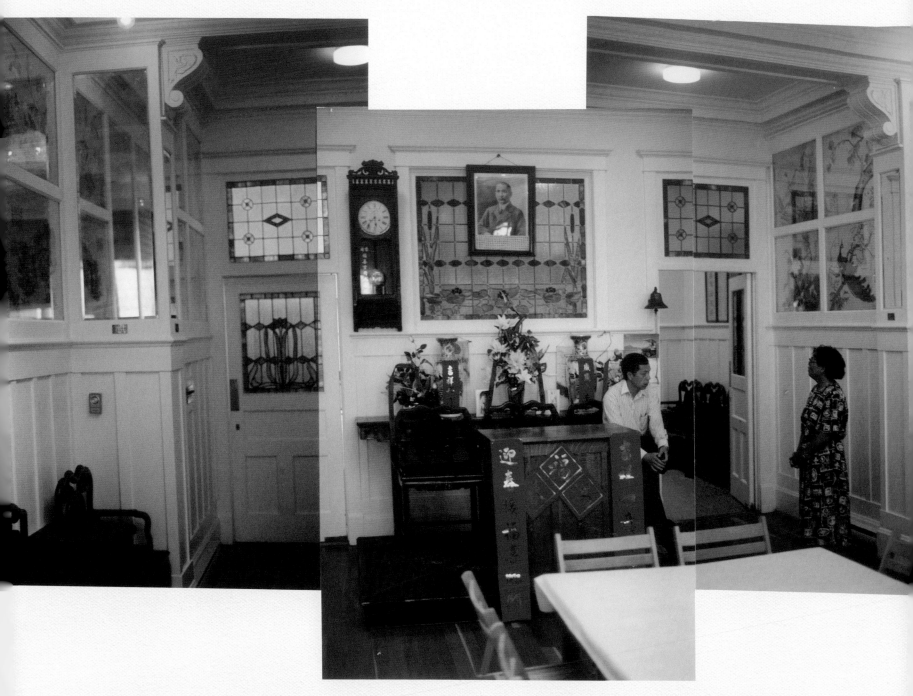

A modest altar table holds offerings in front of a portrait of Sun Yat-sen, who stayed here during a visit in 1911. The stained glass behind it has a design of bulrushes and water lilies.

在孫中山先生肖像前，一座莊重的神壇上供奉著獻品。孫先生於一九一一年到此訪問。後面的染色玻璃上有蘆葦和蓮花的圖案。

60

Calligraphy presented to the Hook Sin Tong by the Lung Kong Association at the opening of this building in 1911.

一九一一年福善堂現址開幕時，由龍岡公所贈送的書法。

Above the carved wooden altar table of the Hook Sin Tong is a portrait of Sun Yat-sen, himself a Zhongshan man. Sun, regarded as the father of modern China, visited this building in 1911. Beside Sun's photograph hangs a handsome old clock, presented to the Hook Sin Tong at the offical opening by the Zhongshan people of Vancouver. Elegant embroideries were given by Victoria well-wishers at that time, and two large calligraphy panels detail the early history of the organization. A huge mirror in a dark wooden frame blocks the view to the south, past the balcony and out over Herald Street.

In 1978 the building was extensively restored, the result of efforts by more than a hundred people. Among prominent members of the Hook Sin Tong are lawyer Ronald Lou Poy and Alan Lowe, former mayor of Victoria.

在福善堂大堂前的雕刻木壇上方，掛著同鄉孫中山先生的肖像。孫先生於一八九七年首次訪問維市，為推翻滿清，建立共和國的革命籌款。孫中山先生於一九一零及一九一一年再訪維市二次。他後來被尊稱為中國的國父。

在孫中山先生的肖像旁，掛著一口漂亮的古老大時鐘，是由溫哥華的中山同鄉在福善堂開幕時贈送的。牆上的刺繡也是開幕時的賀禮。兩邊牆上的八幅書法福善堂序記錄了該堂早期的歷史。一座巨大的黑木框鏡子擋在南面向著喜路街的陽臺。

在一九七八年，福善堂的建築物嚴重失修。當時發起了百子會籌款，由百人認捐股份而重建堂所。雷亮明律師、前維市市長劉志強等著名人士都是福善堂的會員。

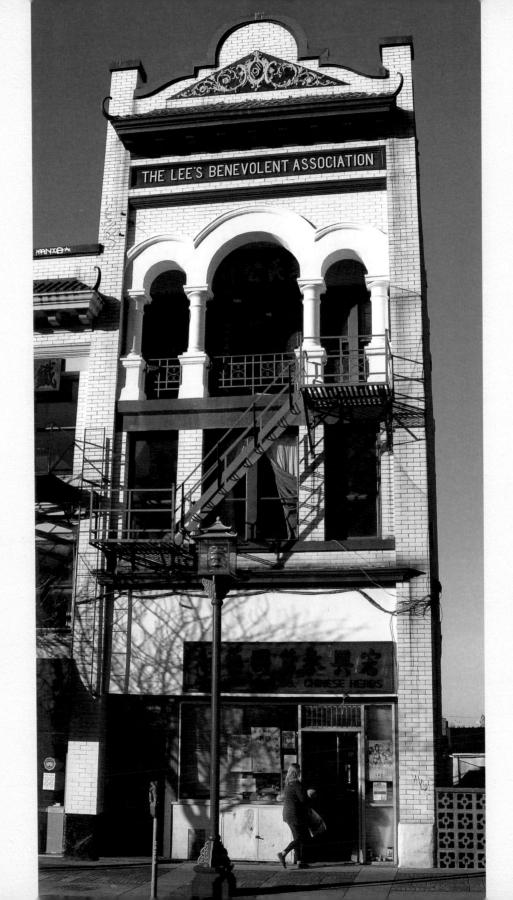

3 LEE ASSOCIATION
李氏公所

The Lee Association name sign, on the balcony facing Fisgard Street.

陽臺上的李氏公所牌匾,面向菲士格街。

The Lee Association building at 614 Fisgard Street is a classic of its type, designed in 1911 by C. Elwood Watkins. A shop occupies the street level; the Nationalist League formerly occupied the second floor. The meeting hall of the Lee Association, with its handsome recessed balcony, takes up the third floor. The top of the building is enhanced with an ornamental roofline and cornice.

李氏公所的會址在六一四菲士格街,是一座具古典獨特風格的建築物。由建築師艾活屈勤斯於一九一一年設計的。樓下有街鋪,二樓曾經是國民黨分部的會址。三樓全層是李氏公所的禮堂,面向街道設置有向內凹進的漂亮陽臺。建築物頂部有突出的飛簷裝飾。

President Gordon Lee and past president Jack Lee of the Lee Association.

李氏公所現任主席李國棟及前任主席李惠賢。

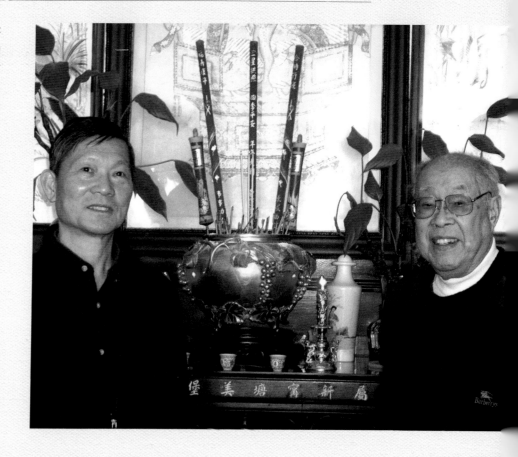

Every member of the Chinese community belongs to two associations: a family name group and a county group. The Lee Association is one of the oldest family associations in Victoria. The grand ancestor of the Lee family is Lao-tse, born in 604 BC and the founder of the philosophy called Taoism. There are Lees all over China, but most of the Lees who came to Victoria, beginning in the 1850s, came from the Pearl River delta in the southern province of Guangdong. Since then six or seven generations of Lees have made their home in Victoria.

李氏公所是維多利亞市最古老的姓氏堂所之一。在當時，幾乎所有的維市華人最少參加兩個堂所，一是其姓氏，二是其祖籍。

李氏公所的太始祖是老子。老子於公元前六零四年出生，他是道教思想的始創者。李姓是中國的大姓，全國各地都有姓李的，但維市李氏公所的同姓宗親大多數來自中國南方廣東省的珠江三角洲。自一八五零年代首批抵埠的李氏宗親計起，李氏公所的會員至今已經過了六、七代。

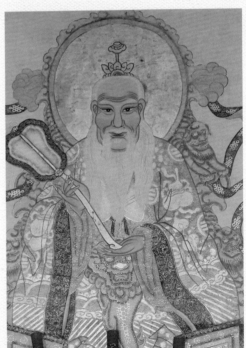

FAR LEFT Shrine and altar at the north end of the Lee Association rooms.

最左圖：設置於李氏公所內的神壇及神龕。

LEFT Painting of Lao-tse, Chinese philosopher and grand ancestor of the Lee family. Lao-tse, born in 604 BC, was the founder of Taoism.

左圖： 李氏公所太始祖老子畫像。老子於公元前六零四年出生，他是道教思想的始創者。

The first Lees came overland from the goldfields of California around 1858, to seek their fortune on the Fraser River. In 1859 the first Lee to arrive in Victoria, a merchant named Lee Chung, came by ship from California. As Victoria's population grew, the Lees combined their efforts to create a just society for their countrymen. By 1880 the Lee Association was well established, looking out for the welfare of its members. Six of the original members of the Lee Association were merchants and as was usual in traditional Chinese society, they took on the responsibility of caring for those less fortunate. They were leaders in the formation of the Chinese Consolidated Benevolent Association in 1884.

In 1911, a hundred members of the Lee Association contributed to the purchase of a piece of land on Fisgard Street, central to Chinatown, where they erected a handsome three-storey building. The first floor was a commercial rental, the second floor had offices and on the top floor was the meeting hall with a balcony. By 1916 the association was registered under the Societies Act. At the grand opening people named Lee from South China sent the handsome carved altar table which is still in use.

A painting of Lao-tse hangs over the altar. Lao-tse was a man, not a god, and thus this is a place for remembering his good example. Offerings to his memory are made in the form of flowers, fruit, incense and wine. The fine painting of Lao-tse is bordered by embroideries and calligraphy on silk.

Lee Tin Suk a merchant who immigrated to Victoria, was a founder of the Lee Association. This is an oil painting of him, painted on the inside of the glass.

李天實是位移民到維多利亞市的商人，他是李氏公所的創辦人之一。這是他的畫像，繪畫於玻璃內面。

首批李氏宗親於一八五八年經三藩市淘金區，抵達菲沙河域。商人李祥於一八五九年由加州坐船抵達維市，是首位到維市的李氏宗長。其後人口漸增，在當時缺乏法律保護，沒有公民權之環境下，李氏宗親團結起來，為宗族爭取權益。至一八八零年，李氏公所正式成立。李氏公所的六位創會創辦人均為商人。他們尊循中國社會的傳統，照顧那些際遇較他們差之人。該堂所不只為宗族謀福利，也為於一八八四年成立的中華會館鋪下創會之路。

一九一一年，李氏公所發起百子會籌款建築會址。百名會員合資在華埠中心購地興建了一座美侖美奐的三層高建築物。頂樓置有禮堂及面向街道的陽臺。至一九一六年，該堂所正式向政府註冊存案。開幕時，來自中國南方的維市李氏宗親送來精緻的雕刻神壇作賀禮。該神壇目前仍保存於禮堂內。

神壇上方掛著老子的畫像。老子是位真實的人物，並非菩薩。木壇上供奉著鮮花、水果、酒水及上香，讓後輩們向他致敬，及紀念這位傑出人物的好榜樣。牆上精美的老子畫像兩旁，附有絲綢刺繡的書法。

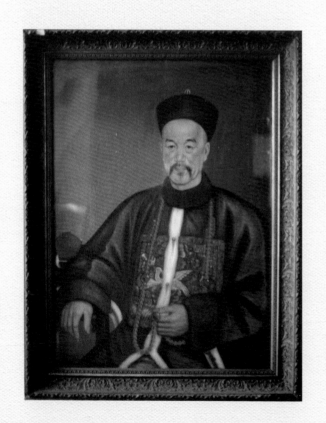

Every year the Lee family observes five major festivals. The most important is Lao-tse's birthday, celebrated according to the lunar calendar around February 15. July 5 is the time for dragon-boat racing; August 15 is marked by a "meet the autumn" festival; a summer picnic and a Christmas party round out the year's activities.

The Lee Association has about 300 dues-paying members who make this club their social meeting room. It's a homey place for playing table tennis, singing karaoke and having a friendly game of mahjong. The members often bring food to share. The Lees are proud of their record of community service and their scholarship program. This includes the Wah Hin Lee Memorial Scholarship provided by Wah Hin Lee's family for an outstanding student who is a member of the Lee Association. There are now Lee Associations in almost every city in the world; each is independent but they form a global network that welcomes other Lees.

目前李氏公所每年有五大活動。其中最隆重其事的是農曆二月十五的老子誕。另有農曆五月初五的端午節,農曆八月十五的中秋節,夏季郊遊野餐及聖誕節等。

李氏公所約有三百名會員。他們以會所為聯誼之所。經常舉辦的活動有乒乓球,卡啦OK及友誼麻將等。李氏宗親一向熱心僑社服務及下一代的教育,該會所為李氏子弟設立了獎學金。

目前幾乎世界各城市均有李氏公所或李氏宗親會,他們雖是各自為政的獨立會所,但之間也互相聯繫。與本華埠特輯中所報導的其它團體一樣,是屬於私人團體,並不對外開放。

Lee Mon Gow, first chairman of the board of the Chinese Public School and its principal for 11 years, was the unofficial Chinese consul and spokesman for Victoria's Chinese community.

李夢九 (一八六三 – 一九二四),維多利亞市華僑公立學校的首任校長,任校長之職九年。他是位 <非正式華人領事>,也是維市僑界的發言人。

Detail of a table that was presented to the Lee Association in its early days. This is one of three inlaid tables positioned under the main altar table. The mother of pearl was cut and engraved, and then inlaid in the dark wood.

這是李氏公所早年獲贈的三張鑲嵌木桌之一,現擺放於神壇下。製造鑲嵌木桌所用的珍珠母經切割及雕刻後,鑲嵌入深色木中拼合成各種圖案。

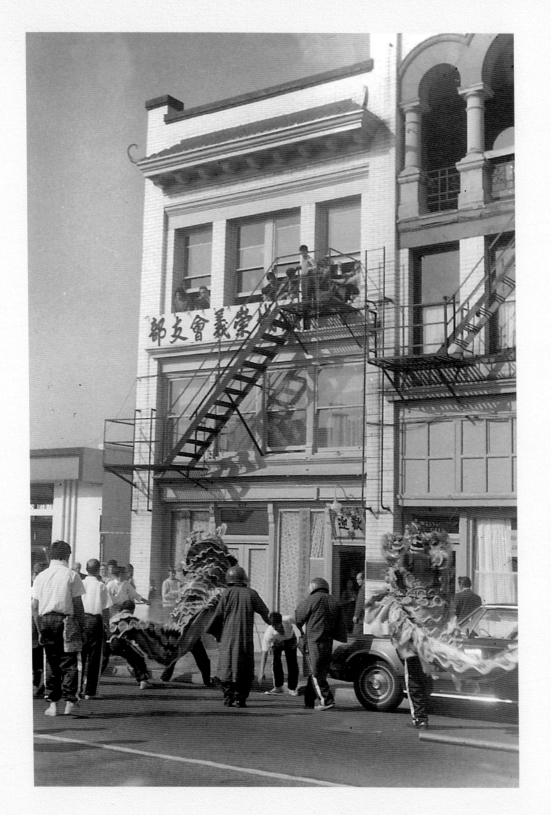

The Shon Yee Benevolent Association has its home in a building attached to the west side of the Lee Building. Built in 1912 at 612 Fisgard Street, it has been the association's home since 1935. This photo, from October 1971, shows lion dancers receiving donations from Shon Yee members looking down from the third floor.

維多利亞鐵城崇義支會的會址在菲士格街六一二號，整座建築物緊貼著李氏公所的西邊，建於一九一二年。鐵城崇義支會會址自一九三五年至今，一直設於該處。這幅攝於一九七一年十月份的相片，可見舞動著的瑞獅，正在"採青"，迎接崇義支會會員從三樓懸掛下來，俗稱 "掛青" 的吉祥賀金。

SHON YEE BENEVOLENT ASSOCIATION
鐵城崇義支會

The name plaque of the Shon Yee Benevolent Association is affixed to the front of the building.

鐵城崇義支會的新牌匾掛在
該會所建築物的前門。

The construction of the Canadian Pacific Railway during the 1880s required an enormous amount of manpower and among those who came to work on it were many men from Zhongshan County in Guangdong Province of South China. Some of them brought old rivalries from China, and conflicts arose. One group from Zhongshan formed the Hook Sin Tong, and others from Zhongshan, who were named Lee, gave their allegiance to the Lee Association.

Still others, who were not part of either the Hook Sin Tong or the Lee Association, formed the Shon Yee Association in Vancouver in 1914 to address social, legal and financial issues and to protect their basic rights. The disruption of wartime and an economic depression prevented the formation of the Victoria chapter until 1918.

在一八八零年代，加拿大建築太平洋鐵路，在勞工來源上的需求很大。其中有很多勞工是從中國南方廣東省中山區域來的。當時正值清末動亂時期，苛捐雜稅，民不潦生，往金山謀出路是貧窮鄉民的求生途徑。

這些來到加國的勞工，像奴隸般的工作，在艱苦處求生。在"金山"，勞工的生活環境簡陋儉苦，以求能早日償還從中國來的路費及加國政府徵收人頭稅的借款。在這段孤苦、受欺凌的淒慘歲月，這群來自中山區域的勞工，因需求而組成了鐵城崇義支會。

作為鐵城崇義會會員，這些年青人找到了可交往的朋友也受了到保護。他們在多方面互助守望。話雖如此，在這些中山同鄉中也相應而產生了競爭和磨擦。有很多從中山來的同鄉，組織了中山福善堂。也有李姓的中山同鄉加入了李氏公所。非李姓的中山同鄉約於一九一四年成立了鐵城崇義會。以維護中山同鄉的法定權利，社交，財政事務及保障中山同鄉的基本權益。鐵城崇義會最初是在溫哥華成立的。由於戰時及經濟蕭條的影響，維多利亞市的鐵城崇義支會直至一九一八年才成立。至一九二三年，卡加利也成立了支會。

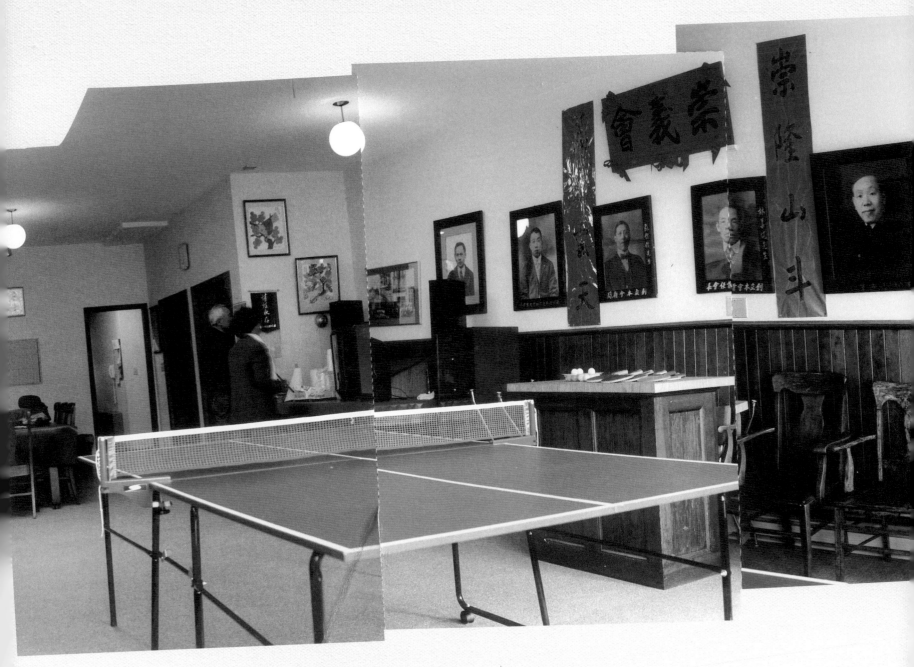

There is no particular altar or shrine in the Shon Yee rooms, though a raised table is placed in front of the pictures of some notable members below the club's name sign. On this table paddles and balls stand ready for a game of table tennis.

鐵城崇義支會的禮堂沒有特定而設的神壇或神龕。禮堂內掛著牌區的牆上貼滿重要會員的活動相片。一張擺放著球拍和乒乓球的大桌子，讓會員可隨時來場乒乓球比賽。

The Shon Yee Benevolent Association provides strength in numbers. Donations and investments in real estate have, over the years, generated funds for emergency relief, housing for seniors and recreation and encouragement for young people.

The association comes together for a business and planning meeting on the first Sunday of every month but the clubroom itself is in use almost every day and pride of place is given to table tennis. Shon Yee is proud of its 30-year-old athletic division, which encourages sports and martial arts. Members also come to the club to enjoy lion dancing, kung fu practice and Chinese traditional opera. The Victoria club is known particularly for its willing support of the Chinese Consolidated Benevolent Association, and often entertains visiting government officials from China.

Along the side wall above the karaoke machine hang photographs of the founders. There are also photographs of two young men who were killed by a rival group in 1925, to remind members of the reasons for the founding of this association. Two paintings by a more recent member, Wing Lim, grace a wall nearby.

鐵城崇義會發展迅速，多年來的捐款及地產投資為會所累積了緊急基金，以作耆英會員的住宿補助，及年青會員的康樂和獎勵計劃等。

鐵城崇義會在每月的首個星期日舉行聚會，商討會務及計劃。會所禮堂幾乎每天都有活動，一張乒乓球桌佔用了禮堂的大部份空間。鐵城崇義會積極推廣體育及武術活動，對其已有三十年歷史的體育部引已為傲。 會員到會所練習舞獅，武術及練唱傳統粵曲。鐵城崇義會維多利亞支會一向支持中華會館的活動，經常參與招待中國來的政府訪問團。

在會所禮堂的卡拉OK唱機上方，掛著創會者肖像。亦掛著在一九二五年，為維護會所權益而與競爭者發生衝突，不幸遇難的殉難者肖像，以紀念這些為會所捐軀殞首的同鄉先僑，也讓會員勿忘創會的宗旨。禮堂中亦掛了較近代的已故元老會員林福榮的二幅工筆國畫，滿壁生輝。

Ken Chee is the past president of the Shon Yee association.

鐵城崇義支會前任主席徐 鈞

Ng Ming Hor and Lum Tai Gok were murdered by rivals from Zhongshan in a shingle mill in Port Moody in 1925 and are commemorated by their fellow members of Shon Yee.

殉難者吳銘賀和林太谷的遺像。兩位年青會員於一九二五年在末地港為會所權益而獻出生命,被來自中山地區的對敵所殺。他倆獲崇義會會員們永遠銘記。

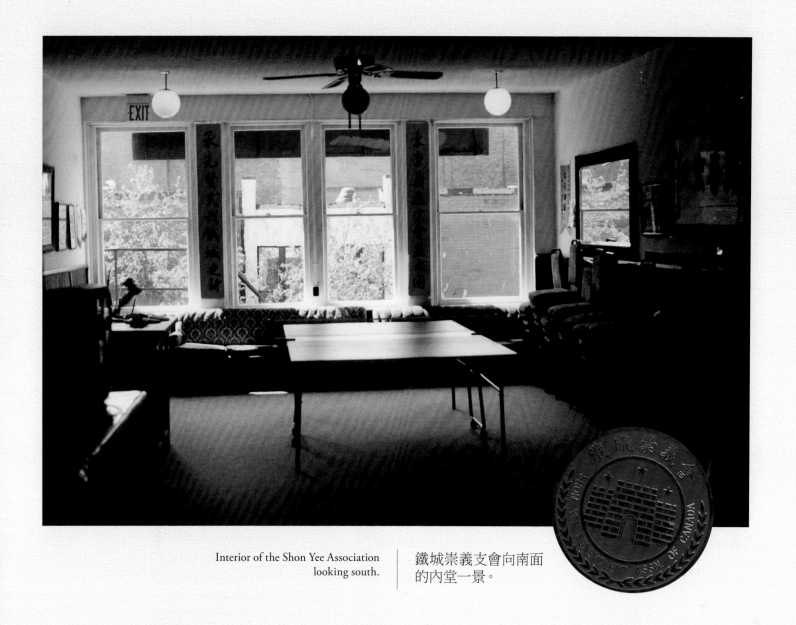

Interior of the Shon Yee Association
looking south.

鐵城崇義支會向南面
的內堂一景。

The front door of the club at
553½ Fisgard Street.

禹山分所正門，地址是菲士格
街五五三又二分之一號。

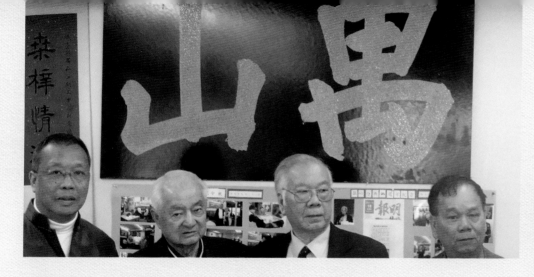

Four men who have served as president of the Yue Shan Society, standing before their club's name signboard. From left, they are Joseph Leung, John Joe, Tim Choo and Stan Chu.

相片中四位男士為現任及前任主席，由左至右：梁肇成、周伯昌、周貴剛及徐錫河。

5 YUE SHAN SOCIETY
禺山分所

The Yue Shan Society was formed by men from the Yue Shan district of Panyu County near the city of Guangchou in South China. In the 1850s men from Yue Shan first trekked north from the California goldfields to seek their fortune on the Fraser River. More men came later to work in the forest, in the coal mines of Nanaimo and on the construction of the Canadian Pacific Railway. In 1885 the society was among the founders of Victoria's Chinese Consolidated Benevolent Association.

In the early days illiterate labourers would come to town from their work sites just once or twice a year. Certain Chinese shops, where mail, banking, letter-writing and translation services were available, became their depots; through them, the men could maintain communications with China.

The Yue Shan Society operated at first from a storefront on Government Street. Since 1961 members have enjoyed socializing in the modest second-storey rooms they rent at 553½ Fisgard Street. Everyone is welcome to join in the activities at this "free organization." Each day of the week, from 7:00 A.M. until after midnight, games of mahjong and dominoes go on, while Chinese television and newspapers are available. This club is the only place in town to offer Chinese chess.

禺山分所是維市最古老的僑團之一。該會所是由一些來自中國南方廣東省番禺地區的鄉親所創立的。在一八五零年代，這些人從三藩市淘金區經維市前往菲沙河域尋找運氣。更多勞工到此往森林區伐木、到乃磨市的煤礦挖煤，或建築加拿大太平洋鐵路。在一八八四年，中華會館成立時，創辦人中也有禺山分所的鄉親在內。

在早期，目不識丁的勞工，每年只到市區一至兩次。某些華人商店便成為這些勞工的郵件傳遞站，使這些勞工能獲得郵件傳遞、銀行業務、代寫書信及傳譯等服務。

禺山分所最初設址於華埠加富門街某鋪位，自一九六一年起，鄉里們相聚於菲士格街五五三又二分之一號，即現址二樓舒適樸素的單位。該會所每週七天，每天由早上七時至午夜開放，歡迎各界僑胞到會所參與麻將、中國象棋等娛樂消遣；亦可在客廳的一角靜靜地欣賞中文電視節目或閱讀中文報章。禺山分所是華埠中唯一設有中國象棋的會所。

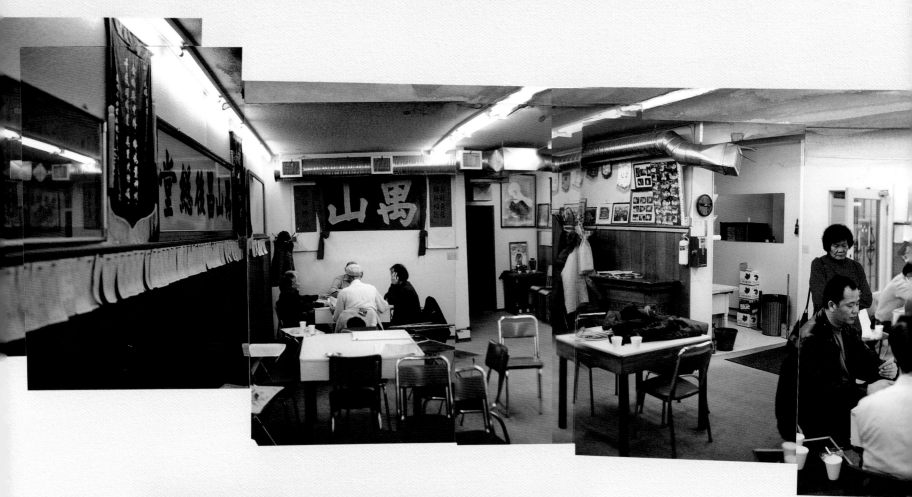

ABOVE A panorama of the club's meeting room, showing members enjoying games, coffee, conversation and television at 10:00 A.M. on a weekday morning.

禺山分所禮堂全景。從相片可見在平日的早上十時，會員們已在搓麻將，品嘗咖啡，閒談或看電視。

LEFT The full name of the club, Yue Shan Cheung Hao Tong, is painted on a framed glass panel. It hangs above a row of receipts for donations made to the society.

禺山昌後堂的牌匾掛在一排列的捐款收據上方。該牌匾是寫在鑲有鏡框的玻璃上。

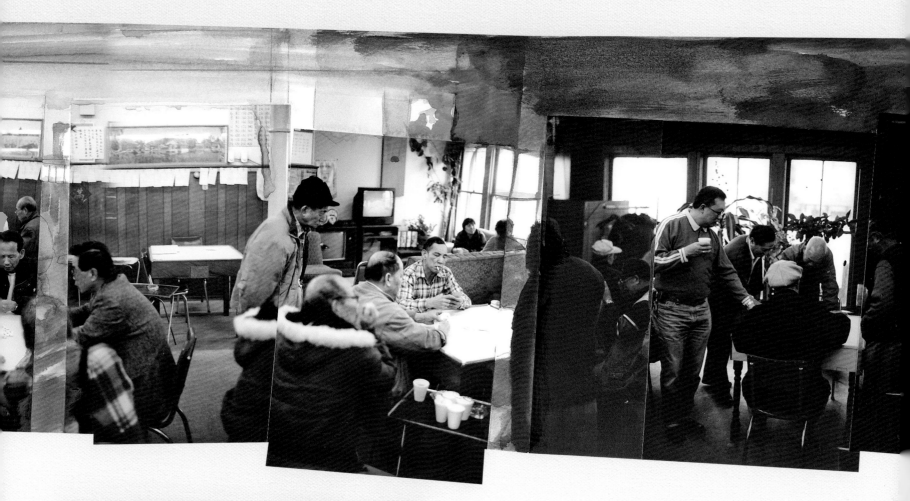

Members enjoy a game of Chinese chess.
鄉親們正在聚精會神地對奕中國象棋。

LEFT A painting of Kwan Yin.

左圖：觀音菩薩神像掛圖

RIGHT A small altar in a back corner
of the club holds simple offerings
beneath a painting of Kwan Yin,
the goddess of mercy.

右圖：大慈大悲觀音菩薩神像掛
圖下設有小神龕，並供奉獻品。

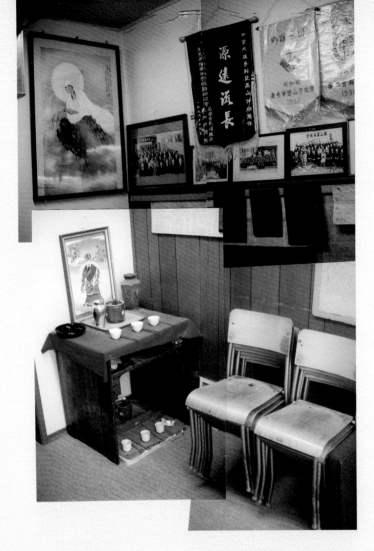

Yue Shan members pay respect to their ancestors at the Harling Point Chinese Cemetery during the Qing Ming festival in early April and again on September 9. They also get together for the Yu Len Festival (festival of gods and devils) on July 14 each year and celebrate the Moon Festival on August 15.

Unlike many of the other groups, the Yue Shan Society, with 100 current members, does not own any buildings. In early times the society built and maintained the storehouse at the Chinese Cemetery at Harling Point, where the bones and ashes of Chinese men who had died in Canada were stored. These remains were kept in wooden boxes, awaiting return to their ancestral homes. The practice was discontinued in 1936, and the building no longer exists.

禺山分所鄉親每年的定期活動包括清明春祭、及農曆九月初九的重陽節，前往哈寧角華人墳場拜祭先僑。也在農曆七月十四日盂蘭節拜祭鬼神，及在農曆八月十五日慶祝中秋節。

與埠中其他僑團稍有不同的是，目前約有一百名會員的禺山分所本身並沒有產業。日常活動的經費來源主要來自會員。早期，禺山分所在哈寧角華人墳場內築有小屋，為葬於該處的先僑執拾骸骨或骨灰，置於木盒中，以便定期運送回家鄉安葬。此運作已於一九三六年停辦，該墳場小屋現也已不存在。哈寧角華人墳場則已被列為國家傳統保留區。

6 SAM YAP SOCIETY
三邑同鄉會

The Sam Yap Society is a smaller group whose activities are administered by the Yue Shan Society. It is composed of people with roots in any of three neighbouring counties in South China—Panyu, Nanhai and Shunde—who speak a common dialect.

三邑同鄉會是禺山分所屬下的一個兄弟機構，由禺山分所管轄。來自三邑的鄉親，其祖籍包括中國南方廣東省的番禺、南海及順德。三邑人士說同一種方言。

LEFT This carved wooden plaque shows that the meeting hall is also the headquarters of the Sam Yap Society.

三邑同鄉會的木刻牌匾。該會所與禺山分所共用同一禮堂。

BELOW A member enjoys the Chinese-language television channel.

三邑同鄉會鄉親正在觀看中文電視節目。

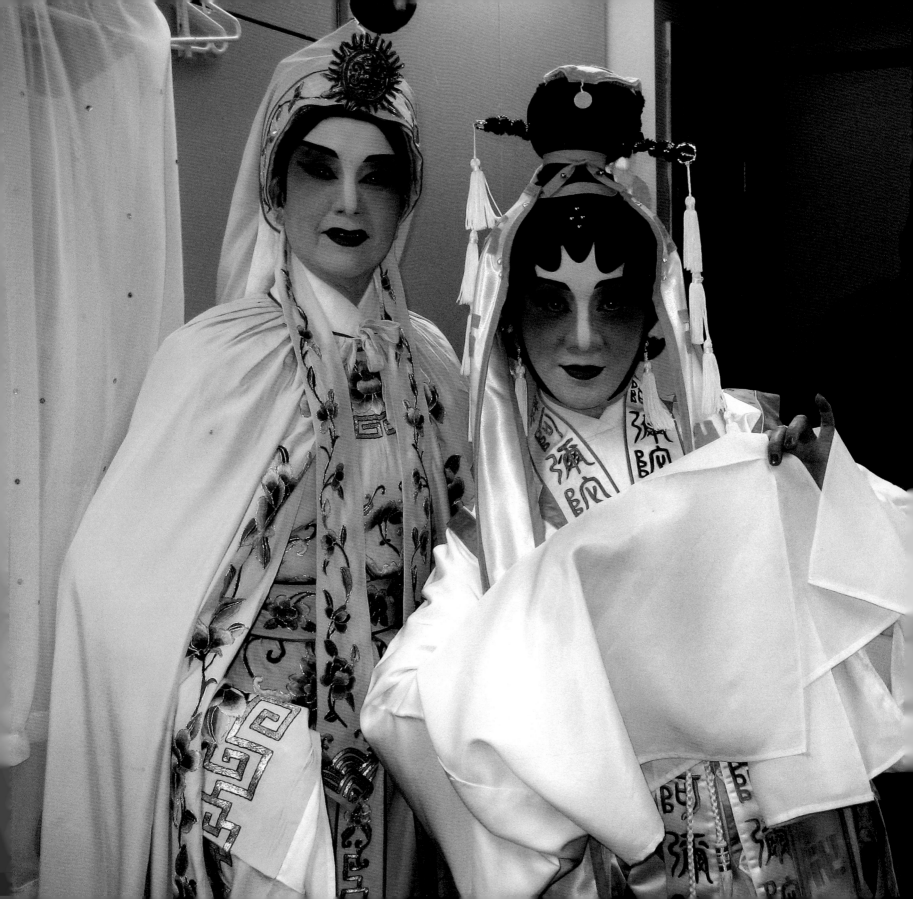

7 GUM SING MUSICAL SOCIETY
金聲音樂社

The name of the Gum Sing Musical Society is picked out in gold leaf on red velvet on their festive banner.

金聲音樂社在節慶用的橫匾，是一幅精緻的紅底鑲金字天鵝絨。

Gum Sing means "golden voice" in Cantonese. The society was formed in 1980 under the direction of Leung Kwong Yip, a professional musician from China who continues as its musical director. Every Saturday night, members get together in their comfortable second-floor meeting room to rehearse vocal and instrumental performances of the traditional operas of South China. The singers usually prepare arias, working toward Gum Sing's annual gala performance. During the 30 years the society has operated, more than 10 short operas have been presented, complete with elaborate costumes. The makeup alone can take each artist as long as three hours to put on. Recently, a collection of splendid Chinese opera costumes was given to Gum Sing, the gift of a woman known as a "living legend" of Cantonese opera.

若您在星期六晚上經過華埠金聲音樂社樓下，必定會被從二樓傳來的悠揚音樂及歌聲吸引。金聲的意思是金嗓子。金聲音樂社由來自中國的專業音樂手梁廣業於一九八零年創立。他目前仍是該社的領導人。

社員每週一次在該社舒適的禮堂中聚會，練習奏樂及練唱粵曲。粵曲是中國南方的傳統戲曲。社員通常預先練習一小段戲曲或折子戲，以備週年社慶紀念時演出。約三十年來，該社演出的折子戲已超過了十齣。表演折子戲的主角會穿上傳統戲服及化上傳統的粧，這個傳統的化粧約需三小時才能完成。年前，該社獲贈一批粵劇名伶「國寶」紅線女之女兒紅虹曾用過的華麗戲服，全社上下如獲至寶，珍而藏之。

LEFT Gum Sing members Margaret Koh (left) and Frances Leung (right) prepare for an opera performance in costumes recently donated to the society.

金聲音樂社會員高嘉文與勞家儀在粵劇折子戲帝女花之"庵遇"中的造型

RIGHT Leung Kwong Yip is the founder of the Gum Sing Musical Society, and plays the erhu.

金聲音樂社創辦人梁廣業，他奏的樂器是二胡。

Gum Sing's bandstand is fronted by a small dance floor and seating for an audience of about 30. To one side is an anteroom with a few comfortable chairs and the music library.

金聲音樂社的會員每逢週六晚上齊聚於該社舒適的練習廳中練習。
演奏臺前的舞蹈地板上設置了小型的觀眾席，約可容納三十名觀眾。
廳中的一邊擺放著數張舒適的椅子，及設置有音樂資料收藏庫。

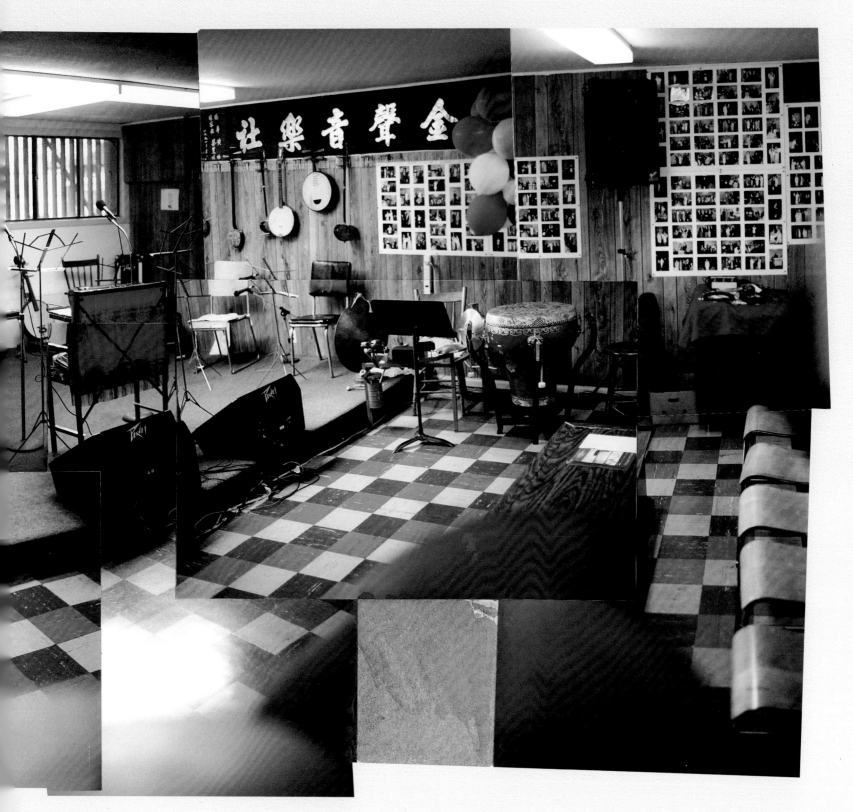

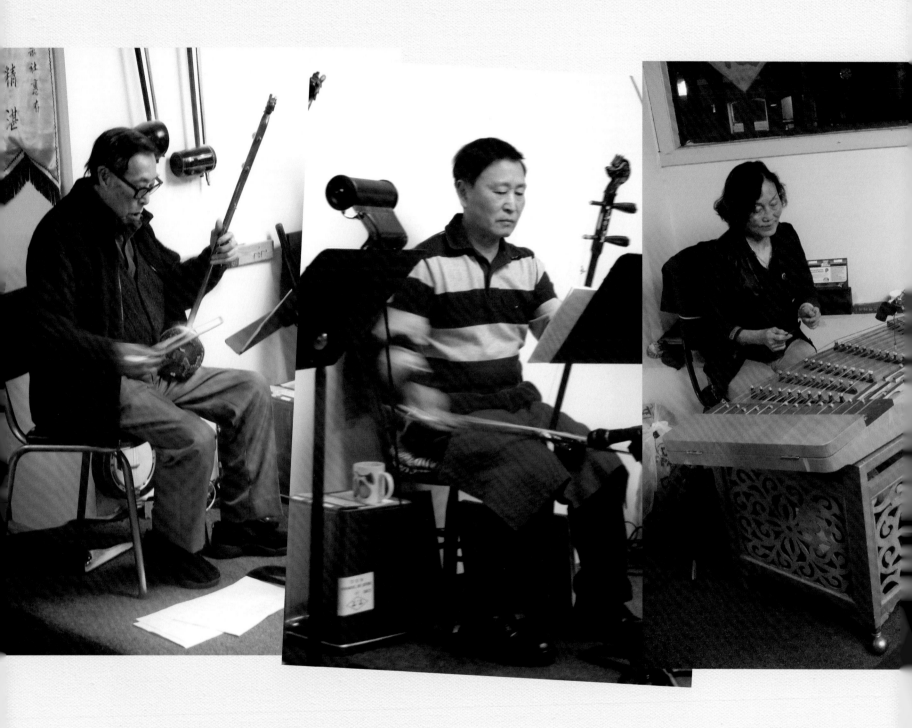

FROM LEFT TO RIGHT Leong Kwong Yip, erhu; Benny Low, erhu;
Betty Lee, butterfly harp; Henry Low, yuen.

由左至右：梁廣業_二胡，劉衍雄_二胡，李碧兒_洋琴，
劉鴻就_大阮。

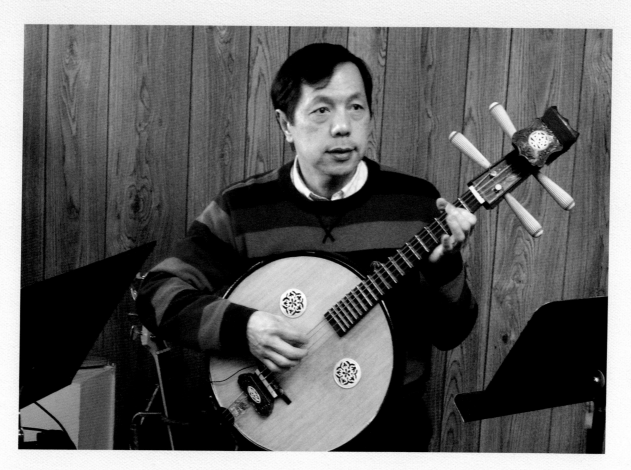

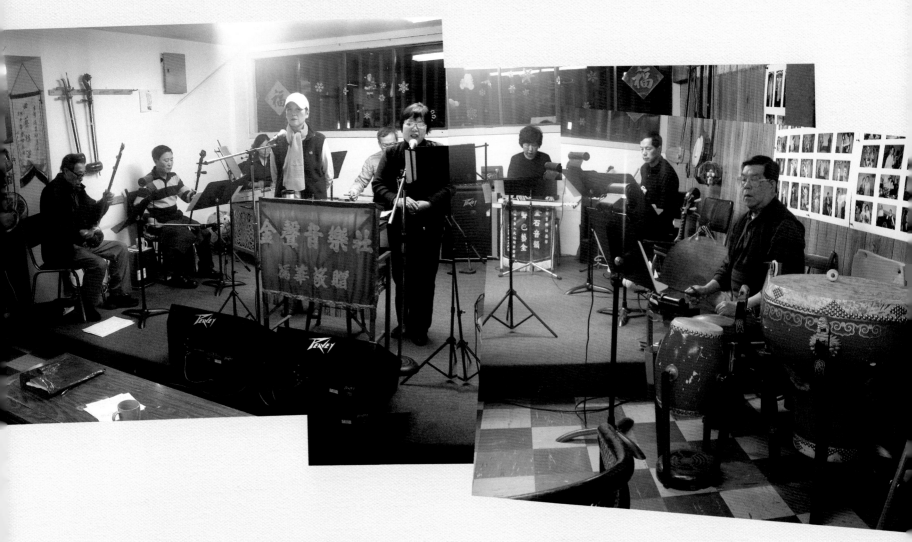

A Saturday night rehearsal, with orchestra and soloists on stage. Margaret Koh (left) takes the lower voice part, with Linda Shew (right) singing the higher range. Drums, gongs and wooden blocks make up the percussion ensemble played by Mel Jung.

這是在某個週六晚上的彩排。樂師和演唱者均在演奏臺上。由鄭務本主掌的敲擊樂掌板部有風鑼，各種鼓類及木魚等。

The Gum Sing orchestra features a variety of instruments, including different sizes of *erhu*, the two-stringed "Chinese violin" with a snakeskin head. The many-stringed butterfly harp is played with two flexible bamboo mallets, hammered like a zither. The four-stringed *yuen* has a big round moon shape and contributes the bass line. Electric bass guitar and Hawaiian guitar are also included. An elaborate percussion ensemble of blocks, sticks and hide-covered drums adds rhythm and colour. Each song concludes with a impressive note played on the big brass gong.

Vancouver, with a population of 400,000 Chinese, has 20 to 30 musical societies that keep alive the opera traditions of China. Victoria has a much smaller Chinese population, but the 20 members of the Gum Sing Musical Society can be proud of their achievements. They work hard to bring Cantonese opera to Canada's diverse cultural mosaic. Gum Sing members present concerts all over Vancouver Island and in Vancouver, enabling everyone to share in the pleasures of the music of South China.

金聲音樂社置有秦琴、二胡、高胡、大阮、洋琴等各種管弦樂器。二胡有二條弦，樂器基部用蛇皮包著，又稱中國小提琴。多弦的洋琴是用兩條有彈性的小竹棒敲出曲調。琴身像圓月的低音大阮有四弦。另有低音電結他和中音夏威夷結他。敲擊樂掌板部有沙鼓、雙皮鼓、戰鼓、大鼓、角魚、木魚、京鈸、文鑼、京鑼等，為曲調添增節奏及色彩。當然，每首曲更少不了令人振撼的風鑼聲。

在有四十萬華人的溫哥華，可容納二、三十個類似的音樂社存在，使中國的傳統戲劇可繼續流傳下去。在華人社區細小的維多利亞市，共約二十名社員的金聲音樂社社員們，為他們的成就而引以為傲。他們為推廣粵曲粵劇而付出努力，經常往溫哥華島各地，甚至溫哥華演出，與這個多元文化的加國社區分享源自中國南方的美妙曲調。

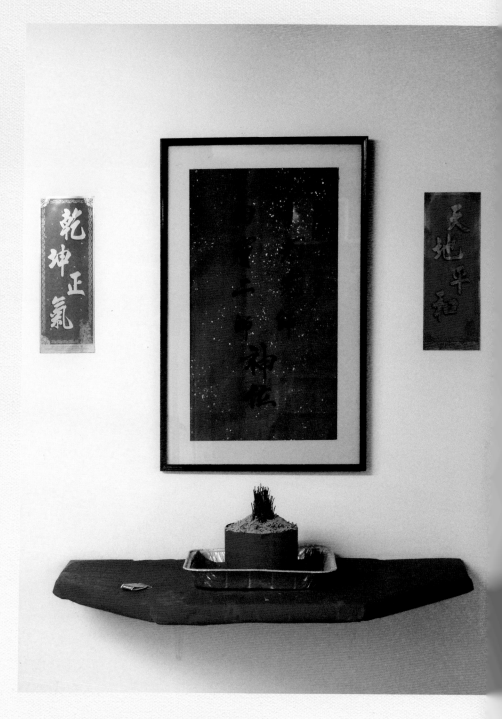

A small shelf holds incense. This is a simple altar for offerings to ensure the success of this musical group's activities.

小木架上設置神壇，以供奉香火，為音樂社的活動祈福。

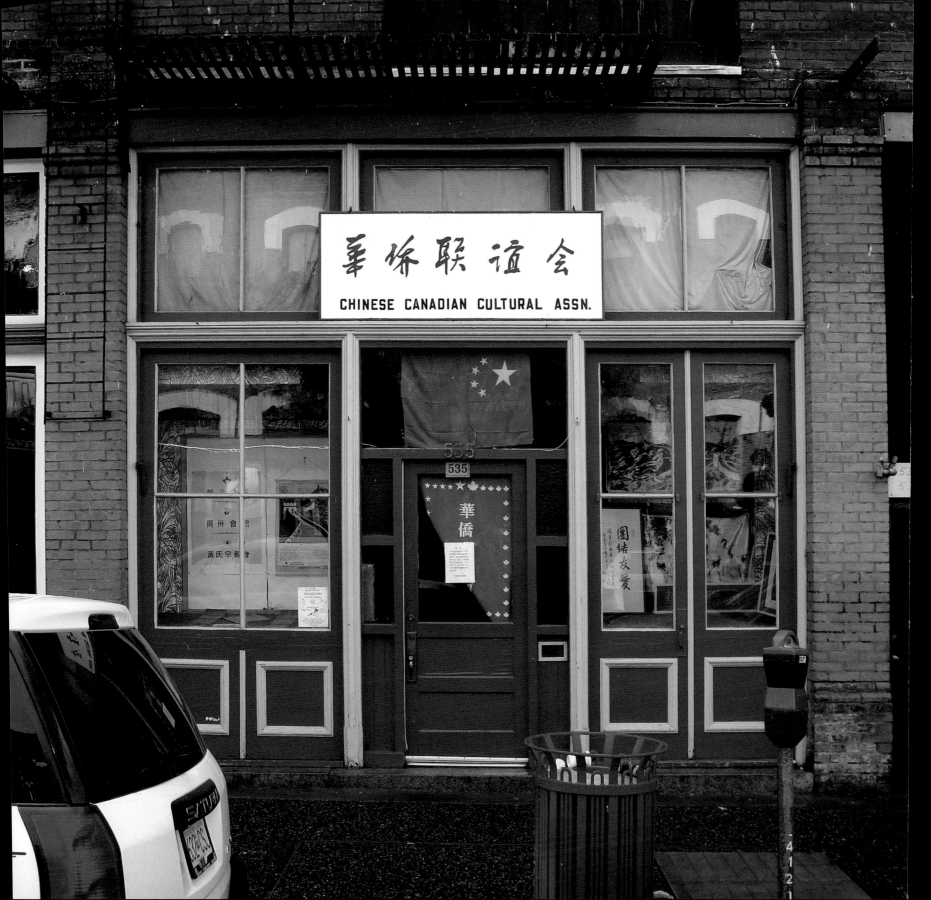

華僑聯誼會

CHINESE CANADIAN CULTURAL ASSN.

8 CHINESE CANADIAN CULTURAL ASSOCIATION
華僑聯誼會

The official sign of the CCCA.
華僑聯誼會的牌匾

The Chinese Canadian Cultural Association (formerly known as the Chinese Canadian Friendship Society) has its headquarters at 535 Fisgard Street. Started in 1971, the CCCA was intended to help new immigrants from China adapt to life in Canada. The founders were Fred Choo, G. K. Chow and Tommy Ma.

華僑聯誼會成立於一九七一年，會址設於五三五菲士格街的地下。該會的英文會名中曾含有"友誼"二字，但中文會名則一直沿用華僑聯誼會而沒改變。該會成立的宗旨是協助由中國來的新移民儘快融入加國社區的生活方式。華僑聯誼會的創辦人是周朝公、周貴剛、及馬今衛等。

PREVIOUS PAGE The Chinese Canadian Cultural Association at 535 Fisgard Street. Built in 1901, it originally featured a balcony opening from the front of the second storey .

華僑聯誼會的會址在五三五菲士格街。該建築物建於一九零一年，建築物的二樓最初是設有露台的。

LEFT Frank Wong, president of the CCCA.

華僑聯誼會主席黃幸逢

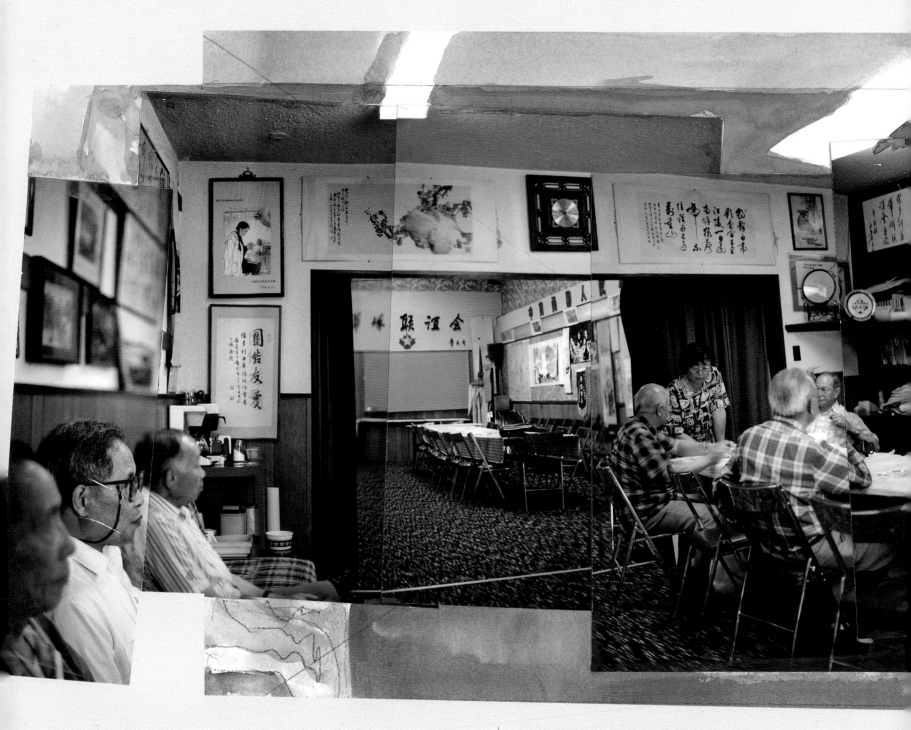

Members enjoy coffee, newspapers and conversation every morning.

華僑聯誼會內，會員們每天大清早共聚一堂，品嘗咖啡、閱讀中文報章、及閒話家常，樂也融融。

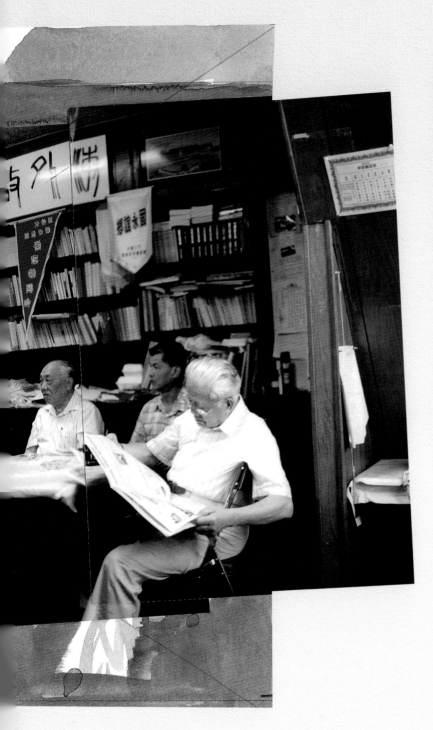

Since its inception, the CCCA has maintained close connections with the consul of the People's Republic of China in Vancouver. Together, they arrange visas for travel to China and organize payments to Chinese pensioners living in Canada. The association is proud to have been the first in Victoria to raise the "five star flag" of the People's Republic of China.

The CCCA often acts as host to official government visitors from China and offers help and hospitality to crews from Chinese cargo vessels that stop in the port of Victoria. The club celebrates the Chinese New Year, and on October 1 they make China's National Day a special occasion.

Three other groups call this club their home: the Hoy Ping, Wong and Kong Chow associations.

華僑聯誼會自成立至今，一直與中華人民共和國駐溫哥華總領事館保持緊密的聯繫。該會的工作包括協助總領事館代旅客申請中國簽証，亦經常協助在加國的耆英，安排領取其在中國的退休金。華僑聯誼會是維市首個懸掛中華人民共和國「五星旗」的僑團，該會對此感到非常自豪。

多年來，華僑聯誼會一直接待來自中國政府的官員，亦接待在此泊岸的中國貨船船員。該會每年均舉辦一年一度的春節聯歡會及十月一日的中華人民共和國國慶慶祝會。

開平會館、岡州會館、及黃氏宗親會等三個華埠僑團，亦將其會址設於華僑聯誼會。

9 HOY PING ASSOCIATION

The association for people from Hoy Ping County in South China was one of the founding groups of the Chinese Consolidated Benevolent Association. Later, Hoy Ping came to boast more than a thousand members. However, as the years passed and life in Victoria changed, many Chinese immigrants became too busy for non-profit organizations, and the Hoy Ping Association disappeared from Victoria.

However, the association had not vanished altogether. The Canadian headquarters is in Vancouver and there are branches in every province. In 2006, the Hoy Ping Association was reformed in Victoria and it now has 90 active members.

People from Hoy Ping take pride in their community involvement; two current members of BC's Legislative Assembly, Ida Chong and Jenny Kwan, are Hoy Ping members.

10 WONG ASSOCIATION

The Wong Association was founded to bring together people of that name. An older organization of the same name was discontinued many years ago and the current Wong Association was formed in Victoria in 1978. The initiative for this new group came from Master Sheung Wong, founder of the Sheung Wong Kung-fu Club.

LEFT The official sign of the Hoy Ping Association.
開平會館牌匾

MIDDLE The official sign of the Wong and the Kong Chow associations.
黃氏宗親會及岡州會館牌匾

RIGHT A statue of Chairman Mao Zedong indicates the association's affiliation with the People's Republic of China.
華僑聯誼會內擺放著毛澤東塑像，可見該會與中華人民共和國之間的淵源。

9 開平會館

開平會館在維市華埠歷史悠久，早期同鄉眾多，人數最高時逾千人。當中華會館於一八八四年成立時，其創會會員中亦有開平鄉里在內。近數十年來華裔生活環境日趨改善，不須再為生存而掙扎，華裔移民開始投入各種非牟利組職，而維市開平會館亦基於不明的原因，漸漸煙消雲散。

然而，開平會館并沒有完全消失，其總會館一直設立於溫哥華，全加國各省均有開平會館。維市開平會館亦於在二零零六年重組，目前該會有會員共約九十人。

開平鄉里熱心參與社區活動。目前，卑詩省省議員張杏芳、關慧貞等，均為開平宗親。

10 黃氏宗親會

黃氏宗親會成立的宗旨是團結黃姓宗親。維市華埠在早期已有黃氏宗親會，多年後逐漸失了聯繫，至一九七八年由已故的黃相師父重新聯絡黃氏宗親而重組黃氏宗親會。黃相師父也是黃相健身會的創辦人。

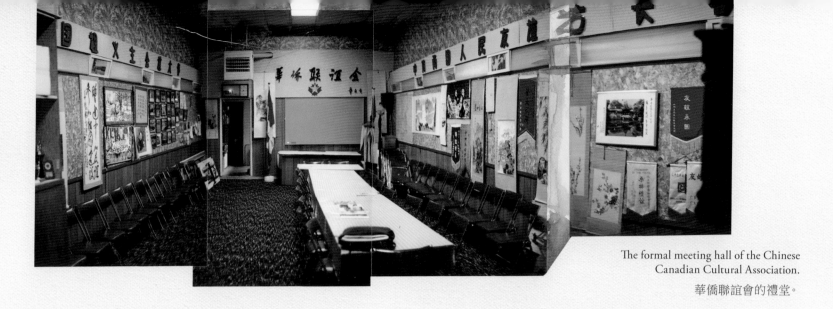

The formal meeting hall of the Chinese Canadian Cultural Association.

華僑聯誼會的禮堂。

The Wong Association hosts a New Year's banquet annually, and also celebrates the Qing Ming Festival each spring at the cemeteries at Harling Point and Royal Oak. During Qing Ming, members gather at a stone memorial in the lawn that commemorates all those ancestors named Wong. Offerings of roast pork, cooked chicken, flowers and incense are made in memory of their forefathers and the celebrants then retire to a local restaurant for a convivial meal.

🔢 KONG CHOW ASSOCIATION

The Kong Chow Association was created to unite those with roots in the village of Kong Chow in Guangdong Province of South China. The group was first formed in 1915, but eventually dissolved. It was refounded in 1977 in response to the growth of its sister organization in Vancouver.

This small group meets with the Hoy Ping, Wong and Chinese Canadian Cultural associations at 535 Fisgard Street most mornings. They get together to make plans for the Chinese New Year and the Qing Ming Festival. The Kong Chow Association also observes the Fall Festival each year on September 9, attending to the commemorative tablets that honour their ancestors.

Among well-known members is Frank Wong, who has been president of a number of CCBA clubs and has worked as a chef in Chinatown his whole life.

黃氏宗親會每年舉辦春宴、清明春祭等活動。春祭包括往哈寧角華人墳場及來路屋墳場。兩處墳場均置有黃氏先僑的紀念碑。春祭祭品包括燒豬、煮熟的有頭雞、包點、鮮花及點奉香燭以紀念先僑。春祭後各人同往華埠的餐館午餐，共聚一堂。

🔢 岡州會館

岡州會館會員的祖籍是來自中國南方廣東省的岡州地區。該會於一九一五年成立，後會員間失了聯繫，至一九七七年再重組。該會與溫哥華岡州會館互相聯繫。

岡州會館、開平會館、黃氏宗親會及華僑聯誼會的會員通常在早上聚會，討論慶祝中國新年或清明春祭等事宜及閒話家常。岡州會館在農曆九月九日重陽節時也舉行秋祭。

黃幸逢是僑界中大家所熟知的僑領。他是中華會館屬下多個僑團的主席。目前是黃氏宗親會及華僑聯誼會的主席，也曾任岡州會館主席多年。他退休前在華埠擔任廚師。

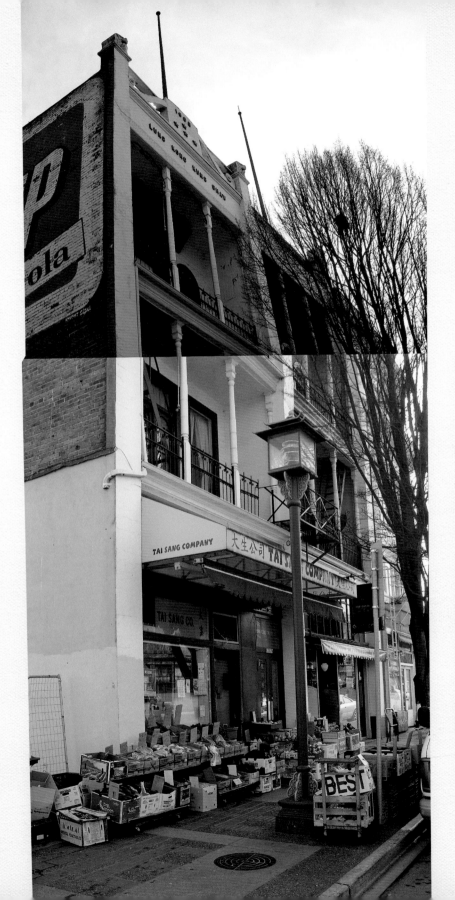

LEFT Recessed balconies and an ornamental cornice grace the building of the Lung Kong Association at 1717½ Government Street. It was built in 1905 for the Chinese Empire Reform Asociation, which disbanded in 1911.

向內凹進的陽臺，及頂部突出的飛簷裝飾，使這座位於加富門街一七一七又二分之一號的建築物更具魅力。該建築物建於一九零五年，為清末保皇黨組織所擁有。該組織已於一九一一年解散。

BELOW John Cheung, past president of the Lung Kong Association.

龍岡總公所的前任主席張傑強

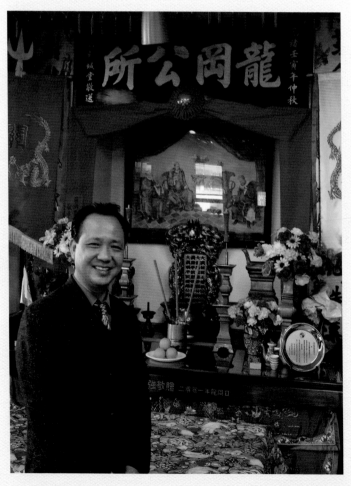

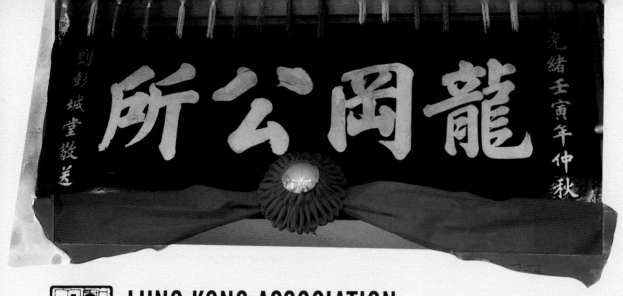

12 LUNG KONG ASSOCIATION
龍岡總公所

The Lung Kong Association in Victoria is the Canadian headquarters for a worldwide network of people who share four surnames: Lau, Kwan, Cheung and Chiu. As their legend explains, during the Three Kingdoms period four men from different places met in a peach grove and vowed to act as brothers "to unite our hearts and strength, to help each other in danger, to serve the country as well as to save the people."

The Lung Kong Ancient Temple was established in the city of Hoiping in South China's Guangdong Province in about 1661. There are now four million people worldwide who share this allegiance, and they hold a global conference every four years.

Locally, the Lung Kong Association was formed in 1902. In 1912 they were able to buy the northern half of what had been the Chinese Empire Reform Association building. At the time, the CERA's goals had been achieved and it disbanded. The Lung Kong Association set up their meeting hall on the top floor, which is fronted by an open balcony.

龍岡是劉、關、張、趙四姓宗親的組織,是屬於世界性的。維市的龍岡親義總公所是全加拿大龍岡組織的總部。據說在三國時期(公元二二零年至二八零年),漢昭烈帝劉備、漢壽亭侯關羽、桓侯張飛等三位不同姓氏的英雄好漢,在桃園結義,成為異姓兄弟。後順平侯趙雲與他們在古城相會,結成四姓兄弟。他們本著團結互助,匡世救民,力扶漢室精神,四姓聯宗。

位於中國南方廣東省開平縣的龍岡古廟,約建於一六六一年。目前全世界約有四百萬名龍岡宗親,他們每四年舉辦一次世界懇親大會。

維市的龍岡總公所成立於一九零二年。至一九一二年,買下清末保皇黨組織北面的半邊樓宇作為堂所。當時,保皇黨組織在目的已達後解散。該址有三層高,禮堂設在頂樓,前有面向街道的陽臺。

Every year, club members celebrate Lung Kong Day on April 4. There is a ceremony at the altar table in front of a picture of the four founders to reinforce the purpose of the organization: friendship and support. Members of the sister association in Vancouver come over and the day culminates in a banquet for as many as 300 people. It's a time for karaoke, prize draws and much "brother and sister mingling."

At appropriate times during the year, the birthdays of the four founding "brothers" are also commemorated. Members reflect upon the teachings of the ancestors and the virtues of loyalty, righteousness, kindness and courage.

As well as paying reverence to those eternal verities, there is a strong desire to teach children how the relationship established by the four "brothers" has been maintained from generation to generation. While former mayor Alan Lowe's county association is the Hook Sin Tong, he is also a member of the Lung Kong Association because his family name is Lowe (Lau). Ida Chong, Member of the Legislative Assembly, is another active member; her family name Chong (Cheung) places her among the four.

龍岡親義總公所每年的最大活動是四月四日的世界龍岡日。該日禮堂中有拜祭四姓先祖儀式，以銘記該會所成立的宗旨 - 友愛及兄弟情。溫哥華龍岡公所亦會派宗親前來道賀，約三百人參加在該日晚上舉行的宴會，卡啦OK演唱、抽獎、及最重要的 <兄弟姐妹情>，令這項活動更具意義。

除了世界龍岡日，龍岡親義總公所每年舉行四大神誕拜祭先祖儀式，以紀念劉備、關羽、張飛、及趙雲等四姓先祖。并秉承忠、義、仁、勇的精神，四姓兄弟互相幫助，共謀福利。

龍岡精神的另一重要宗旨是教育下一代四姓結義的團結和諧。維多利亞市前任市長劉志強的祖藉是中山，所以他是中山福善堂的宗親；但由於他的姓氏是劉，所以他也是龍岡宗親中的劉大伯。卑詩省省議員張杏芳則在劉、關、張、趙四姓宗親中排行第三，人稱張三姑或三姑娘。

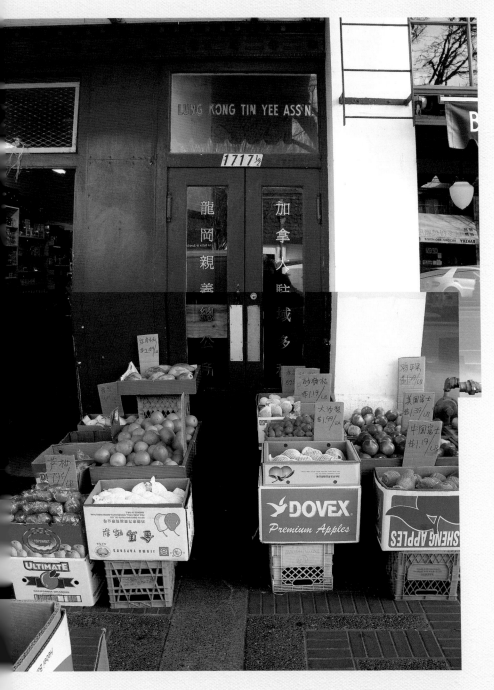

Front door of the Lung Kong Association.
龍岡總公所的正門。

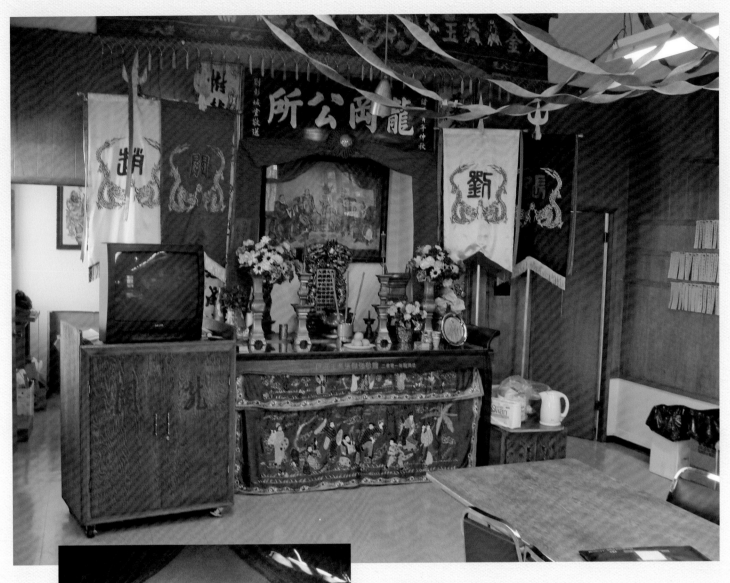

ABOVE The Lung Kong Association in 2008.
龍岡親義總公所，攝於二零零八年。

LEFT A painting of the four men who met in a legendary peach grove and founded the Lung Kong brotherhood.
一幅劉關張趙四姓兄弟結義的繪畫。

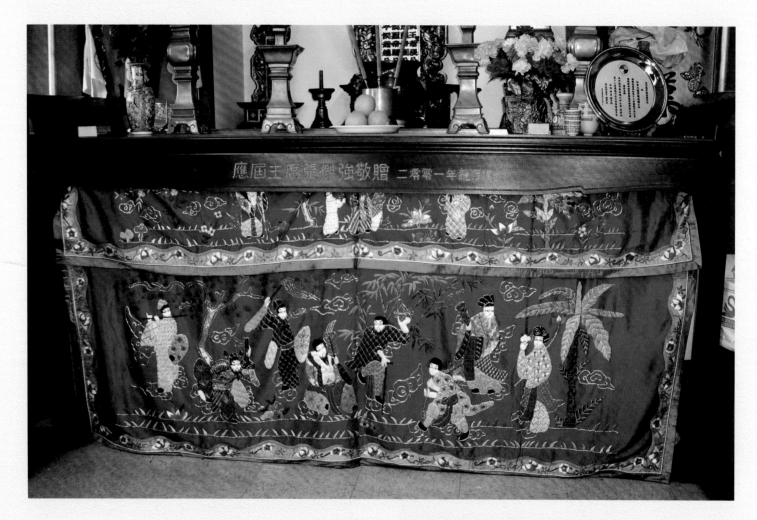

This handsome embroidered altar cloth is a recent addition to the furnishings at the Lung Kong Association, donated by the Cheung family.

這張掛在神壇前的精緻錦繡被，是由總公所中某張姓宗親的家庭在近年贈獻的。

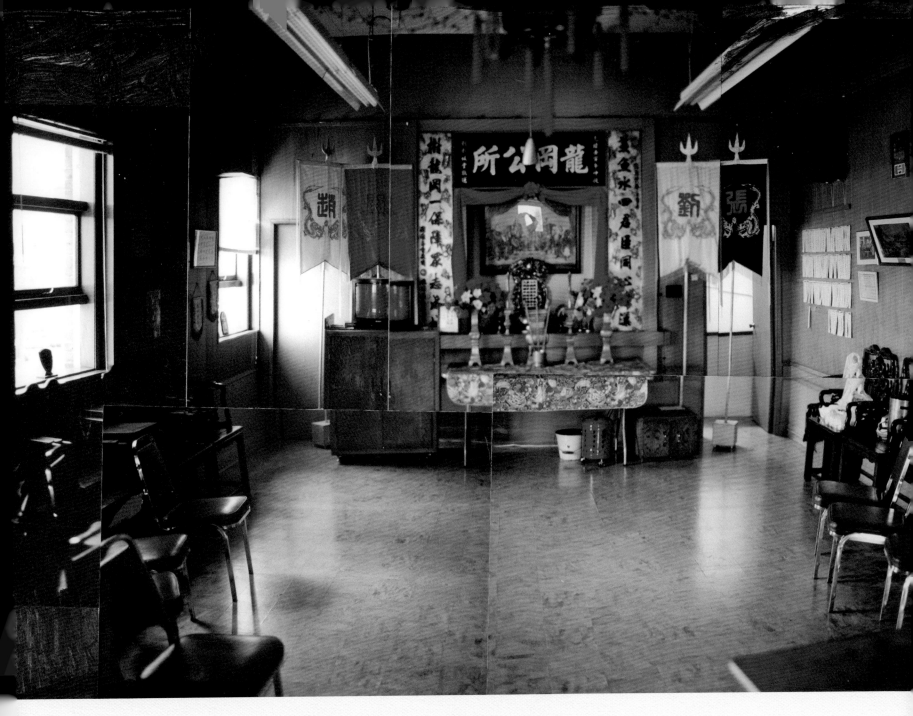

The Lung Kong Association meeting room in 1999.

龍岡親義總公所的禮堂，
攝於一九九九年。

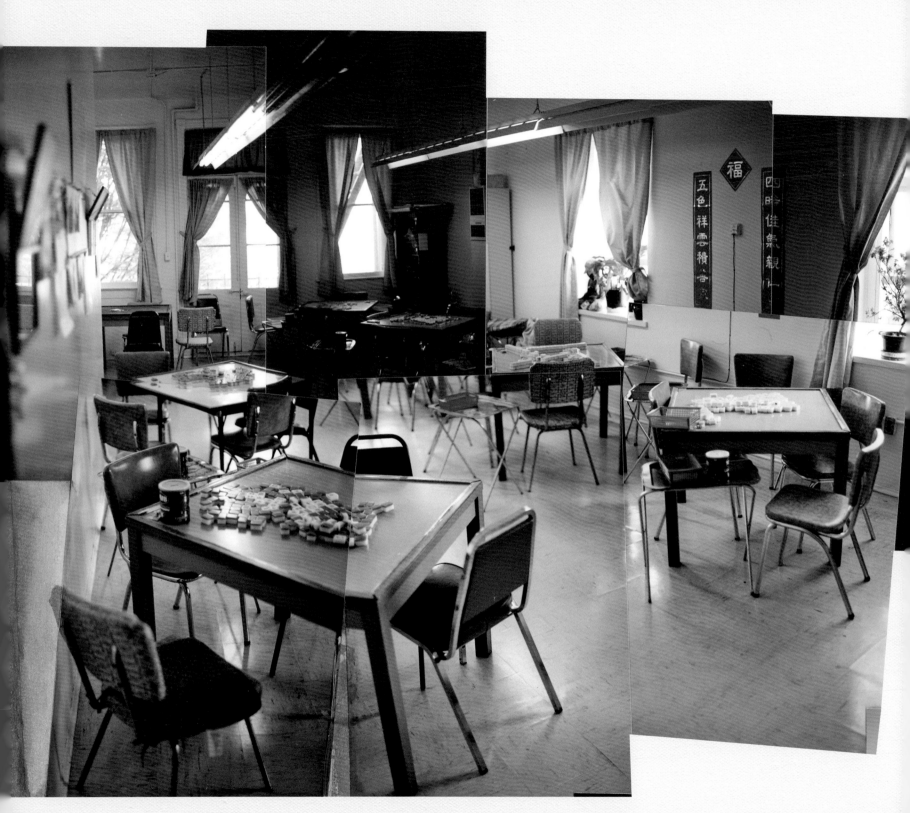

12A LUNG KONG WOMEN'S ASSOCIATION

The women of the Lung Kong Association have their own meeting hall on the second floor of the building. It's a bright and cheery room where, every Saturday and Sunday, keen mahjong players gather to enjoy their game. The women also have a well-deserved reputation for providing wonderful food for the association's various events.

12A 龍岡親義總公所婦女部

龍岡親義總公所的婦女部在二樓有獨立的聚會場所。明亮及充滿生氣的大廳，是每週六、日麻將耍樂的好去處。婦女部嬸姆們的巧手精製家鄉食品，更在不少會所活動中備受好評。

Old coloured glass in the doorway to the women's meeting room is decorated with signs conveying good wishes for the New Year.

通往婦女部的門廊上有古舊的彩色玻璃，大廳中貼有新年的吉祥揮春。

MAHJONG

Mahjong is a game for four players involving skill, strategy and a certain degree of luck. The word *mahjong* means "sparrow"; the game appeared in China in the 19th century. Each player is dealt either 13 or 16 tiles and then draws and discards them.

Though betting is not necessary, mahjong is popularly played as a gambling game and, as such, was banned in China in 1949 when the People's Republic was founded. After the Cultural Revolution, it was revived and has once again become a favourite pastime in China, and in Chinatown.

麻將

麻將是一種由四人組成的娛樂遊戲，這種遊戲的玩法需具技巧、謀略、及運氣。麻將亦稱 <麻雀>，此遊戲於十九世紀時已在中國出現。在遊戲中，擲骰子決定東南西北四家的坐位後，每位參與者摸出十三或十六隻麻將牌，然後各人輪流從桌上已排列成四方陣形的麻將牌中摸出一隻，并抽出要放棄的牌子放回麻將桌上。

雖然並非一定要下賭注，但麻將耍樂一般已被視為賭博，正因如此，中華人民共和國於一九四九年成立時曾下禁令，至文化大革命後才解禁。麻將耍樂在中國，及世界各地的唐人街，已成為極受歡迎的日常消遣娛樂。

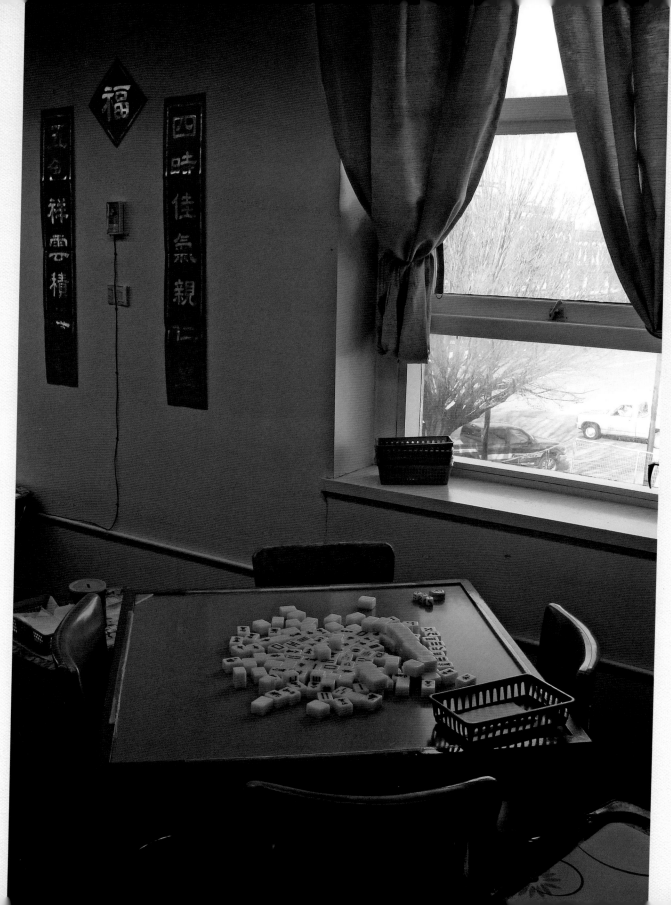

Mahjong tiles await the resumption of play.

未排列好的麻將牌子

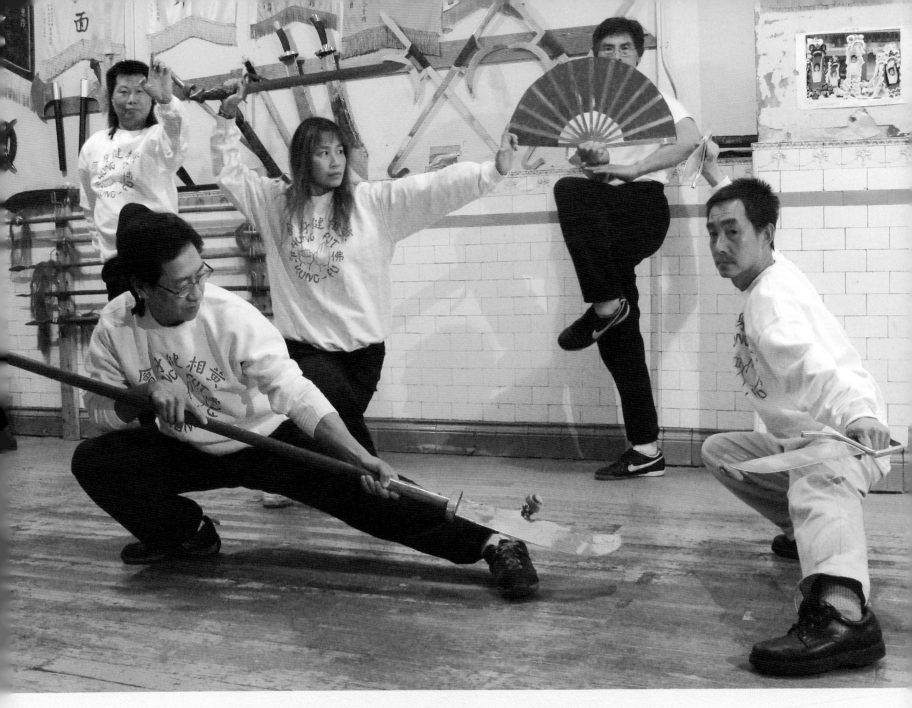

Sifu Edmund Wong with chief instructor Terry Lee, senior member Mark Albany and Sheung Wong's granddaughter, Gloria Tsoi, in the club's gymnasium.

黃相健身會的資深教練們在練武廳中擺起洪佛拳招式。

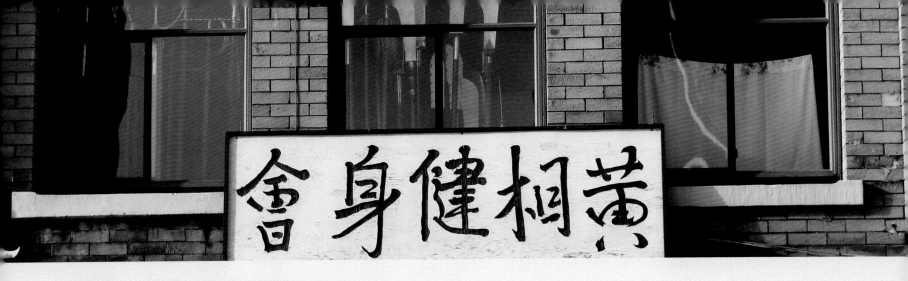

 # SHEUNG WONG KUNG-FU CLUB
黃相健身會

Sign and second-floor window of
the Sheung Wong Kung-fu Club.

譚公廟的金漆雕刻牌匾

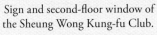

The Lee Block at 1620½ Government Street was built in 1910. The second-storey window there is filled with spears and axes and shiny weapons. This is the home of the Sheung Wong Kung-fu Club, where men and women of all cultures come to practise martial arts.

加富門街一六二零號又二分之一的建築物建於一九一零年。二樓臨街的一個窗戶內可見排列著閃亮的長矛、紅纓槍、斧頭等各類兵器，這裏就是黃相健身會。不同族裔的男女，到此學習俗稱功夫的中國武術。

Sifu Edmund Wong, leader of the club
and son of its founder.

黃相健身會主持人黃永安師父，
是該健身會創辦人黃相師父的兒子。

Victoria's kung fu club was founded in 1974 by Sheung Wong, who had recently arrived from Hong Kong. This is the only Hung Fut Kung-fu club in Canada, and follows the 400-year tradition developed at the Southern Shaolin Monastery in Fujian province, China. Distinct from almost all other styles of kung fu, Hung Fut is "left-handed," meaning that its martial arts moves begin with the left hand. This is thought to give practitioners an advantage when countering the more common right-handed moves. Sheung Wong, who died in 2001, was not only an Honorary Citizen of Victoria but also a Grand Master of the Chinese Freemasons, one of only three in Canada.

The Sheung Wong Kung-fu club does not rank or grade its members and is not competition-oriented. Improving the general health and well-being of the community is the club's goal. The club's crest shows the closed fist and open palm, and training includes a stunning array of weapons.

維多利亞市的黃相健身會由黃相師父於一九七四年創立，當時黃師父剛從香港移民到此地。黃相健身會是加國唯一教授洪佛拳的武館。洪佛拳源自中國南方福建少林寺，已有四百年的歷史。洪佛拳與其他功夫有別的特色是"左拳"。其中涵義是由左拳先動而帶出右掌。其中優勢是當與對手對擊時，可較一般先出右拳的拳法佔先機。黃相師父於二零零一年逝世。他生前不只獲頒維多利亞市的榮譽市民榮銜，也是全加洪門民治黨的三位盟長中之一位

黃相健身會教授武術并不分班級或段數，是因人而教的。健身會的宗旨是強身練體及為社區服務。其會徽上有握拳及開掌相併的洪佛拳圖案。健身會的武術訓練，包括令人驚嘆的各類武器。

Master Sheung Wong, founder of the club,
in the gymnasium, May 1999.
黃相健身會的創辦人黃相師父攝於練武廳

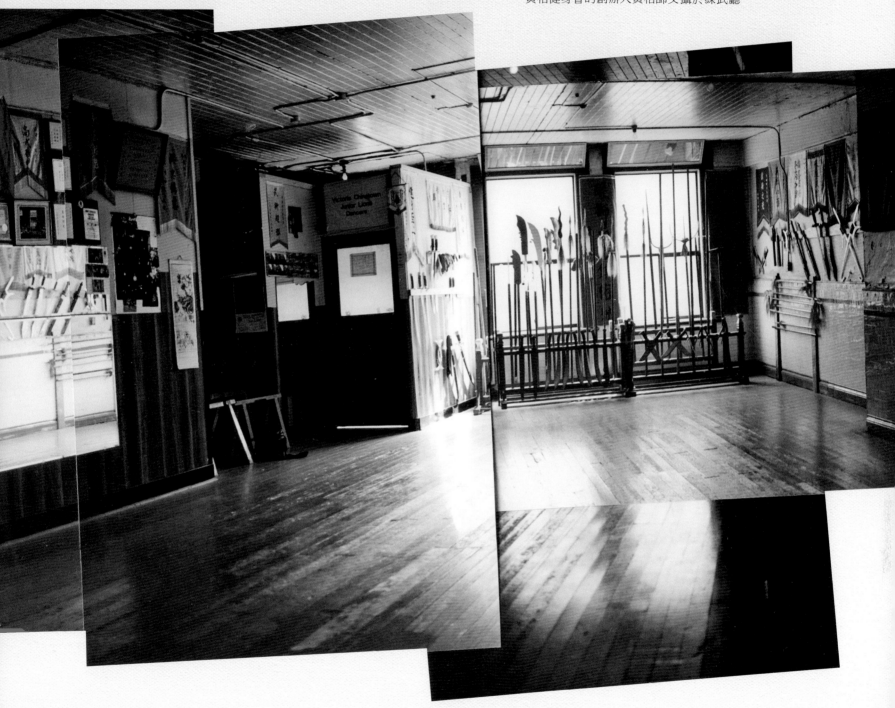

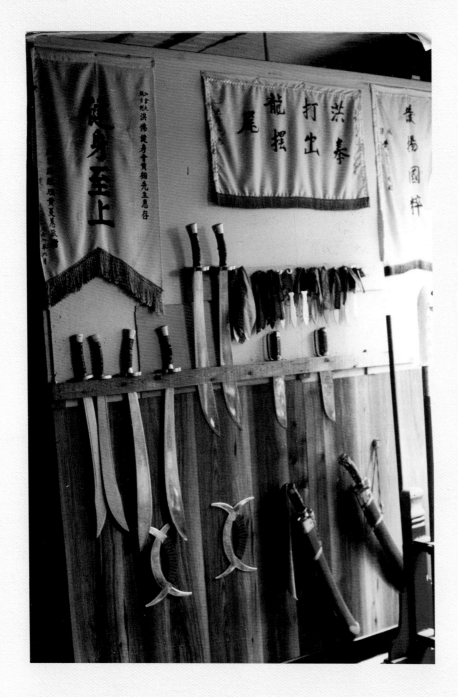

The club has two parallel gymnasium rooms, one of them with a wainscotting tiled in white and turquoise. The walls are richly decorated with banners and photos. Sifu Edmund Wong, son of the late founder Sheung Wong, is a diminuitive and soft-spoken man, but his inner power became clear as he posed for these photographs. Wong is seen with chief instructor Terry Lee, senior member Mark Albany and Sheung Wong's granddaughter, Gloria Tsoi, herself a lifelong practitioner. "We're like a family," Tsoi explained. "We all work together." At the moment the club has about 30 active members.

健身會內有二個並排而列的練武廳，其中一個的牆壁鋪上白及藍綠色的瓷磚，上面掛滿各款紀念旗及相片。黃永安師父是已故創辦人黃相師父的兒子，現為黃相健身會的主持人。黃永安師父身型瘦削，說話語調溫和，他的深厚內功可由他擺功架給我們拍攝時窺豹一斑。黃永安師父手下有首席教練李劍輝，資深會員馬克.愛巴尼、陳基榮及黃相師父的外孫女蔡吳瑞蓮。蔡吳瑞蓮從小跟隨其外公習武。她表示，整個武館就像一個大家庭，互相幫助，共同努力。目前，健身會有約三十名會員。

Some of the weapons on hand for kung fu practitioners.
健身會內的練習武器

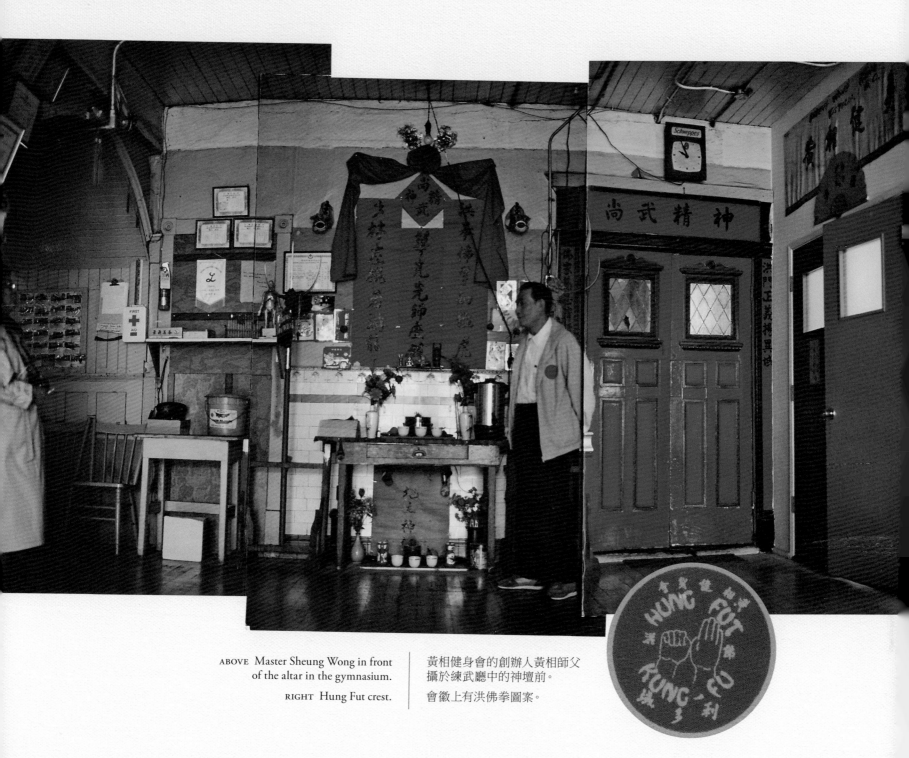

ABOVE Master Sheung Wong in front of the altar in the gymnasium.

RIGHT Hung Fut crest.

黃相健身會的創辦人黃相師父攝於練武廳中的神壇前。

會徽上有洪佛拳圖案。

In addition to their Hung Fut training, members of the Sheung Wong Kung-fu Club are proud to form Victoria's Lion Dance Team. The lion dance is a Chinese tradition, presented by all kung fu schools to chase away evil spirits and bring good luck and prosperity. Dancers need strength, stamina and balance. It takes a special effort for the dancers to visualize their dramatic movements. The colourful costumes and well-rehearsed martial arts routines make this a dramatic performance, and over the years it has been presented to Queen Elizabeth II and the Governor General of Canada, among others.

When demonstrating kung fu moves, lion dancers use the black lion head. For funerals they choose the white. The brilliant colours of the other heads are used for weddings, grand openings, New Year's celebrations and other special events. The kung fu club is an integral part of Victoria's Chinese community, involving many girls and boys who have formed the Junior Lion Dance team, which operates through the Chinese Public School.

除了日常的洪佛拳訓練之外，會員也組成了令他們引以為傲的醒獅隊。舞獅是中國的傳統文化，由武館組隊演出。舞獅的意義是驅逐惡魔，迎接吉祥及幸運。醒獅健兒須具強壯體力、毅力、平衡力及能力，才能靈活配合此高難度的舞獅動作。色彩繽紛的醒獅表演服飾及訓練有素的武術功力，令醒獅表演成為萬眾以待的表演項目。多年來，醒獅隊演出無數次，包括歡迎英女王伊莉沙白二世及加拿大總督的來訪。

醒獅的獅頭及獅身有不同的顏色，各有其義。一般來說，在表演武術時用黑獅，送殯時用白獅。華麗燦爛的彩獅可用於婚禮、店鋪開張及社區喜慶活動等。黃相健身會是社區中不可缺的一份子。眾多青年男女孩子曾在此受訓，包括華僑學校學生及幼童醒獅團的團員。

LEFT TWO IMAGES Lion dancers perform on Fisgard Street.

左兩圖：在華埠菲士格街的醒獅表演

RIGHT Lion dancers perform on Fisgard Street at the New Year's festival, 2009.

右圖：二零零九年春節，醒獅隊員在菲士格街表演。

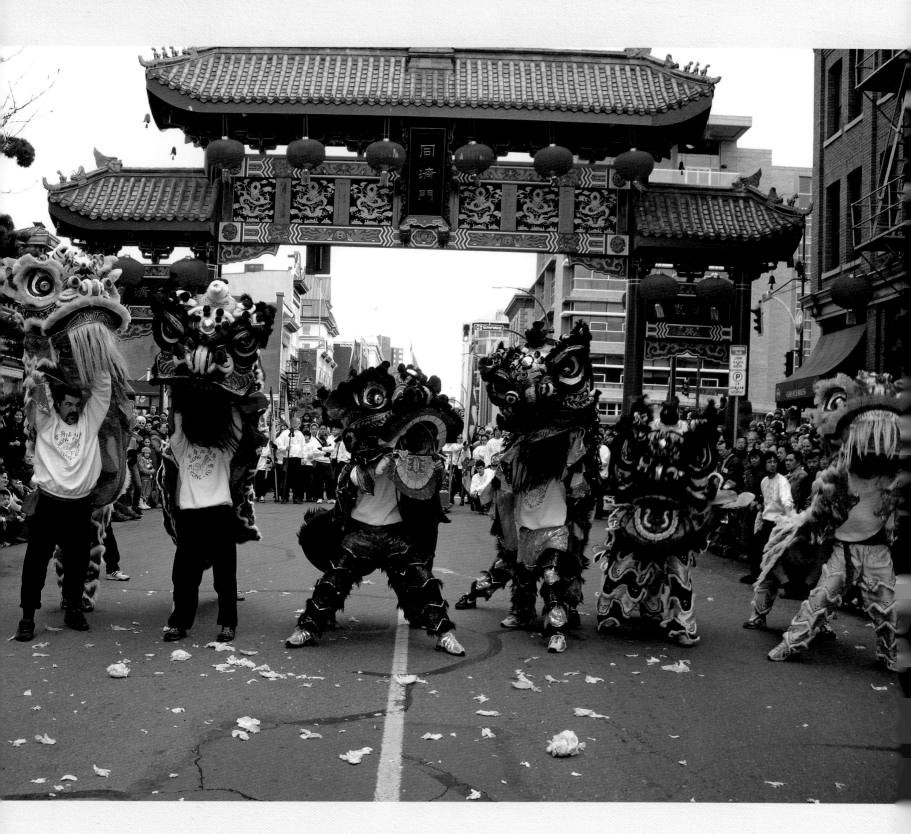

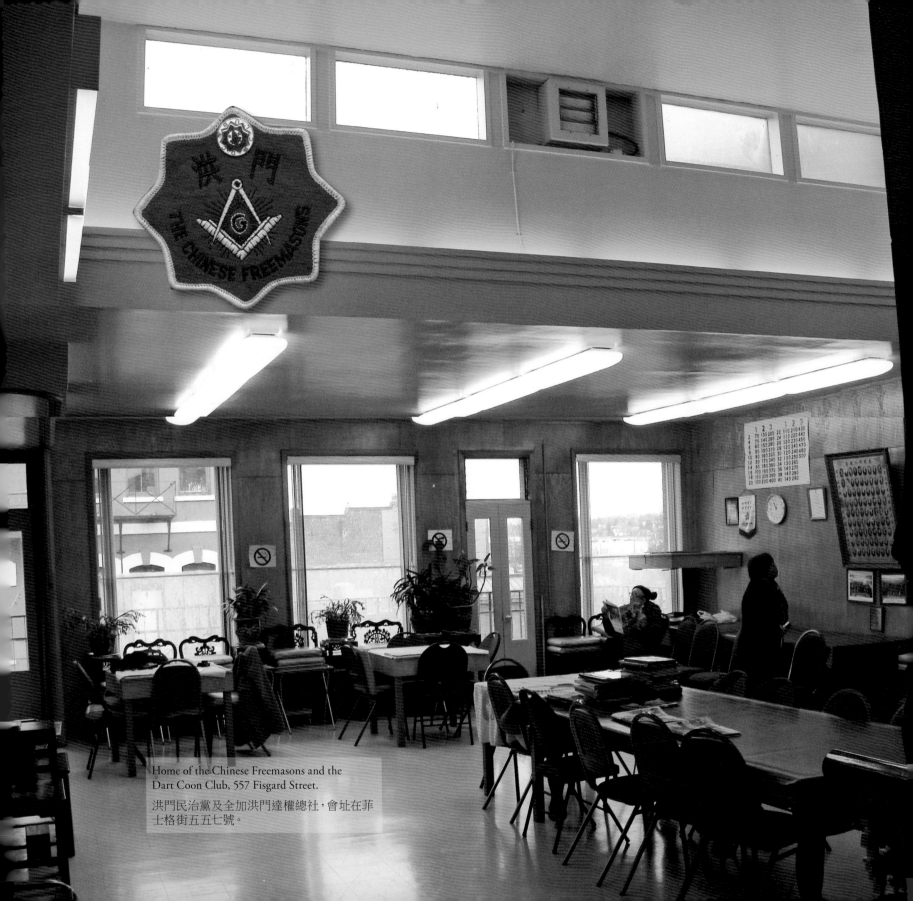

Home of the Chinese Freemasons and the
Dart Coon Club, 557 Fisgard Street.

洪門民治黨及全加洪門達權總社，會址在菲
士格街五五七號。

CHINESE FREEMASONS ASSOCIATION
洪門民治黨

The black glass and gold-leaf sign of the Dart Coon Club.

洪門達權總社的黑玻璃鑲金字牌匾。

The Chinese Freemasons Association was established in Victoria on January 26, 1876. The organization is dedicated to the principles of loyalty to one another, faithfulness to the good of the people and noble-minded generosity to all.

The name "Freemasons" in this case has nothing to do with the European Freemasons. The Chinese Freemasons Society is another name for the Chee Kung Tong, a blood-brotherhood created in opposition to the Manchus who defeated the Ming Emperor and ruled China as the Qing Dynasty. The CKT was dedicated to ousting the Manchu invaders and thus they operated as a secret society. Among the anti-Manchu rebellions was the Taiping Rebellion. When that failed in 1864, many CKT members had to flee China and some came to Gold Mountain.

Some of them dug and panned for gold in California and then followed the gold seekers north to Barkerville. There, in 1863, they founded a Canadian branch of the CKT. This was certainly the major, and perhaps only, Chinese association in the Canadian mining settlements, and it undertook the political and welfare functions in many communities.

洪門民治黨於一八七六年一月二十六日在加拿大創立。其宗旨是本著忠、義、俠精神，以民治、民有、民享為三大主張。

有點要注意的是，洪門民治黨的英文會名與歐洲人所組織的同名之共濟會是不同的機構。洪門民治黨的前身是致公堂，是在一六六四年明朝亡國後的一個典型的反清復明之民間愛國團體。當時是屬於一個<秘密活動>的組織，以推翻滿清恢復明朝為己任。在一八五零年至一八六四年期間，太平天國叛亂組織亦以推翻滿清為口號。在反清復明遙遙無望後，眾多的致公堂會員只好離開中國，其中有些遠渡太平洋來到了金山。

部份致公堂會員在加州以淘金為生，後循著淘金路線經蒙大納州及愛達荷州而至加拿大卑詩省內陸的百加委路鎮，在此落地生根。這些淘金者於一八六三年在此鎮創立了<洪順堂>，洪順堂後來改名為<致公堂>，百加委路鎮是為加國洪門的發祥地。鎮上的華人，幾乎都是致公堂的會員。在當時，全加國有超過六十個的洪門組織，共有會員逾萬人。致公堂是當時華人社區最大的組織，負起了排解礦業糾紛，為華人爭取在政治及福利上權益的責任。

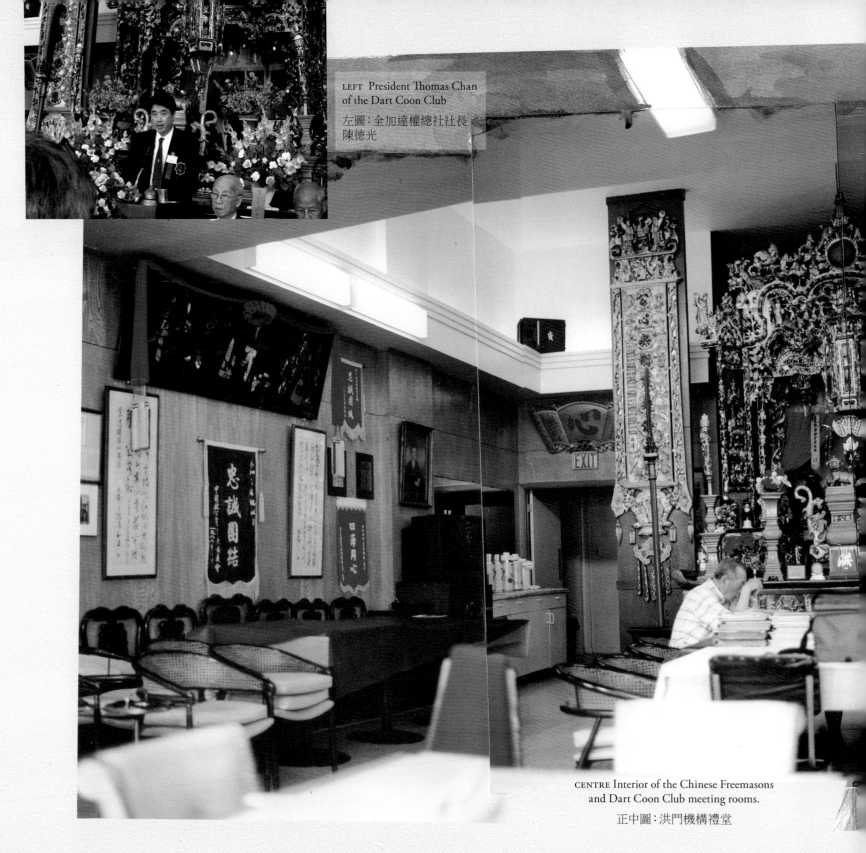

LEFT President Thomas Chan of the Dart Coon Club

左圖：全加達權總社社長
陳德光

CENTRE Interior of the Chinese Freemasons and Dart Coon Club meeting rooms.

正中圖：洪門機構禮堂

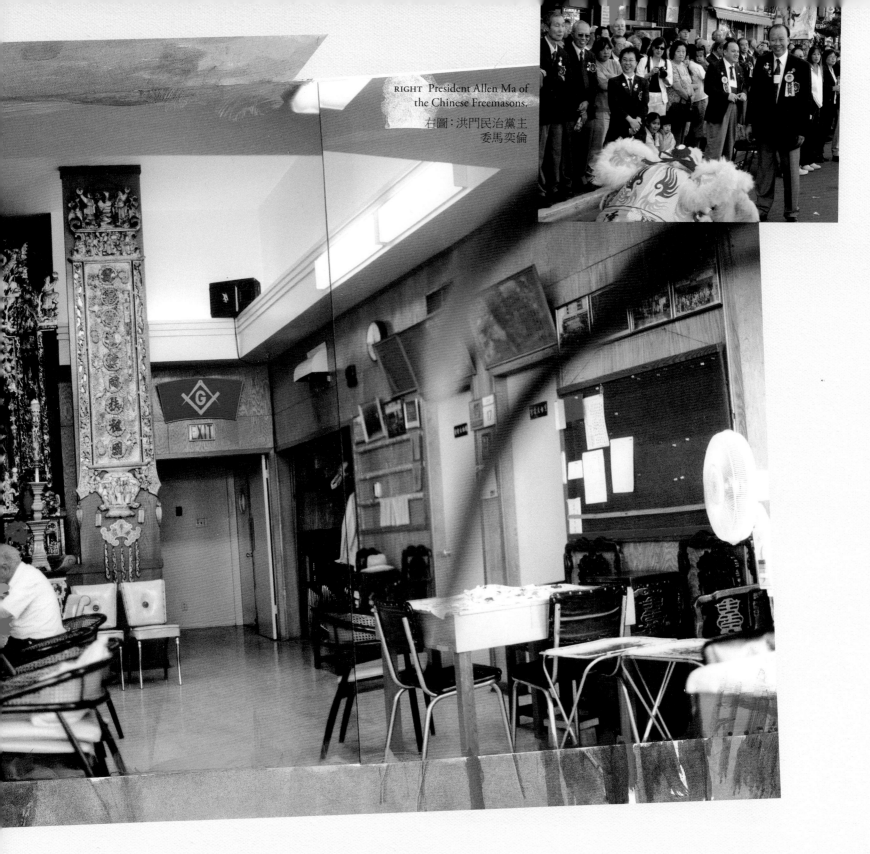

RIGHT President Allen Ma of
the Chinese Freemasons.

右圖：洪門民治黨主
委馬奕倫

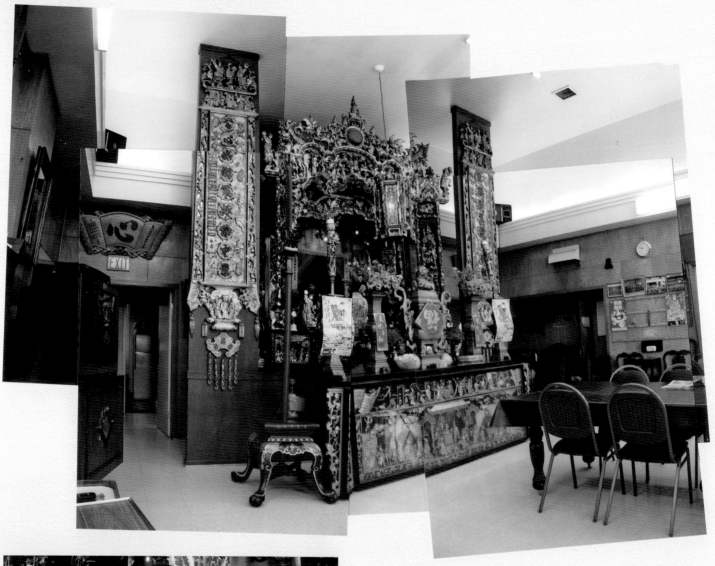

ABOVE Gilded altar and shrine of the
Chinese Freemasons.

上圖：洪門民治黨禮堂內的鍍金神
壇和神龕。

LEFT Carvings on the altar table.

左圖：神壇上的雕刻。

In 1876 the CKT was founded in Victoria by members from Seattle and between 1885 and 1914 it grew to have over 40 branches across Canada, with Victoria as its headquarters until 1929. One of the leading organizations in the city, it added stability to many aspects of life in the Chinese community.

The young Sun Yat-sen joined the CKT during a visit to Hawaii in 1903 and on February 14, 1911, he arrived in Victoria to raise funds for another rebellion against the Qing Dynasty. Members of Victoria's Chinese Freemasons showed their support by mortgaging their club's building on Fisgard Street, raising $12,000.

This rebellion soon succeeded in establishing a "new China" and the CKT, in China as well as in Canada, shed its secret nature and became an open political party. In 1920 the party began to call itself the Chinese Freemasons. It actively created liaisons with other CKT organizations in Canada and internationally as a political and welfare organization.

With the establishment of the People's Republic of China in 1949, the CKT's earlier political orientation toward China ended and the Freemasons turned their attentions toward the problems of the Chinese in Canadian society.

The Chinese Freemasons and the Dart Coon Club meet formally once a month in their handsome meeting rooms at 557 Fisgard Street, and serve the local Chinese in many ways. Still faithful to their roots in China, they are always ready to help the motherland—for instance, in making donations of aid for the massive Szechwan earthquake of 2008.

15 DART COON CLUB

In 1915 the Dart Coon Club was formed within the Chinese Freemasons of Victoria. *Dart Coon* may be translated as "to reach the goal, to keep the power." In the atmosphere of political violence that prevailed in those early years, this was an inner circle of members who demonstrated unquestioned loyalty to the ideals of the CKT. The club was determined to protect its members from harassment, and martial arts skills, athletic activities and a lion dance team were essential to its ethos.

維多利亞的致公堂於一八七六年由來自西雅圖的會員創立。在一八八五年至一九一四年期間,全加國各地有超逾四十間的致公堂分會。在一九二九年之前,總部是設於維多利亞的。是當時華人社區中舉足輕重的領袖僑團之一。

孫中山先生年輕時,於一九零三年在檀香山訪問時加入了致公堂。他於一九一一年二月十四日抵達維多利亞,籌募革命軍餉,以推翻滿清王朝。維市洪門積極支持,將菲士格街的洪門物業抵押,籌得一萬二千加元經費。後革命成功,成立了中華民國。

在民國成立後,洪門致公堂在中國或加國都不再是一個秘密組織,而是一個公開的民間團體。致公堂於一九二零年改名為洪門民治黨,自此,洪門民治黨與加國及世界上各地致公堂互相聯繫,成為活躍於社會上的民間福利組織。

一九四九年中華人民共和國成立後,致公堂在中國的活動結束。洪門組織的活動中心漸轉移至加國社會的華裔社群。

洪門民治黨與達權總社的會員們每月開會一次,開會地點是在菲士格街五五七號三樓漂亮的禮堂。該機構為海外僑胞提供多種服務。保存優良的愛國愛鄉傳統。隨時隨地為祖國的需要而作出貢獻。如近期的四川地震,該機構便發動了籌款賑濟災民的活動。

15 全加洪門達權總社

洪門組織的忠堅分子於一九一五年成立核心達權社,其總部設於維多利亞。達權的意思是保存一己之公權,不致被人欺侮,務求達到目的為止,故名曰達權。在早期,洪門在政治上最艱苦的時刻,洪門內的不肖分子,助紂為虐,違背洪門忠義俠精神,幸有一群忠於洪門的忠堅分子,堅信洪門三大信條,不向惡勢力低頭,成立了核心達權社。輔助洪門在加拿大之生命,完成達我公權之目的。為了保護會員不受欺侮,成立了洪門體育會,會員接受武術訓練,舞獅隊也因應而生。

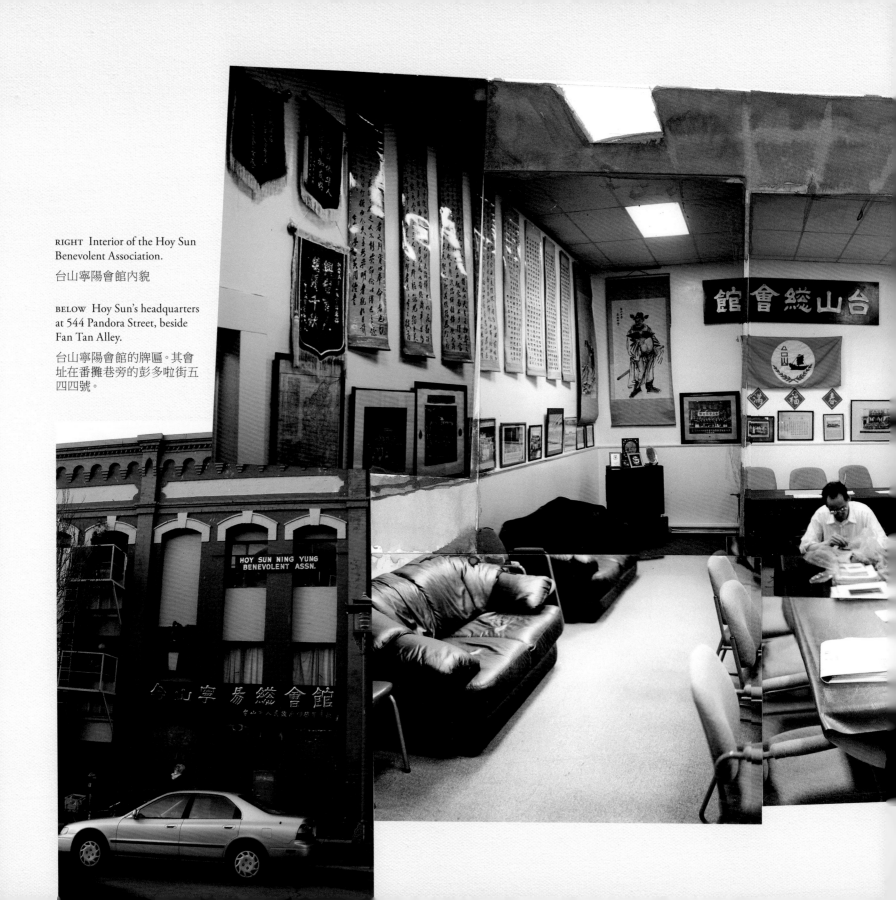

RIGHT Interior of the Hoy Sun Benevolent Association.

台山寧陽會館內貌

BELOW Hoy Sun's headquarters at 544 Pandora Street, beside Fan Tan Alley.

台山寧陽會館的牌匾。其會址在番攤巷旁的彭多啦街五四四號。

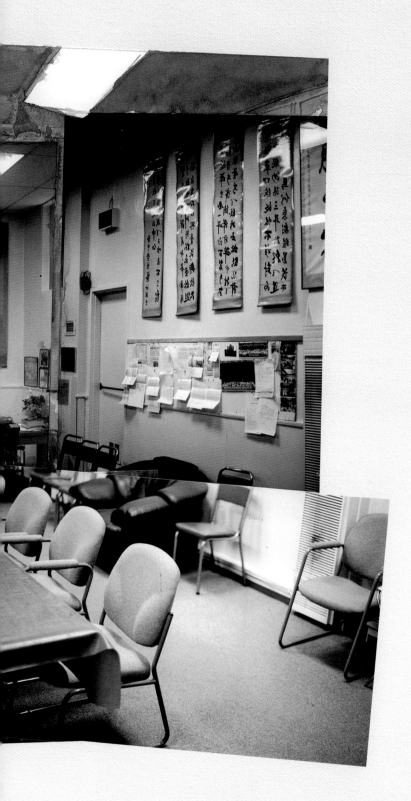

Sign on the front door of the Hoy
Sun Benevolent Association
掛在台山寧陽會館正門的招牌

 **HOY SUN
BENEVOLENT ASSOCIATION
台山寧陽會館**

The Hoy Sun Benevolent Association was formed in Victoria in 1889 by people from Hoy Sun County in Guangdong Province, China. This is the province we now refer to as Taishan. In 1998 the vice mayor of the city of Hoy Sun visited Victoria and reported that over 200,000 Canadians have roots in his home province. From its beginnings in Victoria, this association now has branches in every major city in Canada.

來自中國廣東省台山地區的華人，於一八九九年在維多利亞市成立了台山會館，以聯絡鄉情，團結互助。台山市副市長鄺錦鏞於一九九八年到訪維市，出席第八屆全加台山邑僑懇親大會暨維市台山寧陽會館一百零九週年紀念時稱，全加國約有二十多萬台山鄉親。目前，全加國各大城市均成立了台山會館。

中國國民黨域多利分部

17 CHINESE NATIONALIST LEAGUE
國民黨分部

PREVIOUS PAGE Detail of Winter, one of the four
seasons scrolls at the Nationalist League.
左頁：國民黨分部內的其中一幅冬景國畫掛軸。

ABOVE Name sign of the Nationalist League.
上圖：國民黨分部牌匾。

Sun Yat-sen, who was dedicated to overthrowing the declining Qing Dynasty visited Victoria for the first time in 1897. His countrymen in exile were eager for change in their homeland and welcomed him warmly. In 1906 a chapter of his Revolutionary Party, whose headquarters were in Shanghai, was founded in Victoria under the name Victoria Communications Branch of the Revolutionary Party.

孫中山先生出生於中國南方的廣東省中山縣。他一生致力於革命，推翻腐敗的滿清朝廷，建立民主政制政府。在一八九七年，當他在英國倫敦時，他被綁架並禁閉於滿清使館內兩星期。在英國政府的調停下才被釋放。後來他乘船前往滿地可，繼續為救國救民籌款，於一八九七年首次來到維市。

當時海外加國華人都渴望他們的故鄉能改朝換代，對孫中山的革命熱烈響應。在一九零六年，他的其中一個擁護組織，總部設於上海的改革黨，在維市成立分部，當時的名稱是維城交通部。

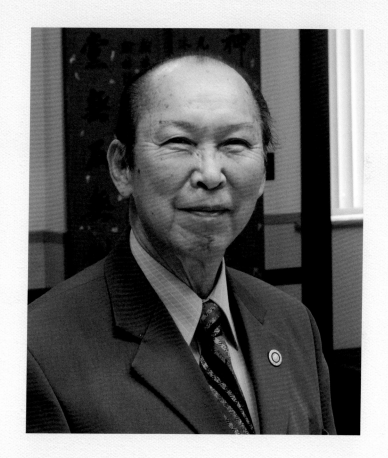

Paul Chow, president of the Chinese Nationalist League.
國民黨分部常委周步發

121

Meeting Hall of the Chinese Nationalist League
decorated with flags for Taiwan's national day.

國民黨分部慶祝雙十節，禮堂內掛滿了青
天白日旗。

After the uprising of 1911, the Revolutionary Party was successful in overthrowing the Qing Dynasty. Sun Yat-sen's Kuo Min Tang (or Nationalist League) developed into the paramount political party in the Republic of China and branches were set up in Chinatowns throughout North America. At that time the Victoria organization changed its name to the Chinese Nationalist League, Victoria Branch.

The revolution was, in fact, far from over. By 1949 the Communist Party had forced the KMT off the mainland, and it became the ruling party on the island of Taiwan.

Through its most active years the Victoria branch operated a newspaper and organized a youth group. It sponsored visits by young performers from Taiwan and presented exhibitions of art in the McPherson Playhouse. The Nationalist League, on more than one occasion, came up with emergency funds to keep the City from repossessing the Chinese Public School for non-payment of taxes.

President Paul Chow points out that the focus has been changing over the years, "more to the local community than to national goals." The Nationalist League remains open to members from other organizations who subscribe to the ideals of Sun Yat-sen.

18 HAN YUEN CLUB

The Han Yuen Club is a part of the Nationalist League. *Han Yuen* means "a place for leisure" and is more concerned with social activities than with the political intentions of the Nationalist League.

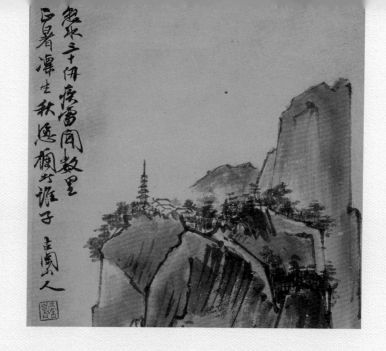

於一九一一年，改革黨革命成功，推翻了清朝。孫中山就任為中華民國臨時大總統。改革黨在孫中山的領導下，於一九一二年改名為國民黨。北美洲各埠的唐人街均設立國民黨分部，維多利亞市的維城交通部改名為域多利國民黨分部。

革命其實尚未完全結束，於一九四九年，中華人民共和國成立，共產黨執掌政權，國民黨避離大陸，在台灣另起爐灶。

域多利國民黨分部在最活躍的年份中，曾出版新民國日報(後來報章的出版轉移到溫哥華，約十年前因追不上新科技的需要而遭淘汰)。當時，青少年也是國民黨分部的服務對象，該分部贊助台灣青年藝術團到本市麥花臣戲院表演，也借出場地給本地畫家開畫展。早期，曾多次捐款及籌款給中華會館華僑學校繳交欠市政府的地稅，使其逃過被政府收地的危機。

國民黨分部常委周步發指出，多年來，社會的需求已逐漸改變，目前，該會的主要服務對象是在本地而非全國性。該會歡迎信仰孫中山思想的人士入會。

18 閒園俱樂部

閒園俱樂部是國民黨分部的一個分會。「閒園」是一個休閒的交誼會所，是不涉及政治活動的。

Nationalist shrine with a portrait of Sun Yat-sen and flags
of the Kuo Min Tang and the Republic of Taiwan.

國民黨分部禮堂的一角，牆上掛著孫中山先生遺像
及國民黨黨旗。

124

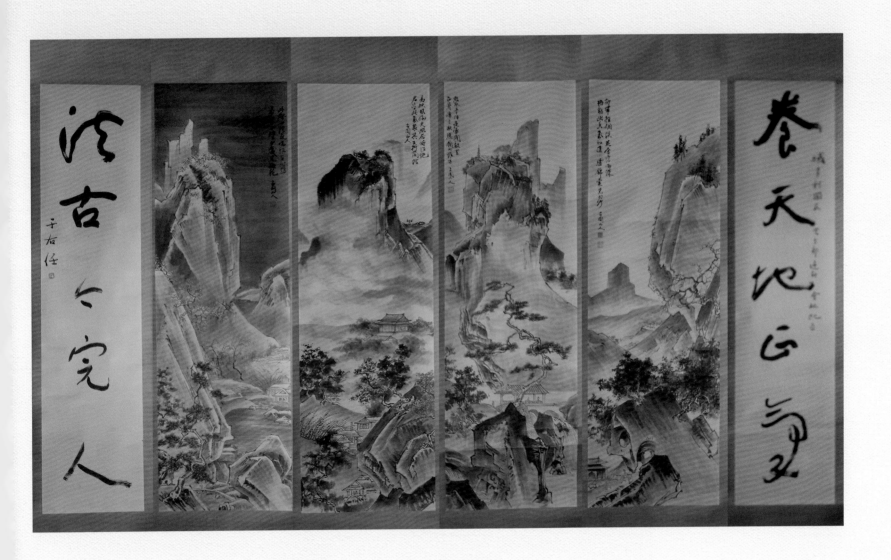

A set of ink paintings of the four seasons, with flanking scrolls of calligraphy.

一組四季景色水墨畫掛軸，兩側有于右任的墨寶題字。

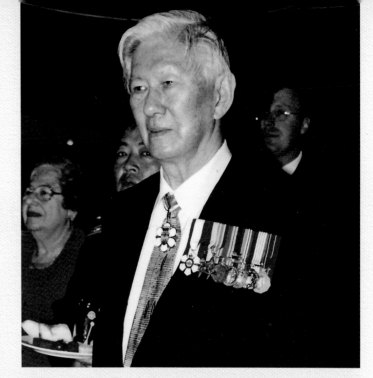

ABOVE LEFT Victor E. Wong, a Canadian soldier ready for duty in 1944.

加拿大士兵黃活光於一九四四年在赴戰場前攝影。

ABOVE RIGHT Douglas Jung was born in Victoria. He was a lawyer and subsequently the first Chinese Canadian elected to the Canadian parliament. A much decorated war veteran, he also received the Order of British Columbia.

華裔退伍軍人鄭天華是維市土生。他是一位律師，也是首位華裔國會議員。他曾獲頒加拿大員佐勛銜。

RIGHT Proud members of the Victoria Chinese Canadian Veterans Association.

一群自豪的維多利亞華裔退伍軍人

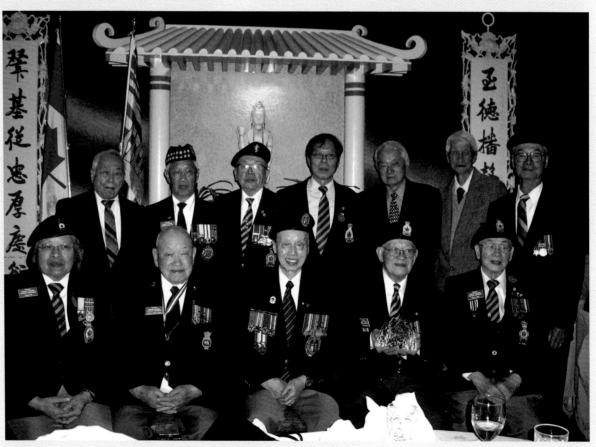

19 VICTORIA CHINESE CANADIAN VETERANS ASSOCIATION 華裔退伍軍人會

The Chinese in Canada were, from the beginning, diligent in their efforts to help China wage war against its enemies. During World War II the invasion by Japan inspired 500 Chinese Canadians to join the Canadian armed forces.

Some of the soldiers resented fighting for their country while they were denied full rights as citizens. A draft order of the Canadian government in 1944 granted Chinese Canadians serving in the military a special class of citizenship; they seized this chance to demonstrate their loyalty to Canada, and planned to demand full citizenship later.

In May 1946 these veterans lobbied the Canadian parliament for their rights and on January 1, 1947, they won for all people of Chinese ancestry the privilege of Canadian citizenship and the right to vote under the Dominion Elections Act. Two years later, they achieved the right to vote in municipal elections as well.

Their participation in World War II showed that Chinese Canadians were undoubtedly loyal Canadians. The Victoria Chinese Canadian Veterans Association was founded on October 1, 1967. Since that time its members have been a regular feature of Victoria Day parades and wreath-laying ceremonies on Remembrance Day. These veterans have made many school visits to teach the children important lessons of Canadian history.

加國華人一直熱心支持祖國對付外侮。在第二次世界大戰時與日本的戰爭，號召了五百名加藉華裔加入了加拿大軍隊。

這些為加國參戰的華裔士兵並沒享有公民權。一九四四年加國政府頒發了臨時法令，使這些加藉華裔士兵可享有特殊類別的公民權。他們因此對政府發出抗議，要求獲得正式的公民權。

於一九四六年五月，他們的抗議說服了國會議員通過了公民權及選舉權法案。在一九四七年元旦日，這些華裔退伍軍人，為過去曾經受不合理對待的華裔同胞，爭取了應得的加國公民權及選舉權。這就是加國政府的"選舉權法案"。兩年之後，他們更爭取到參選市政府的選舉權。

他們在第二次世界大戰入伍為國家服務，對加國的忠誠是無可置疑的。維市華裔退伍軍人會在一九六七年十月一日創立。多年來，他們每年參與維多利亞日花車大巡遊、和平紀念日獻花圈，向為國捐驅的英雄致敬、也為學校的學生講解加拿大歷史及和平紀念日的意義及其重要性。

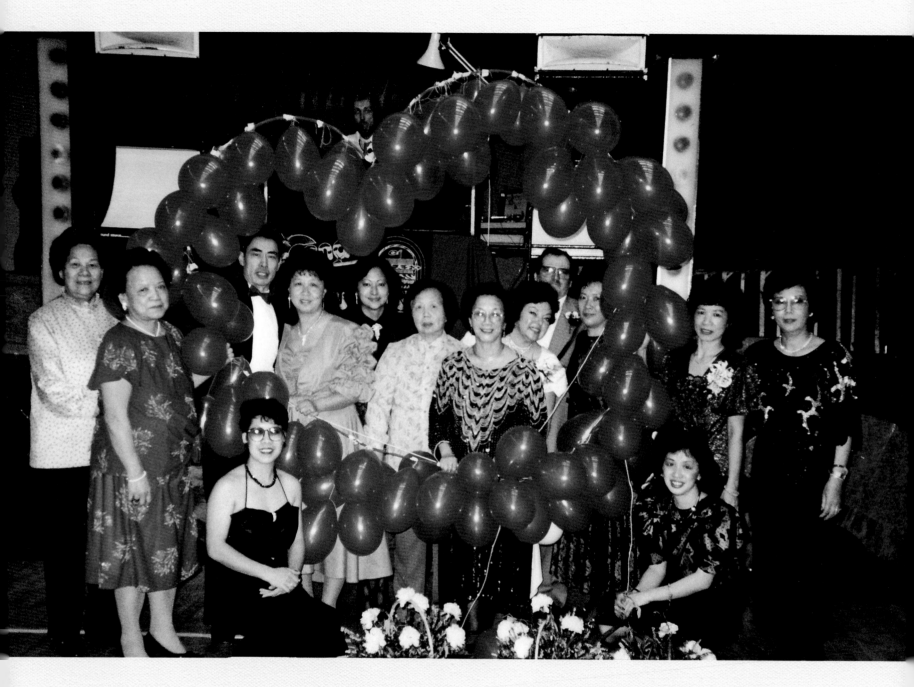

Members of the Victoria Chinese Ladies Club celebrate Chinese New Year's Day and, coincidentally, Valentine's Day, with a dance party, 1988.

中華婦女會舉辦舞會慶祝中國新年及情人節，相片攝於一九八八年。

20 VICTORIA CHINESE LADIES CLUB
中華婦女會

The original organizations of the Chinese Consolidated Benevolent Association were restricted to men, though through the years most developed an unofficial women's auxiliary. Some women in the Chinese community felt isolated by their language and culture, and the Victoria Chinese Ladies Club was created to address the needs of all women. It was founded in August 1973 by four women whose purpose in coming together was to enjoy socializing and to raise funds for worthy causes.

At first, the Ladies Club met once a month in the fourth-floor rooms of the Tam Kung Temple. A mahjong competition was often among their activities, as were music classes, Mandarin lessons and tai chi practice.

Over the years the club's charitable activities have taken precedence. The annual ballroom dancing gala is their major event and it has raised money for the Chinese Public School, the Harling Point Cemetery and the Chinatown Intermediate Care Centre. As part of their involvement with the care centre, the Ladies Club provides gifts of money in the traditional "red envelopes" and baskets of fruit to the seniors for Chinese New Year.

In recent years they have contributed to Chinese flood relief, sent aid for Taiwanese earthquake victims and helped after the devastating Pacific tsunami of 2005. Locally, their donations have assisted the Queen Alexandra Hospital and many other causes.

維多利亞市中華會館屬下的二十九個僑團中，有些僑團仍是以男性為主要會員的。只有少數的僑團設有婦女部。中華婦女會於一九七三年因華埠中眾多婦女的需求而創立。她們創會的目的是聯絡感情、慈善籌款、及娛樂。

在此之前，華埠中有些婦女由於語言不通，文化有別而感到孤立。婦女會最初在譚公廟之閣樓聚會，每月一次，互相交流人生經驗。她們經常舉辦麻將比賽、音樂班、普通話班及太極班等，多姿多采。

多年來，該會每年一度的慈善籌款舞會已成了她們最隆重的活動，所籌得的款項曾捐往華僑學校、美化哈寧角華人墳場、華埠療養院等。在農曆新年時，該會會員專誠往華埠療養院給住院老人家送上利是紅包及生果等，向長者們拜年。

近年，她們亦捐款救濟中國水災災民、台灣地震災民及零五年的南亞海嘯災民等。在本地，她們亦捐款給亞歷山大兒童醫院等各慈善機構。

 # CHINATOWN LIONS / LIONESS CLUB
華埠獅子會 / 華埠女獅子會

21 CHINATOWN LIONS CLUB

When an increasing number of second-generation Canadians of Chinese parentage began to take jobs outside the traditional ethnic economy, their interactions with Western organizations grew. Many men had professional careers; they participated in mainstream society and were on the road to becoming middle class.

The Chinatown Lions Club was chartered in 1956, with 21 members. Part of an international service club, it was the first Chinese Consolidated Benevolent Association member group to belong to a non-Chinese organization. The club benefitted from the breakdown of discrimination against the social and economic mobility of the Chinese.

The Lions International organization, with its high-profile public service, is compatible with the Chinese ideal of benevolence and generosity. Also, its style of leadership is similar to the traditional Chinese associations. The Chinatown Lions have helped to develop water-safety programs and projects related to diabetes, drug and alcohol awareness, blood donation and children with disabilities. Special assistance for Chinese senior citizens and the Miss Victoria Chinatown pageant are among their local initiatives. Participation in these Lions activities has encouraged social integration for both Canadian-born Chinese and Chinese immigrants.

22 CHINATOWN LIONESS CLUB

The Chinatown Lioness Club was formed in February 1991, sponsored by the Chinatown Lions Club. Over the years its members have supported innumerable charitable activities. Although the Chinatown Lioness club is part of an international organization, the members have never forgotten their roots and many of their events promote Chinese history and culture. They often organize tours of Chinatown, leading adults and schoolchildren through the oldest Chinatown in Canada. They have also hosted dinner lectures featuring historians and well-known authors.

The Lioness Club's community service events allow them to make many contributions. They assisted with fundraising for the construction and restoration of the Gate of Harmonious Interest, had a Chinese-style bulletin board designed and built at the corner of Fisgard and Government streets and made donations for a mural commemorating the 150th anniversary of Chinatown.

The Lioness group created a bursary in 1994 for students at the University of Victoria. They have made significant contributions to flood relief in China, tsunami relief in Indonesia and earthquake relief in Taiwan and China. Locally, they donate to organizations such as the Lions Society for Children with Disabilities, the Women's Transition House, the Canadian Cancer Society and many programs benefitting women and children.

21 華埠獅子會

當維市第二代加藉華裔土生為工作而逐漸離開華人社群時，他們與西方社群的接觸漸增。這些男士中有很多是專業人士；他們投入了主流社會中，並漸邁向中產階級之路。

華埠獅子會於一九五六年創立，共有二十一位創會會員。該會是世界獅子會組織中之一個分會。也是中華會館屬下僑團中，首個有非華裔會員的團體。該會的成立，提高了華人社群在主流社會的地位，對主流社會及華人社群間的社會及經濟上的交流有了新的突破。

世界獅子會組織服務大眾的宗旨，與華人的仁愛、寬大慷概的精神互相吻合。其組織形式與傳統僑團大同小異。華埠獅子會歷年來的服務工作包括協助發展飲用水安全計劃，預防糖尿病及兒童糖尿病，毒品及酗酒的警示，捐血等。華埠獅子會也援助華裔耆英，舉辦華埠小姐選舉等多項活動。

22 華埠女獅子會

華埠女獅子會在華埠獅子會的支持下，於一九九一年創立。多年來，該會一直致力於無數的慈善活動。華埠女獅子會雖是屬於其世界組織中之一個分會，但她們並沒有忘記祖藉的根源及文化。該會舉辦的遊覽華埠節目，使眾多的市民及學童有機會認識這個全加國最古老的華埠。該會亦定期舉辦歷史及文化晚宴，邀請著名的學者及作家到場演講。

華埠女獅子會舉辦的各項慈善籌款活動，令她們有機會捐款給有需要的機構。例如重修華埠同濟門、在華埠設置一中國式的佈告板、及捐款贊助為慶祝華埠一百五十週年而設的舞龍壁畫等。

華埠女獅子會於一九九四年在維多利亞大學設立獎學金。該會捐款賑濟中國水災、南亞海嘯及台灣地震等災難。該會亦捐款給本埠獅子會的兒童糖尿病計劃、婦女過渡屋、癌症協會及各項對婦女及兒童福利有關的計劃。

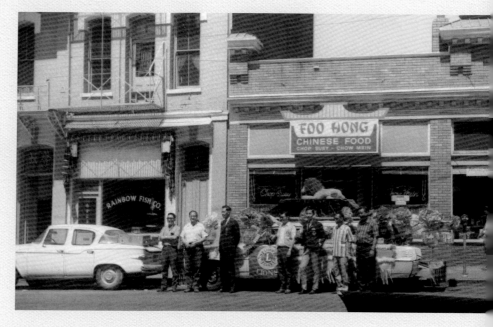

ABOVE A 1964 Pontiac decorated by the Lions for the Victoria Day parade.

一輛由華埠獅子會為維多利亞日花車大巡遊而佈置的一九六四年龐迪房車

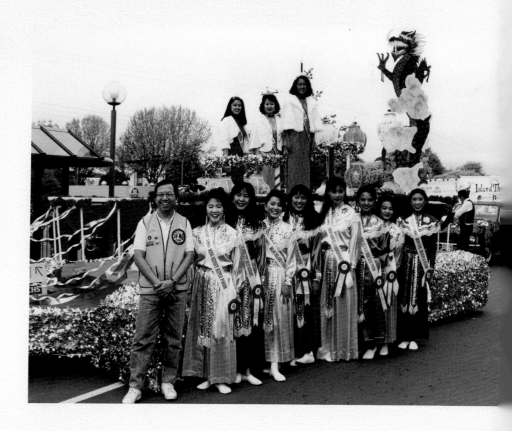

RIGHT Miss Victoria Chinatown finalists and float ready for the Victoria Day parade, *circa* 1984.

維多利亞華埠小姐總決賽的花車，準備出發參加維多利亞日花車大巡遊，相片約攝於一九八四年。

131

Dragon-boat racing in Victoria's Inner
Harbour, 2007.

在維市內港海傍舉行的龍舟競賽，
攝於二零零七年

23 VICTORIA CHINESE COMMERCE ASSOCIATION
華埠商會

The Victoria Chinese Commerce Association was founded in 1991 to promote business and social relationships, and to help Canadians of Chinese descent participate in Canada's commercial marketplace.

The association's original honourary chairman was the Lieutenant-Governor of British Columbia, David Lam. The association has met frequently over the years, usually at various local restaurants, to plan its numerous programs. Goals include promoting Chinese traditions and culture in the Canadian context.

In 1994, in conjunction with the Commonwealth Games Society and with the assistance of the Vancouver Dragon Boat Festival, the association arranged the first dragon-boat demonstration race in Victoria's Inner Harbour. Dragon-boat racing caught on in Victoria, and the festival is now in its 14th year, a popular stop on the international dragon-boat racing circuit.

In 2008, during BC's 150th anniversary, and to honour the arrival of the first Chinese in Victoria, the association presented the Golden Mountain Celebration Pageant, featuring a narrated historical depiction of 150 years of the Chinese experience in Canada, at the McPherson Playhouse. On August 8, 2008, the Golden Mountain Achievement Awards were presented at a gala dinner.

華埠商會於一九九一年成立。創會的宗旨是推廣商業發展與社會關係，及協助加藉華裔參與加國的商業市場。

該會的創會榮譽會長是當時的卑詩省省督林思齊。多年來，該會在不同的酒樓裏舉行定期聚會，商討會務。他們的宗旨是在加國社會中推廣中華傳統及文化。

一九九四年英聯邦運動會在維市舉行，華埠商會在溫哥華龍舟協會的協助下，假維市內港海傍舉辦了首次龍舟競賽。龍舟競賽在維市成了一項引人注目的戶外活動。現已辦到第十四屆，成了世界龍舟競賽巡迴路線的熱門站。

二零零八年是維市一百五十週年紀念，為了表揚一百五十年前抵埠的華裔事跡，華埠商會舉辦了金山慶祝盛會，在麥花臣戲院以說故事的形式敘述過去一百五十年華裔在加國的歷史及經驗。該會並於二零零八年的八月八日，舉辦了盛大的晚宴，頒發了金山成就獎與對社會有貢獻之傑出華裔。

Victoria Chinese Commerce Association 中華商會

華人神召會
CHINESE PENTECOSTAL CHURCH
2215

 ## VICTORIA CHINESE PENTECOSTAL CHURCH
華人神召會

The Victoria Chinese Pentecostal Church originated in 1954 when four local women met in the living room of Mrs. Chew Lok Man for prayer and bible study. With the assistance of the Glad Tidings Tabernacle, the group arranged for Pastor Howard Ha to come from North Vancouver to lead them. A storefront at the corner of Cormorant and Government streets was rented and became the first "church."

In addition to church services and study groups, Sunday school and a cubs pack were initiated for children. A women's auxiliary was active from the start, and English classes for new immigrants were provided. As the congregation grew, vacation Bible school and the Spirit Connection choir were added to the church's activities.

華人神召會於一九五四年創辦。當時有四位本地婦女在趙樂民夫人家中客廳學習聖經和祈禱中,引發了成立教會的意念。後來在佳音教會的恊助下,安排了夏華炳牧師從北溫哥華前來維多利亞主持教會事務。在金馬倫街及加富門街的交界處租了一個鋪位,成為華人神召會的首間教堂。

華人神召會的教會事務除了傳道外,也辦主日學及兒童活動。當時的婦女組是個十分活躍的小組,教會也為新移民開辦英文班。華人神召會的教徒漸多,聖經班及唱詩班也相應而增。

By 1962 the congregation was able to buy property at the corner of Princess and Dowler streets and to build their own church. Within a surprisingly short time it became a challenge to find room for the growing numbers of worshippers and in 1989 a handsome new building was constructed nearby at 2215 Dowler Street. It was designed by long-time church member Alan Lowe, with his architectural partner Jackson Low. A number of pastors have led the group, most recently Lawrence Wan, who arrived from Hong Kong in 1997.

Not all the church members are Chinese and services are now conducted in English as well as in Mandarin and Cantonese. Over the years notable members have included parliamentarian Douglas Jung, artists May Ip and Stephen Lowe, and Lowe's wife, Eunice. Leah and Philip Chan have been stalwart supporters from the very beginning. In fact, their mothers were two of the founders of the Victoria Chinese Pentecostal Church.

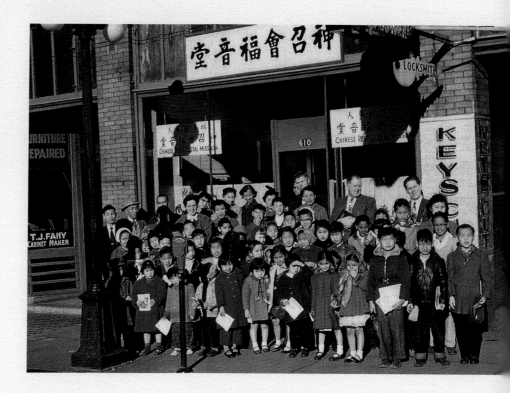

至一九六二年，教會已有能力購買一幅在公主路和道拉街交界處的土地，興建了屬於自己的教堂。稍後，教會會務發展迅速，地方已不夠應用。教會於一九八九年，在附近的二二一五道拉街建築了一座宏偉的新教堂。教堂建築物的設計由該教會的資深教友劉志強建築師與劉卓燊共同設計。神召會先後有數位牧師主持教會事務，目前的主任牧師是尹健全牧師，他於一九九七年由香港前來赴任。

華人神召會的信徒中也有非華裔的，主日的講道分英語、國語及粵語。多年來，眾多的知名人士如曾連任三屆維市市長的劉志強、畫家林玫英、畫家劉允衡和他的夫人譚翠嫦、陳新民及夫人陳利亞伉儷等，都是該教會的教友。已故的陳新民一直是該教會的忠實支持者，事實上，陳新民的母親陳敦夫人與岳母周養夫人，是華人神召會四位創辦人中之兩位。

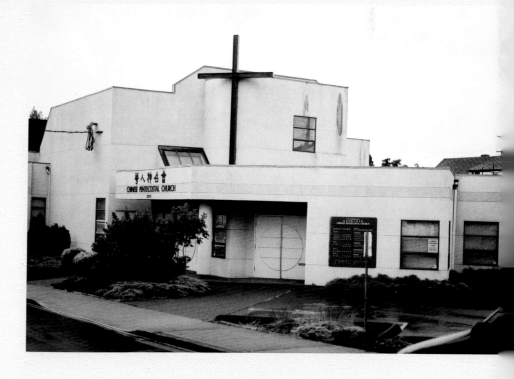

TOP The storefront church on Cormorant Street in the mid-1950s.
位於金馬倫街的教堂，攝於一九五零年代。

BOTTOM The new church, which opened in 1989.
華人神召會的新教堂，攝於一九八九年

25 VICTORIA CHINESE CULTURAL ASSOCIATION
中華文化中心

The Victoria Chinese Cultural Association was founded in 1989 by the poet Hor-ming Lee and the calligrapher and seal-carver Leung Siu. Originally they had their own gallery space where exhibitions of paintings by local and visiting artists were held, as were landmark displays of calligraphy. Since that time the club has given up its quarters and now meets every two or three months in other locations. The 20 members maintain a keen interest in developing their artistic expression. Kileasa Wong is the association's president.

中華文化中心成立於一九八七年，由詩人李可銘，書法家及圖章雕刻家梁韶等創立。創會之初，該中心有會址，舉辦了多個本地及國內藝術家的書法及國畫展覽。當中華文化中心因缺乏經費而失去了其會址後，為數約二十名的會員們，約每隔二、三個月相聚一回。會員們對藝術的推廣保持濃厚興趣。黃吳紫雲是該會的主席。

Wing Lim, artist and member of the Victoria Chinese Cultural Association.
畫家林福榮是中華文化中心會員，

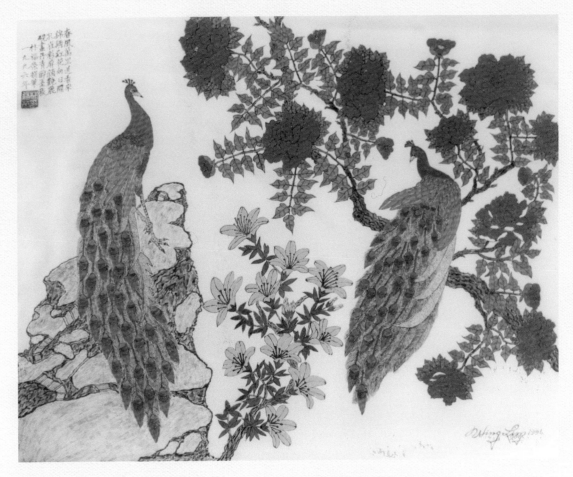

LEFT A painting in ink and colours on silk by Wing Lim.

上圖左：林福榮先生的一幅彩色絲布國畫遺作。

BELOW Members of the Victoria Chinese Cultural Association.

下圖：中華文化中心會員慶祝農曆新年。

Members of the Hong Kong Chinese
Overseas Association. | 香港旅加華僑聯誼會的會員聚會。

26 HONG KONG CHINESE OVERSEAS ASSOCIATION
香港旅加華僑聯誼會

The Hong Kong Chinese Overseas Association is a relatively new member of the Chinese Consolidated Benevolent Association, registered as a society in 1986. Founders Joseph Leung, Petter Lam and Peggy Lee decided to create a social club which would come together to "eat, drink and have fun." Their meetings, which take place four times a year, facilitate communications with friends and government agencies in Hong Kong.

In addition to the dinner parties, the association holds a mahjong competition and often arranges tours and picnics with other expatriates from Hong Kong. As in all Chinese organizations, fundraising for charitable endeavours in the community is a big part of their work.

27 YUN PING ASSOCIATION

The Yun Ping Association is mentioned in the documents of the Chinese Consolidated Benevolent Association as early as 1931. Its particular goal is to bring together people who come from the village of Yun Ping in the province of Guangdong in southern China. In fact, almost all the Chinese in Victoria are from Guangdong (Canton) and speak Cantonese, as distinct from the northerners whose language is Mandarin.

The Yun Ping Association is proud to count Douglas Jung among its members. Jung, who grew up in Victoria, was a war veteran, a lawyer and the first Chinese-Canadian Member of Parliament. A large federal building in Vancouver was named after him in 2007. Currently the president of the Yung Ping Association is Douglas Nip.

香港旅加華僑聯誼會是中華會館屬下僑團中較新的一個團體，於一九八六年註冊為社團。該會創辦人包括梁肇成、林兆昌及李梁碧心等多人。創會的宗旨是一班由香港來的移民定期聚會，以 <吃、喝、玩、樂>會友。該會每年聚會四次，並與香港社區及政府保持聯繫。

除了定期的晚餐聚會外，香港旅加華僑聯誼會也舉辦麻將大賽、旅遊及野餐等活動，與同樣是來自香港的會員相聚，閒話家常。與埠中其他僑團一樣，該會亦舉行慈善籌款賑濟有需要的機構。

27 恩平會館

恩平會館在華埠?史悠久，其會館名字最早於一九三一年已在中華會館的文獻中出現。其創會的宗旨是聯?來自中國南方廣東省恩平地區的鄉親，以便互相照應。事實上，早期維市的華人，幾乎都是來自中國南方廣東省，都說粵語。與中國北方的普通話截然不同。

恩平會館最傑出的鄉親是鄭天華，他出生及成長於維市，是位華裔退伍軍人。他的職業是律師，曾任加國國會議員。在二零零七年，溫哥華的一棟聯邦政府的大樓，用他的名字命名，以表揚他對加國政府的貢獻。恩平會館的現任主席是聶明亮。

28 CHINATOWN JUNIOR LION DANCERS
華埠幼童醒獅團

In 1979 an initiative by Dr. David Lai and Lai Yin Bong resulted in the formation of the Chinatown Junior Lion Dancers. Lai was among a group of parents who wanted their children to learn kung fu and asked Master Wong Sheung to teach them every Saturday afternoon. Both boys and girls, starting when they were five years old, were introduced to martial arts and the lion dance.

The Junior Lion Dancers were, in large part, students of the Chinese Public School, whose award-winning folk dance troupe has long been a feature of the school, and they also belong to the Sheung Wong Kung-fu Club. When that club was called upon to bring its adult lion dance team to open a supermarket or lead a parade, Master Sheung Wong would often call the parents and ask them to "bring the babies"—the Junior Lion Dancers. In Chinatown, everyone is part of the family.

華埠幼童醒獅團由黎全恩博士與龐麗賢女士於一九七九年創辦。黎教授與幼獅團的家長們均希望其子弟能學習傳統功夫，強身健體，特邀請黃相健身會的黃相師父擔任教練。一群由五歲以上之年幼男、女孩子，在黃相師父的訓練下，除了基本功夫拳法，也學習舞獅。

華埠幼童醒獅團的團員，有很多是華僑學校的學生。華僑學校的舞蹈團，多年來經常在各類民族舞蹈比賽中獲獎。幼童醒獅團與黃相健身會的關係密切，當健身會的師兄師姊們被邀請往新店開張、花車遊行中表演時，黃相師父往往吩咐家長帶<小孩>們隨師兄、姊上陣表演。華埠就像一個大家庭，人人都是家庭中的一份子。黃吳紫雲是幼獅團的主席。

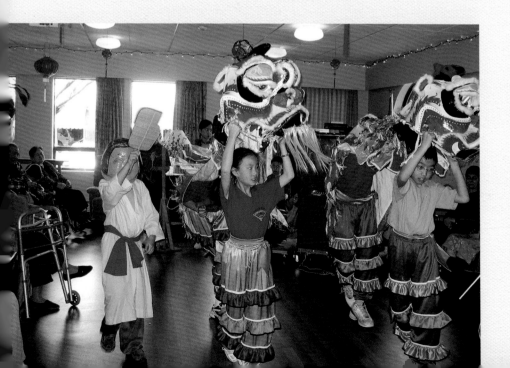

The Chinatown Junior Lion Dancers entertain the residents of the Chinatown Intermediate Care Centre.

華埠幼童醒獅團往華埠療養院探訪，並舞獅娛樂老人家。

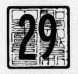

29 CHINATOWN INTERMEDIATE CARE CENTRE
華埠療養院

To establish a Chinese hospital was one of the original purposes of the Chinese Consolidated Benevolent Association. It cared for the elderly and the infirm who could not afford to return to China and the patients were initially all Chinese men.

The hospital served the community for many years though it had no steady source of income. In 1979, the outdated facility was forced to close, yet there was still a need for a care facility for elderly Chinese with special language and diet needs.

In 1982, a new three-storey facility was opened, funded by a combination of government money and support from the Chinese community in Victoria. The Chinatown Intermediate Care Centre, built on the original hospital site at 555 Herald Street, is open to the elderly—not only Chinese men and women, but all who need its help.

About 30 residents live here, each in a private room with bathroom. The staff are mostly Chinese and they all know some simple Cantonese. The meals offer a mix of Western and Chinese cuisine. A nurse is on duty 24 hours a day and residents are free to come and go for shopping, visiting and enjoying Chinatown. A respite room is provided for short-term stays, and a seniors' daycare is also available.

維多利亞華埠療養院的前身是中華醫院,於一八八四年由中華會館創辦。免費收容年老無依,而又沒有足夠旅費回歸唐山養老的華裔男性長者。

由於缺乏固定經費,該院財政上經常處於困境。百餘年來,經過幾許辛酸及變遷,中華醫院終於在一九七九年六月三日關閉。但基於華裔長者在語言上及食物上的特殊需求,華埠迫切需要一間可收容華裔長者的療養院。

在一九八二年二月,由政府撥款,及在維市中華會館與僑界的協助下,一間三層高的療養院,於喜路街五五五號之中華醫院原址落成開幕。定名為維多利亞華埠療養院。申請入住的長者不分國籍或性別,病人入院的資格視乎其需要照顧的程度,及申請的先後。

目前療養院有三十位病人,每人均有獨立房間和廁所。院中工作人員大部分是說粵語的華人,就算是非華裔的職員,也畧懂簡單的粵語,足與病人溝通。院中膳食是中西合璧。療養院全日二十四小時均有註冊護士當值。只要健康許可,病人在日間可自由出入,購物、往華埠閒逛或探友。療養院另有一個房間專接收短期病人,若家人出遠門,可申請把乏人照料的老人家暫托於療養院。該院亦開辦長者日托服務。

The entrance gateway, erected when the cemetery was dedicated as a National Historic Site in 2001. This view is of the Strait of Juan de Fuca and the Olympic Peninsula beyond it.

華人墳場的入口處鐵閘。於二零零一年國家公園局將華人墳場列為國家傳統保留區時建立的。從這處可遠望至雲達富卡海峽甚至奧林柏克半島。

Sign over the gate of the Chinese Cemetery.
華人墳場入口處鐵閘的標誌。

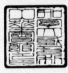

THE CHINESE CEMETERY
華人墳場

The remains of early Chinese immigrants were buried in the low-lying southwest corner of Ross Bay Cemetery but it was susceptible to flooding so in 1891 the Chinese Consolidated Benevolent Association purchased a large plot of land just north of Swan Lake in Saanich. Because of opposition from local residents, it was unable to conduct burials there. The CCBA sold that land and in 1903 purchased the site then known as Foul Bay Point, now Harling Point. It is noted for its excellent geomantic or *feng shui* aspects, as it faces southwest and is auspiciously positioned between a small "mountain" and the sea.

The Chinese Cemetery is a memorial park, not a graveyard. By Chinese custom, bodies were buried for seven years and then the bones were retrieved, cleaned, dried and packed in wooden crates for shipment back to China. There they would join their ancestors in the family shrine. While awaiting shipment, these bones were stored in a "bone house." In early times the Yue Shan Society built and maintained one such storehouse at Harling Point but the building no longer exists.

早期華裔移民的遺體埋葬於羅士灣墳場的西南角低窪地方，但該處易受水浸。中華會館於一八九一年購買了在沙尼治市天鵝湖的一片土地作為墳場，但因附近居民的反對而未能在此地安葬先人。後中華會館賣了該地，於一九零三年購買位於當時稱為浮灣角，後改稱哈寧角的土地。這塊在風水學上被稱為風水極佳的土地，面向西南，是塊背山面海的吉兆福地。

華人墳場在初期是一個暫時性的紀念墳場，而不是永久墓園。按當時維市中華會館的慣例，遺體下葬七年後，其骸骨會被取出，清潔及曬乾後，安放於木盒中，定期運回中國。使能埋葬於其家鄉的墓地及可在家族中設立神位拜祭。在早期，禺山分所於哈寧角墳場內建築了供執拾及貯藏骸骨的小屋，該墳場小磚屋現已不存在。

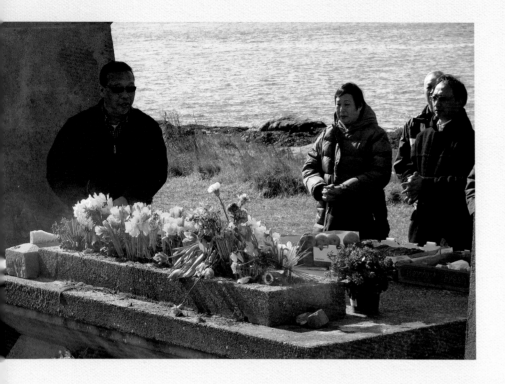

TWO LEFT IMAGES Offerings made on the altar at the Chinese Cemetery on the occasion of Qing Ming, the spring celebration. Daffodils, roast pork, steamed buns, candles and other offerings are visible.

左兩圖：在清明節春祭時，祭壇上供奉著洋水仙、燒豬、包點、香燭及其他祭品等。

RIGHT Looking south across the Chinese Cemetery. The metal doors in the twin chimneys allow commemorative offerings to be burnt and the smoke to ascend to heaven.

右圖：望向華人墳場的北面，可見祭壇傍的兩大烟囱石柱，點燃後的元寶香燭可放進烟囱上的小鐵門內燃燒，讓縷縷上升的香火，直達天堂。

Later, the CCBA took responsibility for bones, which were being returned to China from all across Canada. The last shipment occurred in 1936. The CCBA closed the cemetery in 1950 after all the available burial sites were occupied; however, in October 1961, remains were interred in 13 mass graves in a final ceremony.

Qing Ming, an occasion for communal commemoration at Harling Point and other graveyards, traditionally takes place in April. This beautiful cemetery has now been respectfully restored, its many monuments cleaned and returned to their correct positions. In 2001 it was formally designated a National Historic Site.

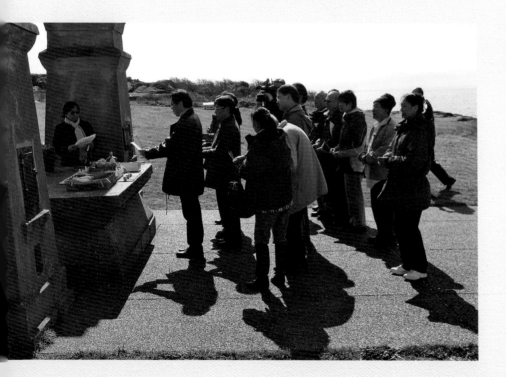

後來，全加國各地的骸骨集中運來哈寧角墳場，由中華會館負起將各地運來的骸骨定期運回中國的責任。最後一次的運送工作是在一九三六年。在墳場中所有墓穴已被使用後，再沒有空的墓地容納新葬，中華會館於一九五零年關閉了墳場。在一九六一年十月，中華會館將存放於磚屋中無人認領的骸骨，依據其藉貫，合葬於十三個大墓穴中。

清明節往哈寧角墳場或其它墓園舉行春祭紀念先人，是華裔的傳統。華人墳場是個風景幽美的墓園，經過美化重修後，墓園中許多殘舊的墓碑經專人整理，重新放回正確的位置。國家公園局於二零零一年將華人墳場列為國家傳統保留區。

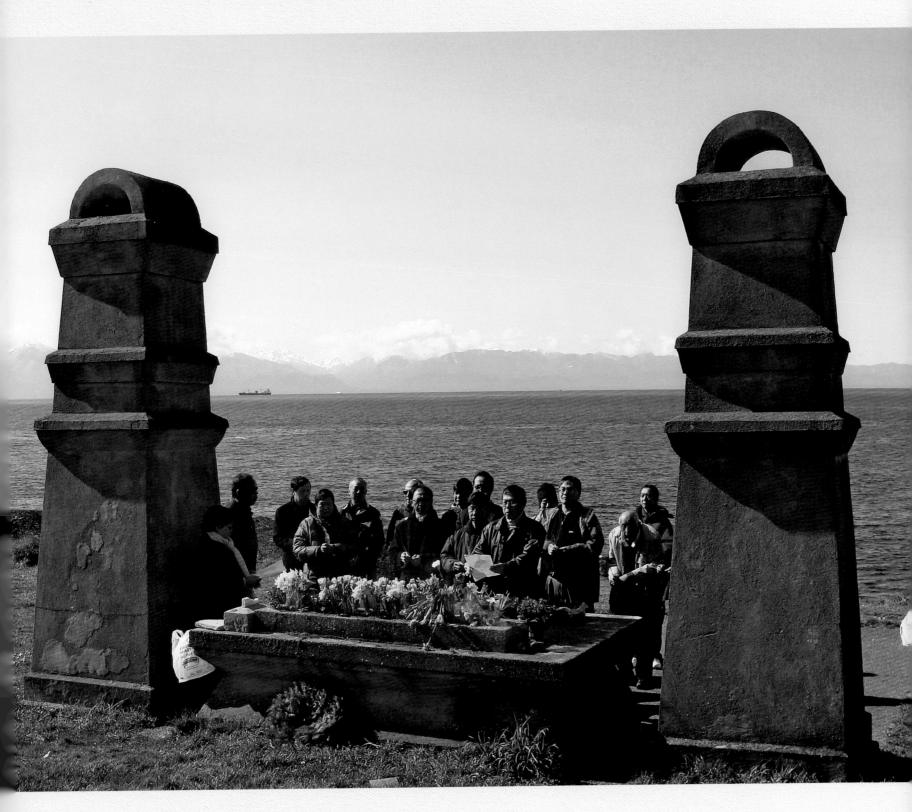

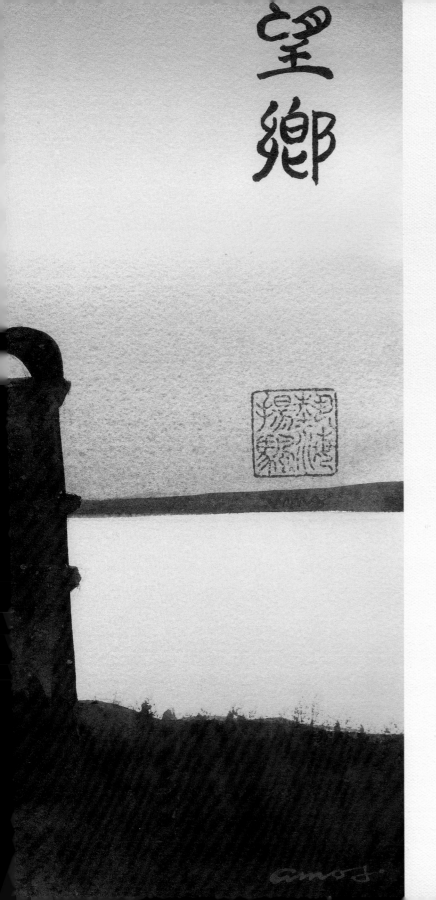

望鄉

A painting of the Chinese Cemetery by Robert Amos and inscribed by Kileasa Wong for Parks Canada. Prints of this image were given to those in attendance when this National Historic Site was restored and rededicated in 2001.

羅伯特.埃莫斯為國家公園局繪畫的一幅華人墳場水彩畫,由黃吳紫雲題字。在二零零一年,華人墳場被列為國家傳統保留區的儀式中,出席嘉賓獲贈該畫的印刷版。

BIBLIOGRAPHY

Ban Seng Hoe, *Beyond the Golden Mountain*, Canadian Museum of Civilization, Ottawa, 1989.

Chan, Anthony B., *Gold Mountain: The Chinese in the New World*, New Star Books, Vancouver, 1983.

Danzker, J. B. et al., *Gum San Gold Mountain: Images of Gold Mountain 1886–1947*, Vancouver Art Gallery, Vancouver, 1985.

Kinkead, Gwen, *Chinatown: Portrait of a Closed Society*, Harper Collins Publishers, New York, 1992.

Kwong, Peter, *The New Chinatown*, Hill and Wang, New York, 1987.

Lai, David Chuenyan, *The Forbidden City Within Victoria*, Orca Book Publishers, Victoria, 1991.

Ng, Wing Chung, *The Chinese in Vancouver, 1945–1980*, University of British Columbia Press, Vancouver, 1999.

Wickberg, Edgar, ed., *From China to Canada: A History of the Chinese Communities in Canada*, McClelland and Stewart, Toronto, 1982.

Yee, Paul, *Chinatown, An Illustrated History*, James Lorimer and Company, Toronto, 2005.

——, *Saltwater City, An Illustrated History of the Chinese in Vancouver*, Douglas & McIntyre, Vancouver, 2006.

PHOTO CREDITS

ROBERT AMOS

2, 3, 5, 6, 8, 15, 25, 31, 36, 39 left, 40 right, 41, 43, 44, 45, 46, 47, 48, 49, 50, 53, 57, 59, 62, 63, 64, 65 top, 66, 67, 68, 69, 70, 71 top. 72, 73, 74, 75 lower, 77, 78, 80, 81, 82, 84, 86, 87 top, 89 top, 90, 91, 92, 93, 94, 95, 96, 97 top, 98, 100, 101, 102 left, 103, 104, 105, 106, 107, 108, 109, 110, 111, 112, 113, 114, 116, 117, 118, 119, 120, 121, 122, 123, 124, 126, 127, 128, 130, 131, 132, 133, 140, 142, 143 bottom, 144, 145 right, 148, 150, 151, 152, 153, 154, 156.

KILEASA WONG

7, 16, 38, 51, 56, 60, 61, 65 lower, 71 lower, 79, 83, 85 lower, 87 lower, 88, 89 lower, 97 lower, 102 right, 129, 134, 145, 146, back cover.

BRITISH COLUMBIA PROVINCIAL ARCHIVES

19, 23, 24.

VICTORIA CHINESE PUBLIC SCHOOL ARCHIVES

11, 12, 35, 39 right, 40 left, 42, 52, 54, 75 top.

PHILIP CHAN

76, 134, 139.

OTHER SOURCES

27 Dan Lore.

32 Chan Dun family, courtesy of Anthony Chan.

136 Carolina Choy.

143 top Victoria Chinese Pentecostal Church.

ROBERT AMOS

Since his arrival Victoria in 1975, Robert Amos has been drawn to Chinatown. At first his artist friends welcomed him to their studios on Fisgard Street and from them he explored Chinatown.

When Amos became a professional artist in 1981 he chose the new Gate of Harmonious Interest as a focus for his work. A five-part panoramic painting of Fisgard Street was the centrepiece of his first exhibition, in 1982. Since 1986 Amos has been the art writer for the Victoria *Times Colonist* newspaper. In 1988, he reviewed an exhibit of Chinese calligraphy at the Chinese Canadian Cultural Association and on that occasion met one of the society's founders, Kileasa Wong. Since then, they have collaborated on many projects.

In 1993 Wong started the *Victoria Chinatown Newsletter* and she used Amos' drawings of Chinatown for the cover of almost every issue. Photographs made as reference material for that series were displayed in Chinatown and at the University of Victoria, and later published as a 12-part series of articles in the *Times Colonist*. Ten years later, many of those photographs have become historic documents. Due to continuing interest in the subject, Wong and Amos were invited by TouchWood Editions to present their unique and informative view inside Chinatown.

羅伯特.埃莫斯

羅伯特.埃莫斯於一九七五年到達維市後,就深深地被華埠風貌吸引。他的藝術界朋友招待他在華埠菲士格街的工作室中出入,以探究華埠。

當一九八一年他正式成為專業畫家時,他選擇華埠同濟門為其主要題材。在一九八二年,他的首次個展主題作品就是華埠菲士格街全景。自一九八六年開始,他在泰唔士報撰寫藝術專欄。一九八八年他應邀前往評賞由中國文化中心主辦的書法展覽,認識了該中心創辦人之一的黃吳紫雲女士。自此,他們在多方面合作無間。

一九九三年黃吳紫雲創辦由中華會館資助之華埠通訊中文雙月刊時,她邀請羅伯特.埃莫斯為其刊物封面繪圖,他那些以華埠為題材的畫作,已成了華埠通訊的傳統特色。在這個特輯裏,您將有機會看到他為繪畫所拍攝的相片。這些相片,曾在華埠及維多利亞大學展出。他們於零八年在泰唔士報刊登了一個共十二期的華埠特輯。十餘年來,有很多相片已成為歷史圖片。黃吳紫雲與羅伯特.埃莫斯接受TouchWood Editions出版社的邀請,決定與大家分享這些珍貴的華埠內貌資料。

KILEASA WONG

Kileasa Wong is known by many names. She was born Wu Chewan in Hong Kong, the daughter of a family from Chaozhou in the northeast corner of Guangdong Province. In Hong Kong she met and married Maurice Wong. They immigrated to Canada and opened a corner store in Victoria in 1974. With the help of their four sons, they have operated it ever since.

When her children grew up, Wong took on a number of projects in the community. She is a long-time student of Chinese painting (under Chow Su-sing of Vancouver) and has for many years been the foremost teacher of traditional Chinese painting in Victoria. She also became a teacher at the Chinese Public School on Fisgard Street. While teaching and parenting during the 1990s, Wong took a Bachelor of Fine Arts degree at the University of Victoria, following it with a Master's degree in education. A few years later, she became principal of the school—in Chinatown she is addressed as "Principal Wu."

Wong is the secretary of the Chinese Consolidated Benevolent Association and the editor of the *Victoria Chinatown Newsletter*, the CCBA's bi-monthly Chinese-language magazine. As principal, editor, dance teacher, mother and artist, she makes a valuable contribution to her community every day.

黃吳紫雲

出生於香港，祖籍廣東汕頭。與夫婿黃武能是青梅竹馬的同學，一九七零移民來加結婚後，其夫經營雜貨店至今。他們育有四子。

待孩子們年紀稍長，黃吳紫雲開始參與社區活動。她拜在國畫大師周士心門下習畫，成為其入室弟子。她後來成為維市知名的國畫老師，多年來一直教授國畫至今。在偶然的機會下，於八零年代末，她開始在域多利華僑公立學校擔任四年級班主任。在兼任教職與母職之餘，於九十年代初，黃吳紫雲往維多利亞大學進修並取獲藝術學士及教育碩士學位。她於九七年被任命為華僑學校校長，成為該校首任女校長。在華埠，人人尊稱她為"吳校長"。

黃吳紫雲擔任中華會館書記多年。她於一九九三年創辦華埠通訊雙月刊，並任該刊主編。作為校長、編輯、舞蹈教師、母親和畫家，她對社區作出巨大的貢獻。

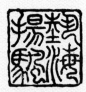

This seal, with the characters reading
"Afloat on the Ocean of Art," identifies
the collaborative projects of
Kileasa Wong and Robert Amos.